D0734485

# ROGUES IN THE GALLERY

BOOKS BY HUGH McLEAVE

Fiction

*A Borderline Case*
*Only Gentlemen Can Play*
*A Question of Negligence*
*Vodka on Ice*
*The Sword and the Scales*
*The Steel Balloon*
*No Face in the Mirror*

Nonfiction

*A Man and His Mountain*
*The Damned Die Hard*
*The Last Pharaoh*
*A Time to Heal*
*The Risk Takers*
*McIndoe: Plastic Surgeon*
*Chesney: The Fabulous Murderer*

# Rogues in the Gallery

## The Modern Plague of Art Thefts
### by Hugh McLeave

David R. Godine · Publisher · Boston

First published in 1981 by
David R. Godine, Publisher, Inc.
306 Dartmouth Street
Boston, Massachusetts 02116

LIBRARY OF CONGRESS CATALOGING IN PUBLICATION DATA

McLeave, Hugh.
Rogues in the gallery.
Bibliography: p. 271.
Includes index.
1. Art thefts.   I. Title.
N8795.M34   364.1′62   80-83956
ISBN 0-87923-378-8

PRINTED IN THE UNITED STATES OF AMERICA

# Contents

*To Ronald Bedford,*
*for all the miles*
*we have traveled*
*together*

# Prologue: The Black Market in Masterpieces

Early on an August morning in 1911, a young man walked past a dozen guards in the most famous museum in the world, strolled through its vast galleries to its most illustrious painting, calmly lifted it from its four supporting hooks, thrust it under his overall, and walked out a side door. In less than half an hour, he had pulled off the most fantastic art theft the world had seen. The Mona Lisa gone from the Louvre! No one could really believe it. France stopped in her tracks, even forgetting for a tumultuous interval the threat of war with Germany over Morocco. The Mona Lisa stared from newspapers in every language, her smile as enigmatic as motives for the theft. For who on earth would steal Leonardo da Vinci's masterpiece, greatest glory of the High Renaissance? And why? What dealer, collector, or museum would touch a priceless work of art, at any price? Every art lover knew it, so there was nowhere the thief could display it. French police ruled out professional criminals and looked for a madman obsessed by the Gioconda smile or a whimsical art student or another *farceur* demonstrating how easy it was to steal a *chef-d'oeuvre* from the Louvre.

It took two and a half years for the thief to surface with the Mona Lisa, pleading he stole it for political and patriotic reasons. His theft, probably the most sensational in art history, inspired

1

hosts of others. Fifty years to the day after the Mona Lisa disappeared, another thief broke into the National Gallery in the heart of London to steal Goya's portrait of the Duke of Wellington. But by then, art thefts had become an epidemic and the traffic in stolen art ranked just behind drug smuggling as the most profitable racket in organized crime. When the underworld discovered that painting, sculpture, porcelain, and other cultural treasures meant big money, its bosses recruited thieves and petty criminals from other rackets like syndicated gambling, prostitution, protection, and burglary into art theft and stolen-art traffic.

But art robbers have a long genealogy. More than 3,000 years ago the Mayor of Thebes in Ancient Egypt had to answer charges of grave robbing; thieves pillaged and ransacked almost every pyramid and only bad luck prevented them from finding Tutankhamen's tomb. Even Cleopatra despoiled her predecessor's grave while her lover, Julius Caesar, and every other Roman emperor, plundered not only art treasures and trophies but carried off likenesses of gods and religious symbols to render their enemies impotent. Tamurlaine, Napoleon, and Hitler all had professional and official looters in their baggage trains.

For sheer cheek, the seventh earl of Elgin takes the palm. As British envoy to Constantinople at the end of the eighteenth century, he carted off two hundred feet of marble frieze sculpted by the greatest artists of Ancient Greece for the Parthenon and other Acropolis buildings. Accused of vandalism, he countered with the blithe argument that, in one form or another, has served for dubious acquisition ever since: he had merely saved the priceless works from the Turks, who were using the shrine as target practice during their war with Greece. After selling the Elgin Marbles to the British Museum for £36,000 gold, this canny Scot complained he had lost £15,000 gold on the deal. Lord Byron, himself a half-Scot but also a Hellenist, fulminated with rage on seeing the Parthenon. He wrote:

> Daughter of Jove! In Britain's injured name,
> A true-born Briton may the deed disclaim,
> Frown not on England — England owns him not:
> Athena! No — the plunderer was a Scot.

2

Napoleon exacted an art tribute from defeated nations. Paris would become the world's artistic capital, luring students, savants, and artists to steep themselves in French culture. Whatever their origin, acquisitions would be declared French by adoption. Behind his emperor went Baron Dominique-Vivant Denon, director-general of museums, to mop up art works and fill the Louvre, Tuileries, St.-Cloud, and Malmaison with them. This hawklike figure, dressed in undertaker black and notorious throughout Europe as the Removal Man, sent museum chiefs and palace chamberlains running for cover when his wagon train appeared. In a sense, Napoleon's dream became reality. His own court painters, David and Isabey, lived like royalty; their pupils, like Ingres and Gros, made themselves rich and respected; students and artists congregated in Paris, cosmopolis of the arts. Gericault sold his *Raft of the Medusa* for a princely 20,000 francs, Ingres realized the same for *The Turkish Bath*, while the state paid Delacroix 6,000 francs for *The Massacre at Scio*. However, such pictures and prices proved the exception. Destined for the museum or palace, this art had no resale value — no market existed. It took more than a century and a revolution in the art world to change things and bring art stealers on to the scene.

In France and other European countries, art had an official stamp impressed on it by fine-arts institutes and official exhibitions which decreed the taste of rich collectors and art lovers as well as the moneyed snob for whom painting and sculpture spelled status. Impressionism, beginning in the mid-1870s, demolished this official art world and helped create the modern market. In the last quarter of the nineteenth century, farsighted dealers, like Paul Durand-Ruel in Paris, were already creating fresh markets for a new generation of painters like the Barbizon School and Impressionists; unknown artists like Monet, Renoir, Degas, Pissarro, and Sisley, barred from state exhibitions, nevertheless began to sell to the collector; one dealer, Ambroise Vollard, was to make himself a multimillionaire by collaring most of Cézanne's output, then sponsoring Gauguin. But long before the First World War even painters like Picasso and Matisse were fetching good prices, and connoisseurs like Gertrude Stein were acquiring these and other avant-garde artists.

3

English art, too, was enjoying a boom. In 1873, Landseer's *Otter Hunter* realized £10,000, and a year later Holman Hunt's *The Shadow of Death* went to an art dealer for £11,000, including reproduction rights. However, Gainsboroughs made the big news. American millionaires like Junius Spencer Morgan, his son, J. Pierpont, and industrial magnates like Henry Clay Frick and Henry H. Huntington waged financial slugging-matches — shrewdly refereed by art dealers like Lord Duveen — to settle who would bid highest for Gainsborough portraits. In 1913 Frick won, with £82,700 for a portrait of Frances Duncombe, only to lose eight years later when Huntington bought *The Blue Boy* for £148,000. Morgan the elder, who obsessively desired the duchess of Devonshire, found himself thwarted not by a rival millionaire but by one of the most colorful characters in crime annals, Adam Worth.

Prince of con men and safecrackers, Worth hailed from Cambridge, Massachusetts, but lived like a London swell on the proceeds of dozens of robberies and frauds; his sumptuous West End flat served as an operational base for a gang of professional bank and jewel robbers. In May 1876, Worth was seeking ways of releasing his brother John from a London prison where he was awaiting trial for forgery; in Agnew's Gallery, Bond Street, his eye lighted on Gainsborough's *Duchess of Devonshire*, just bought for £10,000 ($50,000). Now *that* he might trade for his brother's freedom. Worth broke in and stole the picture; he then found his brother had been freed on a technicality, leaving him with an embarrassing hostage. Smuggling the painting into the United States, he began negotiating with Agnew's for £15,000 ($75,000) in gold. When this failed, Worth held on to the painting until a year before his death in 1902. With the cooperation of William Pinkerton, founder of the famous detective agency, Worth finally returned the painting for a small ransom. J. Pierpont Morgan then acquired it in his father's memory. 'Art never expressed anything but itself,' Oscar Wilde observed in the nineties. But even then it was beginning to express something else — money.

American millionaires like Morgan started raiding European private collections and artists' studios. Morgan made fabulous gifts to the Hartford Wadsworth Atheneum in Connecticut and to the

Metropolitan Museum in New York. Behind him came Benjamin Altman, George Blumenthal, George Jay Gould, Andrew Mellon, W. C. Whitney. Few others had their money or desire, and anyway art collecting remained something of a closed shop. When the Paris treasure trove of Lord Hertford, Sir Richard Wallace, and Sir John Murray Scott came up for sale two months before the First World War, only selected American and European millionaires were admitted to buy. But this cosy club reunion marked the end of an era.

After 1918 American millionaires shuttled back and forth to Europe on luxury liners, like so many carpetbaggers, to return with old masters and new. Albert Barnes used the millions he made out of a medical discovery, Argyrol, to raid along Montmartre and Montparnasse and literally strip bare the studios of painters like Modigliani and Soutine, considered oddities among artists. John Quinn and others ferreted along the Left Bank for modern masters. What motivated these Americans? An atavistic instinct for Old World culture? An attempt to temper or offset the materialism from which they had made their millions with things more spiritual? A ticket to immortality through foundations bearing their names and stuffed with great art? A reflection of their superiority — or inferiority — complex? Whatever the reason, art gathering remained a rich man's game until after the Second World War. Barnes, Quinn, Mellon, and others bought through private dealers or proxy bidders at dignified auctions. Museums and private collectors generally clung to what they had acquired. If art graced public buildings, museums, the lordly manor, and the rich bourgeois mansion, it remained untainted by money; no one said it was the same thing as wealth or investment.

Hitler borrowed Napoleon's idea of appropriating everything of artistic value from conquered countries. But he meant to transform a whole city into a teutonic pantheon with this vast stockpile of plundered art. Like every other human activity, culture needed a *diktat* to decide good and bad. Hitler spurned Berlin as a merely Prussian capital, choosing Linz in Austria, where he had spent some of his boyhood, as the ideal Third Reich site. While Hermann Goering was making his reputation as the world's greatest art thief

5

with 1,600 looted treasures, the Nazi art pundit, Dr. Hans Posse, was using the army and SS to pillage palaces, manor houses, churches, and museums and ferry all this vast haul to a disused salt mine at Altaussee in the Austrian mountains near Salzburg. Much of this plunder simply vanished at the end of the war, and thirty-five years afterward some governments are still trying to undo Posse's efficient thieving. When the art world had recovered its breath after the war, the fifties saw a boom in the prices of old and modern masters. TV cameras and the press moved into auction rooms and picture sales became front-page news. In 1952 a small Cézanne still life was knocked down at 33 million old francs ($73,000) in Paris, reflecting the upward trend. Greek shipowners entered the ring, with Basil Goulandril bidding a Gauguin still life to £105,000 ($230,000) in 1957; just afterward, Stavros Niarchos bought the whole of Edward G. Robinson's Impressionist and post-Impressionist collection for $2.5 million. But the sale that transformed the art trade, brought drama to auctions of masterpieces, and stirred the underworld to action took place at Sotheby's on October 15, 1958. An exceptional evening sale, it included no more than seven paintings from the Goldschmidt collection in Berlin and lasted only fifteen minutes. Two Cézannes, three Manets, a van Gogh, and a Renoir fetched £781,000 ($1.72 million); of this, the late Cézanne, *Boy in a Red Waistcoat*, realized £220,000 ($483,000). A page had been turned in the history of art — and art thefts.

Hitherto priceless art now began to acquire a price tag as well, either in the auction room or from insurance assessors. As masterpieces increased in value, they became a hedge against currency erosion, a sort of exclusive, rich man's bourse, a part of the investment business. Even modest investors entered the market. 'Art's supreme end is delectation,' said the great seventeenth-century French painter, Nicolas Poussin. A wag amended it to read, 'Art's supreme end is speculation.' Dizzying sums changed hands for old and new masters. In June 1959 Rubens's *Adoration of the Magi* fetched £275,000 ($610,000) and a Hals attained £182,000 ($400,000). In November 1961, at a New York sale, Rembrandt's *Aristotle Contemplating the Bust of Homer* went for $2.3 million,

while in London Norton Simon, the American tycoon, paid just over $2 million for another Rembrandt, *Portrait of Titus*. Modern art kept pace. In 1961, Monet's *Winter in Argenteuil* sold for £116,000 ($255,000) and a Cézanne watercolor for £145,000 ($320,000). Picasso and the Cubists had risen proportionately, and even the most abstract artists were selling well. A *London Times* survey indicated that second-rank painters had increased in value from 780 to 1,150 percent over the fifteen years to 1968. Such spectacular profits drew investment companies and institutions into the art market, forcing prices even higher. In 1973 an early Picasso canvas realized $720,000 in New York, and a year later Sotheby's auctioned a 1909 Cubist work, *Seated Woman*, for £340,000 ($775,000).

To these spiraling prices the U.S. federal tax authorities lent new impetus by introducing concessions for gifts to museums and public galleries. This they did to induce philanthropists to part with pictures they might otherwise have hoarded to benefit from the bullish art market. But even the most altruistic millionaire saw at once what a windfall the Treasury had put his way. He would get a 30 percent tax deduction on his gift — but at the museum's assessment of its value. And he could keep the work until his death. So, if he bought, say, a Malevich for $10,000 and got his favorite museum to price it at $100,000, he was saving more than its cost in taxes as well as enjoying it on his own wall and winning recognition as a public benefactor.

As fortunes changed hands for a single picture, crime bosses and even small-time crooks began to buy museum catalogues and art magazines and look hard at old and new masters. Compared with burglary or bank robbery, art theft seemed easy and paid well for little risk. Most museums had never heard of burglar alarms. Insurance companies and owners who wanted their unique treasures returned safely would not argue about rewards or ransoms. So crime bosses began to convert their henchmen into art stealers. When they found the extortion racket worked, they invented others; criminals dealt in stolen religious objects, altering these, then filtering them into the antique market; they created new techniques in art smuggling and selling the unwary novel art forms like Hong

Kong Ming. An inspired rogue even sold Salvador Dali one of his own stolen paintings. Criminals played on human frailty, the fact that every man believes himself something of a discoverer and cannot resist the lure of easy money. They pandered to wealthy fetishists who buy stolen art that only they can contemplate and appreciate. They sold the millionaire collector (sometimes with his connivance) religious or secular art smuggled from countries like India, and from locales in Southeast Asia and Africa. Such thefts, even if discovered, often go unpunished because the objects have been passed through so many buyers and sellers that original ownership has become blurred. In police parlance, they have been 'laundered.' In the past twenty years about one in every twenty paintings, antiques, and art works are thought to have been stolen, fitted with new papers, and sold through dealers or auction rooms. Few art works can trace their ancestry back to the original sale and nowadays, when owners shun publicity and faceless institutions possess art collections, no one probes too deeply into the pedigree of a painting by a minor master. Auction houses that interrogated their clients about the provenance of their sale goods would watch them cross the street to their nearest rivals. In their quest for the spectacular exhibition piece, museum curators and trustees sometimes suspend their curiosity about the itinerary and origin of certain art treasures. Twice in 1970 the Museum of Fine Arts in Boston came under attack for acquiring smuggled art, and the Metropolitan in New York had a similar case.

In the early sixties a rash of thefts in the United States and Europe set people wondering — especially when quite a few paintings turned up mysteriously in station locker rooms, empty apartments, and stolen cars. To those in the know, an insurance reward or an owner's ransom had redeemed the paintings. But fearing imitative crime, the police, insurance companies, and losers said nothing. Since much of this stolen art just vanished, people who knew nothing about laundering and crooked or 'bent' dealers speculated where it went. Thus arose the myth of the mad collector, wealthy fetishist, or eccentric sitting alone, gloating over his criminal hoard. Or else, the myth goes on, this plundered art disappeared into clandestine galleries owned by money-scorning Com-

munists like Fidel Castro or religious fanatics like Colonel Qaddafi of Libya. But rich commissar connoisseurs or psychopathic oil sheikhs are as fanciful as the notion that art thieves are folk heroes like Robin Hood or Raffles. The truth is they share a pedigree with the mugger, handbag snatcher, armed bank robber, and drug pusher.

Straight art theft and crooked dealing alone keep police forces throughout the world occupied. More than $100 million in art objects is stolen each year, making such thefts the biggest criminal pursuit after the international smuggling and peddling of drugs like heroin, cocaine, and hashish. To combat this epidemic of art crime, police in Europe and America have set up special art-theft squads. Detectives trained in the ways of the art market, experienced in the methods of dubious dealers and crime syndicates specializing in art robberies, have linked their efforts to beat the international racket. Their clearinghouse is a gray, functional, featureless building in the rolling country just outside Paris — Interpol headquarters. There, every day of the week, an art-theft squad receives dozens of reports of stolen paintings, sculptures, and other rare objects and immediately circulates them to its offices throughout the world; this information goes down the line to regional police forces, who then check with their informants and contacts in the art trade. More than in any other criminal investigation, speed is vital in disseminating this information and publicizing it in the press and TV. For most stolen art sells easier beyond its country of origin, where it goes unrecognized. But once a stolen masterpiece or a valuable objet d'art appears in the press, on TV, or in trade publications, no honest dealer will touch it and even the bent dealer handles it at his peril. Interpol reinforces its weekly bulletins with a monthly sheet listing 'The Twelve Most Wanted Works of Art,' with pictures, description, and details of their theft. This international police organization covers most of the world, and even Communist countries, which have hitherto shunned it, now request aid when their art treasures are stolen. Its offices in 126 countries are staffed by local detectives who act as liaison men between Interpol headquarters and forces like Scotland Yard, the French Sûreté Nationale, the FBI, and the German Bundeskrimi-

nalamt. Hundreds of paintings smuggled across national frontiers would have vanished forever but for the action of Interpol.

To give an example of the system, when Interpol published its twelve most-wanted art objects in the spring of 1979, the list included five reports emanating from its Washington bureau, three of them for a Rembrandt and two other early Dutch paintings stolen from the M. H. de Young Memorial Museum in San Francisco on Christmas Eve 1978. Alone, the Rembrandt would fetch more than $1 million at auction. Both remaining Washington reports concerned a Renoir and a Pissarro belonging to an unnamed American citizen and stolen as long ago as 1938. Three other reports about paintings came from Rome, Ottawa, and Berne, another from Sri Lanka for a stolen Buddha, and the last from Weisbaden about an El Greco taken from a Saarbrücken church.

Frequent bulletins of 'Stolen Objects' are also issued in English and French, giving the date and details of thefts, describing the missing goods, and publishing pictures of them. Example:

STOLEN
Subject: Theft of a Painting
Date of Theft: May 1979
Country: Canada

An 18.9 cm x 28.4 cm oil-on-panel painting entitled Brest by the French pre-Impressionist, Emile Boudin (1824–1898) signed 'BOUDIN' in the lower left corner, possibly bearing a sticker on the back saying 'Tooth and Sons 2203,' and worth 33,750 Canadian dollars, was stolen from the Vancouver Art Gallery in Vancouver, British Columbia, Canada on May 11, 1979.

It depicts Brest Harbor, showing several sailing ships with their sails lowered, some people in a dinghy in the foreground, a large ship unfurling its sails in the background on the far right, some green wetland vegetation with yellow touches along the shore, some dark green trees in the background on the left, and greenish reflection in the gray water, all under a blue sky with some grayish clouds. See also the accompanying photograph.

PLEASE INFORM GALLERIES, SALEROOMS, ANTIQUE DEALERS, PAWNBROKERS, MUSEUMS, CUSTOMS AUTHORITIES.

Most national police forces have their own information channels. Britain and America have their police gazettes; France publishes notices in various art journals and the *Gazette de l'Hôtel Drouot,* their main auction center; in Germany, bulletins appear in the *Bundeskriminalamt Blatt*; in Belgium in the *Moniteur de Police Belge,* and so on.

In 1968 Scotland Yard formed an art-theft squad, and other countries have followed the British example. In eleven years a handful of detectives, never numbering more than eleven, has helped recover more than $100 million worth of stolen art and antiques, mostly in Britain. In any one year, two thousand or more requests for help come in from other police forces investigating art thefts. At the Yard they have devised methods of identifying stolen objects and programming this information into a computer that records most of the valuable pieces of art stolen from British and foreign collections. Art dealers and auction room personnel often refer dubious items to the Yard before buying or selling. This small detective team has also assembled a unique network of informants throughout the art world in Britain. And since London has become a center for art auctions and a clearinghouse for stolen art, the British team can often alert their opposite numbers abroad.

France, which has suffered its fair share of art thefts and a rash of ransom and extortion cases, now has a special Ministry of Interior department to deal with art thefts. Under a clever and dynamic policeman, Chief Superintendent Gilbert Raguideau, it has brought off some notable arrests, including the gang that stole 118 Picassos from the Papal Palace in Avignon in 1976. In Germany Inspector Karl Berger helped to break the V-gang racket of stealing and transforming religious art from Catholic churches, then filtering it into the legitimate market. Italy has the blackest record as a country rich in cultural heritage that has suffered more pillage from archeological sites, museums, galleries, and public buildings than any other; but it also has the remarkable Rodolfo Siviero — poet, critic, art sleuth and government minister without portfolio — who heads the Delegation for the Recovery of Art Works. Yet even his spectacular success in retrieving art treasures purloined during World War Two and since do no more

11

than point up Italy's great losses and the hairline chance of redeeming masterpieces once they vanish. Often mere chance helps him trace a sculpture or a painting — like the story of a priceless and unique drawing by Lorenzo di Credi, Florentine and fellow-pupil of Leonardo da Vinci. During the war, to protect this and other works in the famous Uffizi Gallery in Florence, Italian officials concealed them in a Tuscan villa. When the Wermacht seized the place, a German private thrust the Credi cartoon into his knapsack. Captured in 1944 during the Eighth Army advance through Italy, he bartered the drawing for a can of sardines. Now in a British kitbag, the drawing traveled to Germany, where the English soldier gave it as a present to his girl friend. For a while it hung in her kitchen, gaining nothing from the aura of smoke and steam before she ran out of money and sold it to a local shopkeeper. A German art dealer spotted it and offered the shopkeeper a good price. No one knows how it crossed the Mediterranean to land in the hands of a wealthy Tangiers collector. He saw its real worth, but to verify his purchase he sent a photograph to the National Gallery in London. There they had no difficulty matching it with the missing cartoon in the Uffizi catalogue. Siviero and the collector came to terms and the Credi cartoon returned to its original home in the gallery.

Much stolen art goes underground for many years until it has established a new sales pedigree and everyone has forgotten about the theft. Then it can reappear in the hands of a private dealer or even in an auction room for legitimate sale. Thieves have other methods. Big crime bosses can place stolen objects in a bank vault until the country's statute of limitations runs out and precludes their prosecution. After five years in France, seven in Britain and the USA, and ten in Italy, a thief need not fear arrest. He can then offer the painting — even to its original owner — for much more than it would fetch on the black market; often the painting or other art object has doubled its value during its cold-storage period. In the early sixties and the seventies, art theft developed into a sophisticated crime business with careful selection of targets and meticulous planning; many raids on museums and private collections bore every sign of commissioned thefts of paintings,

12

usually second-rank masterpieces, which had been earmarked for some private collector or underworld boss. Much of this illicit art was channeled along supply networks established by drug pushers because French, Dutch, Swiss, and other connections existed in the art-stealing racket, closely linked with the narcotics syndicates.

Where paintings, sculpture, tapestries, and other art works are stolen for insurance reward, ransom, or extortion, the police reckon to trace and recover perhaps one in eight or nine missing objects; some countries, like Britain, Germany, Austria, and France, have a better record; other locales, like India, Southeast Asia, South America, and some Mediterranean countries, have a poor security record and thieves and 'fences' find it all too easy. Each year, art worth a fortune estimated in several billion dollars disappears from archeological 'digs,' museums, churches, galleries, exhibitions, rare-book libraries, and private houses; it filters down into that strange underworld where the crook, the fence, the dealer, and the connoisseur meet and do business. In police dossiers only the important art work appears, and for European countries and North America some 70,000 items are listed and actively sought; but six or seven times that number have been reported to the police. Files on the small army of criminals caught or strongly suspected of belonging to art gangs run into hundreds on both continents. And hardly a week passes but several new faces appear in this rogues' gallery.

In the following pages I have taken a handful of exhibits from this ever-swelling gallery and sketched their stories.

# Mona Lisa Goes Home

When Parisians invented the great Mona Lisa joke never did they imagine it would backfire, then degenerate into a sick comedy of errors in which Guillaume Apollinaire, the flamboyant, avant-garde poet, would land in jail and Pablo Picasso, penniless painter of genius, would not only go about fearing imprisonment but also expulsion for receiving stolen Louvre property. Neither the painter nor the poet dreamed the theft of da Vinci's masterwork would leave an indelible mark on them. In fact, both shared the general indignation and amusement that morning in October 1910 when visitors to the great art gallery noticed many of the masterpieces had been covered with protective glass. Art lovers immediately cried scandal and sacrilege. How could anyone appreciate the creative power, let alone the subtleties of these great paintings, through a centimeter of glass! Why, the Philistines had even shrouded that glory of glories, the Mona Lisa, in glass! Parisian wits began to indulge in their favorite farce — needling and humiliating their bureaucrats, especially the civil servants who ran the Louvre. Already several paintings and small sculptures were missing from the gallery. So was *La Gioconda*, the wags affirmed. Someone had stolen and sold her to a New York millionaire, and the authorities had brought in glaziers to conceal the fact that the

14

Louvre was hanging nothing more than a good copy. This proved too much for Théophile Homolle, director of France's museums and Louvre curator. 'You may as well pretend that someone could walk off with the towers of Notre-Dame Cathedral,' he scoffed.

Still the Parisians heaped scorn and ridicule on Homolle and his staff. One caricature showed a man shaving in the picture glass, ogled by a grinning Mona Lisa. This gave the fashionable painter, Louis Béroud, the idea of painting a pretty demimondaine using the Mona Lisa glass as a mirror to do her hair. On August 21, 1911, he appeared with his model and set up his easel in the Salon Carré in front of the vacant space where the Leonardo usually hung. 'Where is *La Gioconda*?' he asked a guard. 'Being photographed, probably,' the man replied. Three hours later, when the exasperated Béroud sent the man to fetch the Mona Lisa, he returned with the sensational news that the painting had disappeared.

Parisians forgot the presence of the German battle cruiser *Panther* off Agadir in Morocco; they ignored the settlement of the crippling British rail strike that had paralyzed Continental traffic; they shrugged aside the visit of the Spanish queen and the Greek king and the stifling heat wave. The Mona Lisa gone! They remembered what the eminent historian Jules Michelet had said of her. 'I'm drawn to her like the bird to the snake.' And George Sand, who wrote, 'No one who has set eyes on her for a moment can ever forget her.' People refused to believe it. Some spoofer had lifted the painting and hidden it in one of the Louvre's 225 rooms or five miles of corridors. Or some fool civil servant had mislaid it.

However, one man took no chances. Police prefect Louis Lepine, a snowy-bearded homunculus, ordered more than a hundred policemen to clear the museum. Within half an hour bewildered copyists were humping their easels and canvases through the main gate, and archeologists, Egyptologists, and other research workers had been run to earth in the vast building and hustled outside, protesting. Inspector Hamard's gendarmes sprouted from the miles of museum roofs along the Seine and round the courtyards, scanning the area, hoping the culprit still lurked there. Inch by inch, detectives searched the galleries and cellars. Two discoveries con-

firmed the theft of the Mona Lisa: its discarded gilt frame lay in the staircase leading to the Cours Visconti; a door handle, wrenched off by the thief, lay on the pavement outside.

Theories abounded about the thief and his motive. Lepine opted for a discontented Louvre guard committing an act of social sabotage, or perhaps someone who intended to blackmail the government. Other investigators suggested a maniac obsessed by the enigmatic *Gioconda* smile; an eccentric artist who wanted to possess the painting and now had it hanging in his attic; one of those troublemakers who had already lifted Louvre items to expose lax security. French patriots saw a political plot by the Germans, who had stolen the Mona Lisa to humiliate France. Berlin countered with the story that French secret-service agents had thought up the scheme to blame Germany and exacerbate war tensions. Nobody had any real facts.

Behind the locked Louvre doors, shut for a week, a portly and puff-cheeked magistrate, Henri Drioux, established his headquarters for the inquest on the theft. Everyone must be interrogated — those who worked in the vast palace; artists who were copying paintings; visitors who might have noticed something abnormal. And since the guards insisted nobody could have left carrying the 38¼-by-21-inch panel on which Leonardo had painted Madonna Lisa del Gioconda, the whole museum must be searched. So Hamard's detectives went over the whole fifty acres and half a million items.

Several hundred informants kept the police chasing clues that led nowhere. Someone had seen a blue-eyed, blond-haired young man who had gazed, enraptured, for days at Mona Lisa; another man joined him, a shaggy philosopher who seemed to be trying to penetrate the smile; a bluebeard with a large packet under his arm had been seen boarding the Paris-Bordeaux express; a young man had written tearful and lovelorn letters to Mona Lisa and had his attic in the Marais district searched. Two women fortune tellers joined the hunt and got their stars crossed. Madame Albanda da Silva claimed it still lay in the Louvre, while Madame Elise stated that it had been destroyed. Lepine's men frog-marched a suspect out of the Bal Tabarin, still clutching his champagne bottle; they

16

searched the transatlantic liner, *Le Champagne*, for a suspicious passenger; they took calls from a lunatic Glasgow man who affirmed he had the painting.

With the French passion for crime reconstruction, Drioux had several men 'steal' a fake Mona Lisa; those who were unaware of how the picture was hung took at least five minutes and then had difficulty; experienced Louvre staff unhooked and detached it in six seconds. This reconstruction convinced Judge Drioux that the painting had really been taken and the thief had planned and executed his coup with great sangfroid and skill; he had probably got himself locked into the museum, unfastened the picture from its four supports at about 7.30 A.M., cut the panel free from its frame in the Visconti staircase, thrust it under the white coat he probably wore, and walked out. His report, compiled five days after the theft, forced Lepine to cast his net wider and circulate what information he possessed to police throughout Europe, North America, and tsarist Russia.

On the following Monday, when the Louvre reopened, huge crowds elbowed through the foyer and upstairs to the Salon Carré to gawk at the four pegs and the bleached patch where the Mona Lisa had hung between Correggio's *Mystical Marriage of Saint Catherine* and Titian's *Alphonso d'Avalos*. Louvre officials looked ruefully at the throng — greater than any that had come to gaze at the painting itself — as it pushed and jostled the four gendarmes and six guards round the blank space; reverentially, a student suspended a floral wreath on one of the pegs; Lepine's plainclothes detectives took his name as they watched the crowd to match those among it with descriptions of suspects and note strange behavior. By now Judge Drioux had moved back from the Louvre to the Palais de Justice.

France was resigning herself to losing one of the world's art treasures, chef-d'oeuvre of Leonardo da Vinci, the only uncontested painting by that universal genius of the High Renaissance. For more than four hundred years that painting had intrigued or moved people until *La Gioconda* and her mysterious smile had become a myth. Four years Leonardo spent on that portrait. And as his contemporary, the art historian Giorgio Vasari related, he had

17

suffered and toiled and retouched during all that time without ever finishing (or perhaps wanting to finish) the face of Lisa Gherardini, fourth wife of Francesco de Bartolommeo del Zanobi del Giocondo. To preserve her enigmatic smile, he had string bands play during their sittings. Vasari said: 'Whoever wants to know to what extent art can imitate nature can easily discern this in examining this head . . . This figure is done in such a way as to make the cleverest artist who might wish to imitate it, retreat trembling.' Some people aver La Gioconda was Leonardo's mistress. Whatever the truth, he would not part with the portrait, bringing it to France when Francis I offered him the honors his own prince refused and placed the manor house of Clos-Lucé in Amboise at his disposal. Francis acquired the Mona Lisa for 4,000 gold coins either from Leonardo or his executor. What did the painting mean to Leonardo and so many people? Did that smile express life's movement and the soul's mystery? Did the hazy blue mountains, the plain and river behind Mona Lisa symbolize the universe that she adorned? Critics perceive such universal meaning in the portrait; others look no further than its beauty.

And now it was gone.

However, just when it seemed the inquiry would never yield anything, Judge Drioux suddenly made an arrest that set Paris and intellectual circles abroad buzzing. For his prisoner was Guillaume Apollinaire, apostle of modern poetry and painting, friend of famous authors and artists. Wilhelm-Apollinaris de Kostrowitsky, bastard son of a Polish lady, Angeliska de Kostrowitsky, and an Italian captain, Francesco Flugi d'Aspermont, had made his name with strange, surrealist poetry and his defense of Cubist painters like Picasso, Georges Braque, de Chirico, and others. Although gossip and several clues connected him with the Mona Lisa theft, Apollinaire was arrested for his part in the previous Louvre theft of Phoenician statuettes. Taken to the Palais de Justice, Apollinaire submitted to almost a whole day of interrogation before admitting he knew something about the statuettes and the thief; but he denied any part in the Mona Lisa theft and pleaded he had returned the two statuettes. Unconvinced, Judge

18

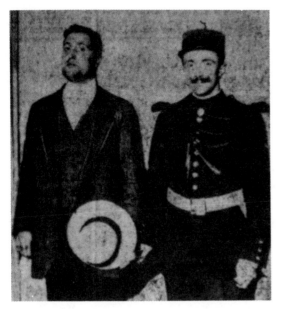

*Guillaume Apollinaire in custody. (Courtesy of Francis Steegmuller)*

Drioux charged the poet with complicity to steal and committed him to a cell in the notorious Santé prison.

> Avant d'entrer dans ma cellule
> Il m'a fallu me mettre nu
> Et quelle voix sinistre ullule
> Guillaume qu'est-tu devenu
>
> Before entering my cell
> They made me strip to the skin
> I hear a sinister wail
> Guillaume what have you become.

In humiliating prison garb, fearing the French government would expel him as an alien, Apollinaire lay for five days in prison wondering, like so many of his friends, how the whole thing had happened. In fact, he had become embroiled in the Louvre thefts through friendship with a young madcap named Géry Piéret, harum-scarum son of a Belgian lawyer; from 1907, four years before the Mona Lisa theft, Apollinaire had used Piéret, off and

19

on, as a part-time secretary. A rolling stone, Pieret lived not very successfully by his wits. He had served twenty-eight days' jail for theft in Belgium before coming to Paris to work on the newspaper where he met Apollinaire. He was sacked for a form of blackmail. But his madcap behavior and flair for telling tall stories appealed to the poet and, indeed, he might have stepped straight out of one of Apollinaire's tales. He became the main character in Apollinaire's book of short stories, *L'Hérésiarque*, under the name of Baron d'Ormesan. Apollinaire himself seemed a strange fellow. As punctilious and conventional in manner as his poetry was bizarre and futuristic, he had cultivated avant-garde writers and artists and numbered among his close friends painters like Picasso, Vlaminck, Kees van Dongen, and Matisse and poets like André Salmon and Max Jacob — the shabby, Bohemian bunch that lived and worked in the Bateau Lavoir, a rickety Montmartre building, and were creating a new art. Picasso introduced him to the painter Marie Laurencin, and she became Apollinaire's mistress.

Piéret stayed with the couple in their Paris flat during 1907. Wandering in the dimmer corners of the Louvre, he noticed the lack of security. Leaving Apollinaire's flat one day, he turned to Marie Laurencin. 'Madame Marie, I'm off to the Louvre this afternoon. Can I get you anything?' She shook her head, thinking Piéret was referring to another Louvre — the Magasins du Louvre department store. A few hours later, Piéret returned with two Iberian statuettes which he offered to Apollinaire. When the poet refused to buy them, the Belgian sold them to his friend, Pablo Picasso, for a few francs. Picasso used them as inspiration for some of his early Cubist studies, notably *Les Demoiselles d'Avignon*, then put them into a wardrobe and forgot them.

Four years passed before Piéret turned up again, now thirty-seven but still crack-brained. He had acquired some money in America but lost it in several days at the Paris races. Back he went to the Louvre and stole a Phoenician statue, which he left in the Apollinaire flat. There it sat on the mantelpiece until the Mona Lisa disappeared, and the frightened poet sent Piéret and it packing. His imagination fired by the sensational Mona Lisa stories and the police hue and cry, Piéret sold the statuette to the

newspaper *Paris-Journal*, then campaigning against gross negligence in state museums. Eight days after the Mona Lisa theft, the paper ran Piéret's own story of how he had stolen two statuettes in 1907, sold them to a Parisian painter friend, and lost the proceeds, 50 francs, at billiards the same night.

This flippant and sardonic story did not amuse Apollinaire, who now felt sure his crazy friend had stolen Leonardo's masterpiece as well. On August 21 the poet gave Piéret his ready cash, 160 francs, escorted him to the Gare de Lyon, and put him on the Marseilles train. But Apollinaire now had another worry. Piéret had blabbed about his two earlier thefts. Picasso had those and refused to give them up. Suppose Lepine's detectives found out about his connection with Piéret and began hunting for the statuettes! His fears heightened when Piéret wrote from Frankfurt, confessing to the theft of the statuettes and trying to exonerate Apollinaire, who had asked him to leave when he discovered the crime. 'My dear friend,' he quoted Apollinaire as saying, 'you'd better go immediately. I don't share your opinions and I'm sorry I invited you to stay with me now that I believe in your crime.'

That letter only ignited police suspicion, and two of Inspector Hamard's detectives called at Apollinaire's flat in rue Gros near the Mirabeau Bridge to inquire about the young Belgian. Terrified, the poet rushed to Picasso's new studio in boulevard de Clichy to warn him that they might find out about the two stolen statuettes. Picasso had just returned from four months in Spain. When he listened to the poet's rambling and hysterical account of what had happened over the Mona Lisa, he too became panic-stricken. Picasso's mistress, a young girl called Fernande Olivier, witnessed these tragi-comic scenes; in her book, *Picasso et Ses Amis*, she related how they both decided first to flee somewhere, anywhere, even abroad to escape the police. Apollinaire dreaded expulsion as an unnaturalized citizen even more than prison, while a sort of primitive terror had seized Picasso. Recalling their behavior, Fernande Olivier said: 'They owe it to me that they didn't lose their heads completely. They made up their minds to stay in Paris and immediately get rid of the incriminating objects. But how? Finally, after a gobbled meal and kicking their heels the whole evening

they decided to go out after dark and throw a suitcase containing the sculptures into the Seine. Towards midnight, they set out on foot carrying the suitcase, and returned at two o'clock, exhausted, played out. They brought back the suitcase and its contents. They had wandered up and down, never finding the right moment and not daring to get rid of their package. They thought they were being followed and their imagination had invented a thousand things, each one more fantastic than the last. Though I shared their anguish, I studied them closely that evening. I am certain that perhaps they were playing a sort of game. So that, despite the fact that neither knew anything about cards, as they waited for the fatal hour of their departure for the Seine, "the moment of the crime," they pretended to play cards all evening, doubtless to imitate certain bandits.'

Next morning Apollinaire took the two statuettes to *Paris-Journal*, which ran another story criticizing authority and thinly veiling the poet's identity. Nettled by this and outraged by Piéret's article, the police searched Apollinaire's flat, where they found enough evidence to arrest him. For five days he sweated in the tiny, sultry cell wondering how they would punish him. He wrote poem after poem:

*Que lentement passent les heures*
*Comme passe un enterrement*

*Tu pleurera l'heure où tu pleures*
*Que passera trop vitement*
*Comme passent toutes les heures . . .*

How slowly go the hours
Like a funeral train

You will mourn your saddest hour
Too quickly gone
As goes every hour

I hear the city clamor and cry
And prisoner with no horizon
I see nothing but a hostile sky
And the bare walls of my prison

Daylight leaks away, but burning still
A lamp in my prison
We are all alone in my cell
Lovely light. Sweet reason.

Early on September 12 a plainclothes policeman roused Picasso from sleep. So violently did he tremble before the detective that Fernande Olivier had to help him dress and see him on to the three-horse bus. At the Palais de Justice he shivered before Judge Drioux, a bull-necked, gravel-voiced man with piercing eyes over pince-nez. Picasso hardly recognized the figure in the judge's room. An unshaven scarecrow with torn collar, unbuttoned shirt, and hollow eyes, it looked nothing like the usually immaculate Apollinaire. He had finally confessed about the statuettes, though declaring Picasso had bought them in all innocence. To Apollinaire's chagrin not only did the painter deny all knowledge of the two statuettes but even denied knowing him. Shattered by this betrayal, the poet had to question and prompt Picasso for some time before he would admit the truth. In front of Judge Drioux, both men wept on each other's shoulders; the judge reprimanded them for their folly, released Apollinaire, and sent them home.

It left a mark, however. Picasso never spoke openly of the incident for nearly forty years, then confessed his shame to film director Gilbert Prouteau in 1959. 'I can acknowledge it now, I didn't behave very well towards Apo on that occasion,' he said. 'I can see him there now with his handcuffs and that look of a big placid boy. As I entered, he smiled at me, but I made no sign. When the judge asked, "Do you know this gentleman?" I was suddenly terribly frightened, and without knowing what I was saying, I answered, "I have never seen this man." I saw Guillaume's look change. The blood drained from his face. I am still ashamed.'

Imprisonment had left a psychological scar on Apollinaire. When he had recovered a little, he wrote his version of the Mona Lisa affair. Paris café society chuckled at police ineptitude. Overnight Apollinaire became an international figure and something of a hero; the *Gioconda* scandal did something for his fame as a poet. Indeed, people continued to whisper that he had really

23

planned and executed the most fantastic of all art robberies. Few realized how those interrogations and his claustrophobic days in Cell 15, Block 11 had wounded him. For months afterward he and Picasso believed themselves shadowed by the police, the artist even changing cabs to confuse his trail. Apollinaire, still haunted by his part in the Mona Lisa theft, died in 1918 from Spanish flu and the aftermath of head wounds received in World War One trenches.

More than two years went by; the public had almost forgotten the theft and even the police were giving up hope when suddenly, almost fatefully, the scene switched to Florence, where the Mona Lisa story had begun just over four centuries before. Alfredo Geri, a Florentine art dealer was mounting an old-masters exhibition in autumn 1913 and advertised in European papers for paintings at top prices. Among dozens of letters came one from Leonardo Vincenzo giving an address in place de la République, Paris. Geri nearly tore it up. For Vincenzo offered nothing less than the Mona Lisa. Twenty-seven months before, Geri had followed the sensational theft and knew how many cranks claimed to have the Leonardo painting. Yet after consulting Giovanni Poggi, head of the Uffizi Gallery, he decided to write, inviting Vincenzo to bring the painting to Florence, where they could examine it. Within days a letter arrived from Vincenzo accepting the suggestion, and he followed this by a wire saying he would arrive on December 10. True to his word, a slim young man with a black mustache and intense brown eyes appeared at Geri's office, declaring he had *La Gioconda* in his room at the Hotel Tripoli-Italia. He wanted £20,000 ($100,000) for it. Geri agreed, but asked him to return next day and meet Poggi.

Just after three on December 11, the trio met and Vincenzo escorted them to his hotel in Via Bergegnissanti; they climbed to the dingy, third-floor room where Vincenzo locked the door, pulled a wooden trunk from under his bed, and emptied its contents in front of the two nervous art experts. A mandolin, plasterer's tools, a mangled hat, workman's overalls, and other items emerged. Underneath, he raised a false bottom and extracted some-

thing wrapped in red silk; this he placed on the bed and unveiled.

'To our amazed eyes,' Geri wrote later, 'the divine *Gioconda* appeared, intact and marvelously preserved. We carried it to a window to compare with a photograph we had brought with us. Poggi studied it and we had no doubt the painting was authentic. The Louvre catalogue number and brand on the back matched the photograph.' While they examined the portrait, Vincenzo was staring at them with a fixed expression as though he had painted it himself.

At the Uffizi, Poggi confirmed his identification and promised to guard the painting. Soon afterward, Vincenzo returned to his hotel, where police arrested him without a struggle. He confessed

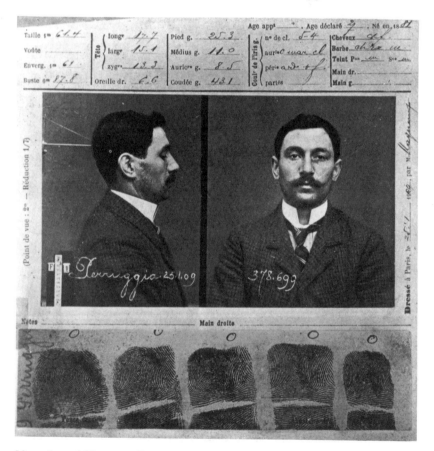

*Mug shot of Vincenzo Perugia. (The Bettmann Archive)*

to stealing the masterpiece and, despite his wish to sell it, he had carried out the theft for pure patriotism, to return the Leonardo painting to Italy where it belonged and revenge some of Napoleon Bonaparte's pillaging and destruction of Italian art. He gave his real name: Vincenzo Perugia, from Dumenza, an Italian citizen. He had worked in France for several years as a house painter and had been employed by one of the Louvre contractors.

Paris and the rest of the world reacted to the recovery of the Mona Lisa with the skepticism they had shown when it was stolen. Finally convinced, the French authorities gave Italy permission to exhibit the painting in several cities before returning it. At the end of 1913, the other villain in the story, Géry Piéret, gave himself up in Cairo. Although he had been sentenced to ten years' jail in absentia, a court acquitted him, deeming him more fool than knave.

From his cell while awaiting trial, Perugia made some curious declarations; his work at the Louvre had convinced him he was a soul mate of great artists, living and dead; for long hours he had silently contemplated Italian masterpieces but resented their presence in France when they should have graced Italian galleries and churches; on the evening he stole the Mona Lisa he had locked himself in his grubby, single room in rue Hôpital Saint-Louis and stood betwitched before the beauty of *La Gioconda*. Gazing at her evening after evening, he fell more deeply under her spell. 'I was in love with her,' he said. Sometimes during those two and a half years of living with the Mona Lisa he feared for his sanity, even wondering if he should not burn the painting. That had decided him to sell the masterpiece.

Italian police refused to believe these airy stories of platonic love. French police remained even less credulous, for they found Perugia in their criminal records — twice. Five years before he had spent twenty-four hours in jail at Macon, near Lyons, for attempted robbery; a few months later, arrested after a street quarrel, he was discovered to be carrying a knife; he got eight days' imprisonment and a fine of 16 francs. Those discoveries dented Louis Lepine's great reputation and caused as big an uproar

as the theft itself; for Perugia had left umpteen clues that Lepine and his police had overlooked or failed to follow up. On the glass covering the painting he had left finger and thumbprints that matched those in their records; their files even included his precise measurements, taken by the Bertillon method; they had a dozen Louvre experts and the judge's testimony all pointing to someone who knew well the gallery and the method of hanging the paintings. A few days after the theft they had Perugia's name on a list of two hundred and fifty given them by the Louvre; he had worked for the firm that glazed the gallery paintings between October 1910 and January 1911. He might even have helped glaze the Mona Lisa. Perugia did not answer the police summons to an interview, so they sent Inspector Brunet to his room, where he quizzed the Italian. Brunet searched the room but found nothing. He accepted Perugia's story that he had gone nowhere near the Louvre on the morning of August 21. But had Brunet checked with Perugia's employer, Monsieur Perretti, he would have discovered that the Italian had arrived at work two hours late that morning — at nine instead of seven. He told Perretti he had overslept.

After Perugia's arrest they again searched the flat and this time found love letters from a girl called Mathilde, whom they traced; she denied knowledge of the theft but remembered Perugia's mania for collecting every scrap of information about the hunt for the *Gioconda*.

In Italy Perugia had become something of a hero. Crowds gathered outside his Florence cell to glimpse him or beg the police to buy mementos for them — even a rag used in his house-painting job. But Mona Lisa eclipsed his celebrity. Back in a Renaissance frame and where she belonged in the Uffizi Gallery, between Titian and Raphael portraits, she caused a street riot when she went on view for the first time on December 14. People cheered and wept and a few fainted in the crush or at the sight of Leonardo's idealized woman. 'What's that bit of red silk round the easel,' somebody asked.

'The cloth that covered *La Gioconda*'s face for two years,' an official answered.

Of course, many people read another chapter of the Mona Lisa

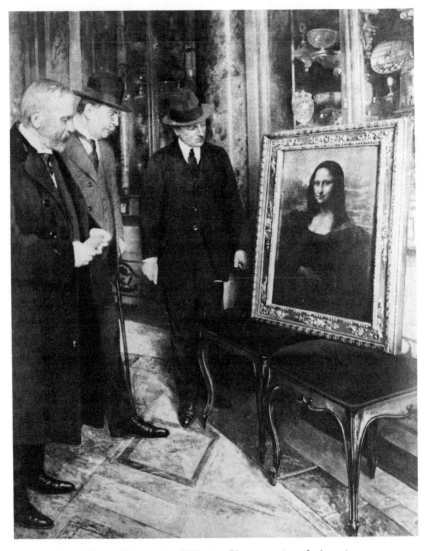

*The restored Mona Lisa at the Uffizi in Florence, just before its return to the Louvre. (The Bettmann Archive)*

enigma into her return. Homesick, she had bewitched Perugia into abducting and returning her to her native Florence, they said. But she spent no more than ten days in Florence before leaving for Rome, to be handed over to the French ambassador and escorted to the frontier, which she crossed on the last day of 1913.

Six months later, the Mona Lisa trial began in Florence. Vincenzo Perugia, a thin, dark-haired man with a black mustache, dressed in a gray suit with a wing collar and black tie, told his story calmly. 'I went into the Louvre about seven o'clock in the morning. I managed to get to the Salon Carré without being seen. There hung the painting that is one of our great chef-d'oeuvres. I detached the *Gioconda*, took her out of her frame, and left.' His theft had taken no more than twenty minutes. Though no longer employed by a Louvre contractor, he donned the white workman's overall the men wore; he stole along the Grande Galerie into the deserted Salon Carré. After taking the Mona Lisa, he stopped in the Viscconti staircase to take the panel from its glazed frame, slipped it under his white overall, and walked past the guards. He told nobody of his plan or about the theft.

'Why did you write to tell your family you had finally made your fortune?' the judge asked.

'Romantic words, your honor.'

But why had he gone to London some months after the theft and asked an art dealer how to return the Mona Lisa to Italy? Was he not trying to sell the painting? Perugia denied this. He did not think to offer the portrait to the Uffizi rather than to a dealer who had offered high prices for masterpieces. He had, however, expected Italy to reward him for redeeming this national treasure. Perugia's lawyer, Giovanni Carena, pleaded that his client had naively believed Napoleon had stolen the Mona Lisa and he was merely returning it to its rightful owners. In any case, Italy had no jurisdiction in the matter since the theft had been committed on foreign soil. Perugia's two previous convictions were trifles.

However, the tribunal evidently agreed with Samuel Johnson, who declared patriotism to be 'the last refuge of the scoundrel.' After two days it brought in a verdict of guilty and sentenced

29

Perugia, whatever his patriotism, to just over one year in prison. But an appeals court cut this to seven months, which meant immediate release. He went back to the obscurity of Dumenza, his Italian birthplace.

Nobody doubted that Perugia wanted to make money out of his robbery. But he had stolen something priceless, something no expert could value. What was the Mona Lisa worth? During the investigation and trial, guesses ranged from the 25,000 gold francs paid by the Society of Friends of the Louvre as a reward to Alfredo Geri to £1 million sterling mentioned in British newspapers. An American computed the value from the 4,000 gold coins Francis I paid for the Mona Lisa in the early years of the sixteenth century. At 3 percent compound interest he arrived at the astronomical figure of $1,629,528,064. A figure to set a whole gallery of rogues dreaming.

# 2

## *Where's the Saint's Navel?*

Over three of the paintings in St. Joseph's Cathedral, Bardstown, legend lay thicker than the patina of dust and age, so thick in fact that it became difficult to separate truth from the gloss of local history. Their theft in 1952 peeled away some of this legend — only to create another in its place. Bardstown, a tranquil, tree-stippled place in the Kentucky hills minutes from Lincoln's birthplace in Hodgenville, calls itself the world's Bourbon whiskey capital and points proudly to the house that inspired Stephen Foster's song, 'My Old Kentucky Home'; it also boasts the third-oldest Roman Catholic cathedral in the United States and the first west of the Alleghenies. Built in Greco-Roman style and dedicated in 1819 by Bishop Benedict Joseph Flaget, it served an immense area throughout Kentucky, Tennessee, and the Northwest Territories.

Thirteen years later, three paintings hung over the altar, beginning the legend which for 120 years drew visitors to see and admire them and hear their story, which varied somewhat with the narrator. St. Joseph's claimed the three five-by-seven canvases had been painted by three masters — *The Flaying of Saint Bartholomew* by Rubens, *The Coronation of the Blessed Virgin* by Murillo, and *The Descent of the Holy Ghost* by one of the van Eyck

brothers. Art scholars and critics remained dubious. To back the story, people at the cathedral explained how Bishop Flaget had become friendly with Louis Philippe, exiled Duke of Orleans who, in 1798, collecting funds for his return to Europe after the French Revolution, sold the paintings to the bishop. In 1832, two years after becoming king of France, Louis Philippe sent the pictures. Gales and Seaton's Register of Debates in Congress on March 19, 1832, referred to a bill that 'authorized the remission of duties on certain paintings and church furniture presented by the King of the French to the catholic bishop of Bardstown, Kentucky.' Other versions affirmed that Louis Philippe fell ill at Bardstown on his way back to France and donated the paintings to repay kindnesses by its citizens. Heretics sneered that tight-fisted Louis Philippe would never have given away masterpieces by Rubens, Murillo, van Eyck, or anybody else. They were fakes.

However, several sacrilegious characters neither doubted the Bardstown legend nor the authenticity of the three paintings. At 5:30 A.M. on November 13, 1952, Father Joseph Howard French entered the cathedral to find the walls around the altar bare. Not only were the three legendary masterpieces gone but six other paintings as well. Two of these, *The Immaculate Conception* and *St. Anne and the Blessed Virgin* were old, but the four above the Stations of the Cross might have hung in any church. Stepping into the dim cathedral, Father French heard scuffing feet and fancied the janitor was arranging pews for early mass. When he noticed the empty picture frames, he realized he must have disturbed the thieves. Two ladders and the three large frames lay against the wall. Shreds of canvas showed how the thieves had ripped the canvases off the wood. They had forced the main lock. Mud on the floor and carpet round the altar had come, like the two ladders, from the building site of St. Joseph's Parochial School.

State detectives and FBI agents from Louisville turned away early-morning worshippers and went over the church for clues. Dust foiled their search for fingerprints on frames, but they found some on a radiator. Although the thieves had left little trace, detectives took them for out-of-town amateurs or men who had gone

*Left, the Rev. Joseph H. French, Assistant Pastor, and the Rt. Rev. James H. Willett, Pastor, of St. Joseph's Cathedral. Right, a wall of the cathedral after the theft. (Both photographs by Courier-Journal and Louisville Times)*

to curious lengths to disguise their professionalism by stealing worthless paintings with valuable ones. No one had seen them. Some people reported a strange station wagon and an orange car; others had seen two well-dressed strangers scanning the paintings. But then the legend lured so many visitors. A loud bang awakened the rectory housekeeper at 3.30 A.M. but she took it for a car crash.

Forensic tests and fingerprint checks led nowhere. FBI officers throughout the country began a hunt for the thieves on the grounds that they had committed a federal offense by transporting stolen paintings across state lines; police circulated descriptions of the pictures, alerting frontier posts along the Canadian and Mexican borders, as well as museums and private galleries. But neither detective work nor the prayer week that Monsignor James H. Willet held at St. Joseph's produced any result. It seemed the paintings had disappeared into the underground market.

At this point another legendary figure made his appearance in the investigation. Afterward he painted a larger-than-life portrait of himself and a graphic picture of his role in the Bardstown story. Of course, the FBI would never admit openly that the stocky, balding man in his fifties, calling himself Jean-Pierre

Lafitte, was one — or even several — of their undercover agents. He gave himself a fascinating pedigree, claiming descent from Jean Lafitte, the pirate chief, fourteen desertions from the Foreign Legion (surely a record), expulsion from the United States and Belgium, and at least thirty aliases. He admitted to working for the FBI.

Under the title, 'Long Shot on a Hot Bundle,' Lafitte told his story through James Phelan in *True, the Man's Magazine*. It went like this:

> At the time of the Bardstown theft I was on close terms with a group of New York hoodlums. They accepted me as a hoodlum, and I was circulating around on the hunt for information about an entirely different matter from the cathedral theft . . . The night after I got my call from the FBI agent I was drinking in a New York bar with a few mobsters. The one sitting next to me was a big man and he had had a few drinks too many. He leaned over closer to a hood across the table and said, 'I hear someone in Chi has some paintings he wants to dump for a couple hundred grand.' That was all. I had a hunch that this might be the thread that would wind back to the nine empty frames in Kentucky . . . The hood next to me wasn't talking to me and I turned my back on him as if I hadn't heard a thing. I didn't want him to flag me in his mind as a guy who had pumped him: That night I took this scrap of information home and tried to analyze it. In the underworld, talk is as cheap as it is anywhere else. Hoodlums' conversation has a high percentage of exaggeration, empty boasting and misinformation . . . I thought this thing might have some weight because the man who dropped it was in the know. And I knew one thing about him that might move me closer to the paintings, if he *had* been talking about the Bardstown loot. He had connections in two Chicago joints where fences and thieves hang out, and he didn't know I knew it. If he'd fished up this information in Chicago, it might have come from one of these two bars. I decided to play a long shot and drop a little bait in the same waters.
>
> A few days later I flew out to Chicago and put in some time at both joints. I drank and talked with Windy City boys who had me pegged as an Eastern mobster under still another name. We swapped shop talk about this and that and I planted a little tale. I passed the word that I'd met a big new fence in New

York who specialized in art — and was in the market. I got a quick nibble. Over some drinks, one of the Chicago boys showed a flick of interest in my fictitious New York friend. 'A guy like this might be good to know some day,' he said casually. 'Tell me how to get to him and if I ever set up a deal we'll ride you with us.' I shook my head. 'This guy don't deal with nobody in the middle. He's a big man and he works direct or no soap.'

'Well,' he said, 'maybe that can be arranged.'

'If you hear something, make your own deal at this end and have your party call him direct,' I told him.

'Sure,' he said. 'What's his number?'

I grew reluctant. 'I gotta be careful with this guy,' I said. 'Last time I see him in New York, he give me his private number. But I don't pass it around like match boxes. He's topnotch, and I don't want to get burned with him.' The man was impressed. 'Sure, sure,' he said. 'Don't worry about it.' I look at him a long minute and let him fidget. 'Okay,' I said finally. 'His name's Gus and here's his number.'

I gave him a New York telephone number — my own.

He had been a little too eager. He had talked about a some-day deal, but he had pushed too hard. I figured he was close to something big — and right now. I poured a few drinks into him, yawned, and told him I was going to turn in. Then I went out, flagged a cabbie, and told him to take me to the airport. I had come out to Chicago on a hunch and now I had a stronger one. I took the early-morning plane back to New York . . . At 1:45 that afternoon, less than 12 hours after I had left Chicago, the telephone rang. The operator said, 'Chicago is calling.' A man's smooth voice came on the line and said, 'I want to talk to Gus Manolettti.'

'This is Gus,' I said. 'What do you want? Who gave you my number?'

'A good friend of yours,' the man said. 'He tells me that you are very much interested in beautiful scenery.'

'You talk too much and too loud,' I said.

'Listen,' the voice said. 'I have something you're going to like — something very special.'

'So what,' I said. 'Come here and I make time to talk with you.'

'It's impossible. The merchandise is too big for me to bring and you have to see it to appreciate it.'

Lafitte arranged to meet the man in Chicago the next day. Now the FBI, which had monitored the call, had identified him. He was Norton I. Kretske, aged forty-seven, ex-convict and former assistant federal attorney in Chicago; he had served fourteen months in prison for rigging a trial in 1939. Lafitte went with an FBI bankroll of dollar bills to wine and dine the crooks and negotiate a deal for the stolen pictures. Covered by FBI agents, he booked a luxury suite in the Drake Hotel, then invited Kretske and his accomplice to a dinner that cost $190.

Next morning Kretske drove him to a north-side apartment and showed him four canvases — the three legendary masterpieces and *The Immaculate Conception* by Jacob Hast. He wanted $200,000 but dropped this to half. Lafitte offered $35,000 and said if they did not clinch the deal that afternoon he would fly back to New York. Kretske agreed on $40,000.

Later Lafitte hired a Cadillac to pick up the paintings and drove back to the Drake parking lot with a tubular bundle sticking out of the car trunk. When the waiting FBI men saw him give the signal by taking off his jacket they pounced and arrested both the men with him.

Newspapers reported that Gus Manoletti, a fifty-two-year-old ship steward who trafficked in everything from dope to diamonds, had been arrested. Another man, Joseph de Pietro, a court bailiff, admitted storing the pictures but denied knowing they were stolen. Nine other men were arrested but released for want of proof. Only Kretske and de Pietro went on trial.

Kretske learned the real identity of Gus Manoletti only when Lafitte took the witness stand in October 1953 and described — in a Maurice Chevalier accent — how he had duped the accused men. Much of the hearing went on long, convoluted arguments about the authenticity of the three oldest paintings and what they might realize on the art market. Prosecution witness Kenneth Donahue, an expert on seventeenth-century art, declared that Rubens had not painted *The Flaying of Saint Bartholomew*; it was the work of a well-known Italian artist, Mattia Preti, and was worth about $7,500. *The Descent of the Holy Ghost* bore no resemblance to a van Eyck and looked like a late seventeenth-century product of the

French classical school, worth about $900; *The Coronation of the Blessed Virgin* was not a Murillo but a Sicilian work, late-seventeenth or early-eighteenth century; he would not have valued it at more than $1,500. *The Immaculate Conception* would fetch a mere $50. The paintings Kretske thought worth $200,000 would have brought about $10,000 on the market.

Price mattered, for the government indictment mentioned a value of more than $5,000. So defense lawyers battled to prove the pictures belonged to lesser or unknown artists and would fetch virtually nothing in the salesroom. Why! defense attorney Myer Gladstone argued, Preti had even got Saint Bartholomew's navel in the wrong place and he looked like a man with no ribs. As for *The Descent of the Holy Ghost,* a defense witness declared no one would buy a sadistic picture like that to hang in his home — especially since modern homes have low ceilings.

So it continued day after day. And Monsignor James H. Willet sat listening to this legal dissection of the Bardstown legend. All he would say was they had prayed for the thieves in the hope they had repented.

Maybe his prayers found some response. Joseph de Pietro was acquitted, and although Nortan Kretske was found guilty he appealed, and the court ordered a new trial because of Lafitte's conflicting statements about his background. When the government decided it did not have sufficient evidence to warrant trying Kretske again, he went free. These legal delays held up the restitution of the paintings. Not until the Good Friday services of 1958 — five and a half years after their theft — did they reappear in their place over the altar of St. Joseph's Cathedral. Straight from the restorer's workshop, they glowed brightly; only their legend had dimmed. But to the parishioners of St. Joseph's, did it matter if it were a Rubens or a Mattia Preti or if St. Bartholomew's navel were misplaced when art, like faith, is in the eye and mind of the beholder?

A year after the Bardstown theft, Canadian police were mobilized to track a gang that had pulled off the biggest art robbery of the century, creating a sensation second only to the disappearance

*St. Bartholomew and his famous navel, restored to the cathedral wall.*
*(Photograph by Courier-Journal and Louisville Times)*

of the Mona Lisa. This time, however, detectives realized they were tangling with professional thieves who knew their old masters. How much they fetched in auction rooms and, more important to them, how much an insurance company would pay to get them back unharmed were what mattered.

At eight o'clock on September 15, 1959, staff coming on duty at the Art Gallery of Toronto noticed a broken front window. Inside, one exhibition room had six bare patches on its walls. A gang had made off with six art works worth about $1.5 million — although the authorities valued them much lower, at $640,000, for obvious reasons. Two Hals portraits had gone — *Izaak Abrahamsz Massa* and *Vincent Laurensz van der Vinne* — Rembrandt's *Lady with a Handkerchief* and *Lady with a Lapdog*, Rubens's *Elevation of the Cross*, and Renoir's *Portrait of Claude*, his son. Five paintings had been ripped free with a sharp knife; the sixth had been taken in its frame. Two other masterpieces showed damage where the raiders had attempted to cut them free but hit the wooden stretchers and desisted. They were Gainsborough's *The Harvest Wagon*, one of the most costly acquisitions, and Van Dyck's *Daedalus and Icarus*.

A progressive gallery with a large and active membership, the Art Gallery of Toronto had half a million dollars a year to lavish on its art collection and possessed a rich store of old masters and figurative and abstract art. If it spent too little on security, who at that time envisaged gangs committing grand larceny in museums? Nobody thought of art as negotiable booty. Yet two previous thefts had shaken the staff. Five years before, a small painting, Krieghoff's *Basketmaker*, had disappeared, but the thief returned it on the promise he would neither be prosecuted nor exposed. In May of the same year, Rubens's *Elevation of the Cross* was stolen. Embarrassed officials learned that a policeman had unearthed it behind a lumber pile near the provincial parliament building several hours after the theft. Since then the city had installed modern burglar alarms, reinforced the locks, and generally increased the security.

Now the Rubens had vanished once more, with four other pictures. No question this time of an eccentric art lover or a casual

thief. Somehow this art gang had operated within the gallery for at least an hour without touching the complex alarm system. 'There were literally dozens of occasions when someone who didn't know how the system worked would have set it off,' commented the gallery director, Martin Baldwin. Obviously the thieves did, for they had tried to cut through a fire door rather than force it open and trigger the alarms. To get in, they had either hidden a man inside to open a window, or they had broken a small window and opened a larger one with a stick. That high window, they knew, had no alarm connections, giving as it did on Dundas Street, a main thoroughfare. However, someone must have risked his neck to reach it, since it meant a twenty-foot climb, using projecting bricks as hand and foot holds. A wet, windy night had kept people off the streets and covered their tracks. Once inside, they knew where to go and what to take.

Nothing like it had happened before. Both detectives and the gallery authorities wondered what the gang would do with their haul. 'Nobody can steal paintings like these without getting his fingers burned,' said Martin Baldwin. Toronto's police chief, James Mackey, took the precaution of alerting border posts and the FBI in case the gang tried to smuggle the paintings into the United States. Art circles were debating whether the gang might try to arrange some deal with the gallery, sell the pictures to a shady dealer, or cross several frontiers to a country where purchase assured title of ownership; some people thought that a very private collector might be willing to pay for such pictures to grace his very private museum.

All speculation soon ceased. For the thieves had verified, long before planning their raid, that the paintings carried insurance for $640,000; they realized too that any insurance company would pay a percentage rather than foot the whole bill if the paintings were destroyed. Their threat to burn the masterpieces made things difficult for Chief Mackey, who had to allow the insurance company some room for maneuver.

Three weeks after the robbery Chief Mackey took a call at his home. 'There's a lock-up garage in Parkdale,' a voice said. 'It's open. You'll find something you've been looking for there.' With

three of his detectives, Mackey went to the suburban garage; in a corner, wrapped in heavy white paper, lay the six canvases. Hals's *Portrait of Isaak Abrahamsz Massa* had lost a bit of paint, and Rembrandt's *Lady with a Handkerchief* had deep scratches, evidently from its passage through the broken window during the theft. A watch on the garage all that weekend yielded nothing, for the thieves had already won their game. Mackey had his ideas about who had pulled off the raid; but if he denied having made a deal with the gang, he carefully avoided denying that the insurance company had paid a reward.

That Toronto raid marked a new trend in art thefts. Now that criminals had proved paintings did have a value outside the auction room, an epidemic of thefts swept across Canada. Sketches worth $40,000 vanished from the University of British Columbia, and icons from a Vancouver art gallery disappeared, while two other Ontario museums lost paintings. Reward payments brought some back; others just vanished into the nether world of the shady dealer and no-questions clients, who combined to make a ready foreign market for stolen art. Soon the epidemic had crossed the Atlantic to infect European crooks with an interest in art and to inspire them to add a few new twists of their own to art theft.

# A Drugged Dog, Cézanne & the Honor of France

Drizzling rain was falling when Madame Baptistine Roux arrived at the Colombe d'Or restaurant she owned in St.-Paul-de-Vence at 1:30 A.M. on April 1, 1960. She had been staying along the Riviera at Agay with a cousin, who had driven her back. Hurrying from the car across the terrace and through the arched main door of the restaurant, neither of them noticed the dark-gray Citroën, with four men sitting in it, parked near the ramparts of the old town.

Before driving back the cousin looked at the restaurant. Of course, he already knew something about it. Who in that part of the Côte d'Azur didn't? In the twenties Madame Roux's husband, Michel, had taken over a sixteenth-century inn to start a restaurant that had become a meeting place for artists, writers, and film stars. Art lover and amateur artist himself, Roux had befriended painters like Picasso, Braque, Matisse, Derain, and Vlaminck, who came to stay in the rooms above the restaurant and enjoy peace and good food. St. Paul, a medieval citadel sitting astride a spur between the Mediterranean and the Maritime Alps offered these artists a magnificent panorama and a million motifs; they painted its battlements and elbow-skinning streets, its stepped terraces thick with orange and lemon groves, its pinewoods and vineyards and

42

exotic flora. Often they traded some of these canvases for board and lodgings at the Colombe d'Or. In this way Michel Roux built his collection with his clientele. When he died in 1955, his widow took over the restaurant; but now sixty-one, she left the running to her son François, thirty-six, and his wife.

Madame Roux switched on the dining room lights. With more than twenty large paintings round the walls, it looked like a gallery, but the cousin thought all that modern art made a superb contrast with the old Provençal room with its timbered, patterned ceiling, massive walls, and medieval, plaster fireplace. No art connoisseur, he nevertheless recognized the Rouault clown, the Picasso flower painting on wood, the strange geometry of Fernand Leger, and the elongated Modigliani, *Woman's Head*. There were also the Bonnard, Braque, Villon, Valadon, Utrillo, Marie Laurencin, and others. A fortune in paintings.

A quarter of an hour later, her cousin gone, Madame Roux sprinkled water on the glowing embers and checked to assure that the heavy inside shutters had their patent hasps in place, with a chair against them for greater security. Saying good-night to the mongrel Kimir, snoring in his corner, she climbed the stairs to her bedroom.

Across the square the four men watched her light go on, then, several minutes later, saw it go out. Two of them left the car and crossed to the arcade, covered with amaryllis, giving on to the terrace. Their reconnaissance several days before had told them it had no lock. They made for the window beside the main door, where the smaller man produced a knife and gouged away the dead putty from the right-hand middle pane of glass. Meanwhile his stocky, swarthy companion was screwing together a drill and one-inch bit. Once the pane was removed he attacked the wooden shutter, working slowly lest they wake the old lady or her son sleeping no more than ten feet above them. They had already laced Kimir's meal with knockout drops. When he had bored ten holes, the stocky man wrenched a square of wood free; his accomplice inserted a hand, lifted the chair off the catch, eased this up, and opened the window.

Avoiding the doped mongrel, the two men entered the dining

room; they had already studied the paintings and how they were hung; within minutes they had collected all twenty and were passing them through the window to the other men, now on the terrace. A quarter of an hour later, their Citroën trunk loaded with canvases, they were driving downhill to the coast and Nice.

At six o'clock that morning Madame Roux came downstairs. At once she realized the pictures were gone. An April Fool joke? No. Her eye went to the open shutter, the missing pane. When the police arrived they found the discarded frames, rain-sodden. Apart from that no trace, no fingerprints, no tracks. Yet they did have clues. Several days before, François had noticed two men who

*Madame Baptistine Roux, owner of the Colombe d'Or, after the theft. (Paris Match/Picherie)*

bought a beer, drank it in the restaurant, then seemed to study the doors and windows on the terrace. Whispering to his barman, Pierre Jacquin, to watch them, he fetched his new camera and snapped them as they left. François almost expected a visit from picture thieves who had struck twice on the Riviera. In January, at Villefranche, they had raided the Villa Masoury, home of Armand Drouant, the art dealer, and got away with thirty modern masters now thought to be in Italy, where purchase assured legal possession. Then, a few days before, in the last week of March, thieves had scaled the facade of Menton's municipal museum, broken a window and stolen seven paintings worth $40,000, including a Modigliani, a Soutine, an Utrillo. They had also crossed into Italy, less than a mile away.

François Roux passed his snapshots to Chief Inspector Gabriel Charpentier, the leading departmental detective. He remembered another strange couple, this time a youngish man and woman who had spent the night at the Colombe d'Or twenty-four hours before the theft. He had rough workman's hands and a cheap suit and she looked . . . well, like what you'd pick up along the Promenade des Anglais at night. They chose a table by the very window the thieves broke. And the man signed the register as a mason from Monaco. A mason in the Colombe d'Or! Like mink and diamonds in a soup kitchen!

*Dining room, la Colombe d'Or, after the theft. (Paris Match/Picherie)*

*The police re-enact the break-in
at the Pavillon de Vendôme.
(Paris Match/Sartres)*

Antoine Petro, the mason, was using a false name. But even
this and the murky snapshot got the police nowhere. As the days
went by they had to pin their hope on the Milieu — the under-
world — which must have heard a whisper. Along the Riviera,
from Menton to Marseilles, every type of racket flourishes, con-
trolled by 'Caïds,' or underworld bosses, who have their own small
armies of henchmen, from pimps and petty thugs to big-money
gamblers and drug smugglers. In the Milieu nothing happens that
escapes these Caïds, most of them known to the police. Indeed, an
uneasy symbiosis exists between these gangleaders and the police;
more often than not they have grown up together in towns and
villages in the northern triangle of Corsica. What mainland French-
men call the Isle of Beauty is a recruiting ground for gangsters —
and policemen — who make up the Mediterranean Milieu; and
that Napoleonic touch many Corsicans feel they possess sharpens
their ambition to become a Caïd, or a police chief. For instance,
the Guerini clan from Calenzana ruled Marseilles, while two other
Corsicans from the same area controlled the Côte d'Azur from
Cannes to the Italian frontier.

46

In this Milieu, French detectives put out feelers and Marseilles assigned one of its experienced Corsican sleuths, Inspector Antoine Sarocchi, to the operation. Within two weeks they had a tip-off. A man called Gaby (Gabriel) Rouzé was boasting openly of having helped pull off the Colombe d'Or coup. That tip-off came from the Nice area, though Marseilles confirmed it. But from whom, the Marseilles Caïds wanted to know. Suspicion fell on Jean-Baptiste (Jeannot) Giudicelli, himself a Caïd in the Cannes and Antibes areas. Although many people felt Corsican gangsters and police mixed too freely, that, like the Sicilian Mafia, the Union Corse flourished too liberally and had too many government connections, the Caïds placed a limit on this fraternization. Some of them believed that Jeannot Giudicelli had overstepped the mark.

In Corsican dialect Giudicelli was Il Cabudo (Big Head) because his head seemed disproportionate to the rest of his small, dapper person. It also signified his importance. Various rackets had made him a fortune, which he had invested in four bars and nightclubs in Cannes and several other business ventures. Detectives often dropped into these places for a chat. People noticed that the Côte d'Azur police invariably had business elsewhere when Giudicelli was smuggling cigarettes, liquor, or perhaps something more noxious. But he also had gentlemanly instincts. When his Corsican home town, Pietralba, elected him mayor, he spent some of his wealth building kindergartens and schools, helping the needy. Giudicelli had influence in high places; but other Caïds like Ange Bianchini and Albert Jaume reproached him for rubbing shoulders with too many people in Sûreté headquarters. Maybe Sarocchi should not have left a police car outside Giudicelli's villa on Cap d'Antibes, for the word got round after that to the effect that Giudicelli was not only ratting on the Colombe d'Or gang but was making a secret deal to return the paintings. A few days afterward, at the siesta hour, Il Cabudo was sunning himself in the garden of his villa, La Dunette, when an outboard launch pulled into the jetty and a man ran up the steps and emptied his revolver pointblank into Giudicelli. Did he belong to the Guerini gang in Marseilles as many thought? Or one of the new mobs in Nice? No

one ever discovered. But that killing triggered off a Corsican vendetta in which the police estimate more than sixty people died over fifteen years.

Detectives followed up their tip-off, tailing Gaby Rouzé, a monolithic figure with reddish hair who had once run a Nice bar. Finally they arrested him and persuaded him, none too gently, to reveal the names of his accomplices and how they had carried out the raid.

Two men had planned the coup, and like every worthwhile French criminal, they had nicknames. They were a thirty-eight-year-old Belgian called Louis de Coene, or Lulu the Belgian, and Michel Paoli, thirty-two, alias Denis the Corsican. They had 'cased' the Colombe d'Or and fixed the first rainy day in March or April for the robbery. Eugène Simoncini (Jeff) had spent the night at the restaurant with a girl to study the layout. He and Paoli had broken in while Rouzé and Jean-Jacques (Jacky) Parsiani stacked the paintings in the car; they had hidden them in an apartment on the Promenade des Anglais, then transferred them to a disused barn near the millionaires' village of Castellaras. What had become of the paintings, he did not know. Did he know what they were worth? Rouzé affirmed he nearly chucked the Picasso out of the car because it was too big. He gagged on his breakfast when *Nice-Matin* informed him that picture alone would fetch 250,000 francs ($50,000). And he was getting 300 francs ($60) for his night's work! If he'd known those pictures were worth 2 million francs ($400,000) . . .

Where had the paintings gone? Their frames came to light near Castellaras, but the canvases had vanished. Rumor whispered an Arab diplomat in Paris had offered 15 million francs ($3 million) in a black-market deal. More insistent rumor suggested the thieves had offered their return against a ransom of $30,000. François Roux refused, hoping the police would soon recover his paintings.

One by one, the suspects were arrested and interrogated. Two more confessed. Simoncini admitted spending the night with a girl called Michèle Aron at the Colombe d'Or, and Parsiani avowed his part in the theft. Michel Paoli, the Corsican older hand, knew arrest meant the police would lean heavily on him before throwing him to the judge, so he surrendered himself to the examining mag-

istrate, Judge Henri Berlioz. Louis de Coene walked into a police station in Ajaccio, Corsica, where he had gone on vacation. A sixth man, Roger Cardinali, was charged with receiving and hiding the paintings. Paoli, a granite-eyed, thin-lipped thug, belonged to a Nice gang and denied everything; he had actually appeared as an extra in gangster films and looked the part. De Coene (Lulu the Belgian) had a perfect alibi since he had been visiting his sick mother in central France the night of the raid. However, he could not explain why a police vacuum cleaner had sucked up fragments of picture-frame plaster in his fashionable flat on the Promenade des Anglais.

French justice took over, and months dragged by without a hint of the paintings. Suddenly, on February 8, 1961, more than ten months after the theft, a priest phoned Inspector Lavalette of the Marseilles criminal investigation division. A man, who said he had hidden the paintings in Saint Charles Station in Marseilles, had confessed to the theft. Next day the police received a luggage ticket, a note attached reading 'Use this and you'll get a surprise.' Nineteen of the twenty paintings lay in a locker. An abstract by Bazaine was never recovered. Nobody believed a Marseilles gang had committed the robbery; if anything, it confirmed a Nice Caïd had planned it since gang foreign policy dictated that the loot be dumped on the rival's doorstep. Although the Roux family kept silent, it was assumed they had paid something like $10,000 in ransom. No one then realized that this transaction was the start of the ransom racket in art thefts. Afterward, uninsured paintings like those in the Colombe d'Or could be used to extort money from owners or museums.

In December 1961 the six men went on trial at Nice. By then they had all agreed to reveal the real villain, the man who had devised and planned the coup. None other than the dead Jean-Baptiste Giudicelli. Rouzé even affirmed having given Il Cabudo the missing Bazaine abstract. 'Why did you wait until Giudicelli was dead before speaking about him?' the presiding judge asked.

'It's not because he's dead I mentioned him but because I'm told he narked [squealed] on me,' Rouzé replied.

Others backed his Giudicelli story. But why, the judge and

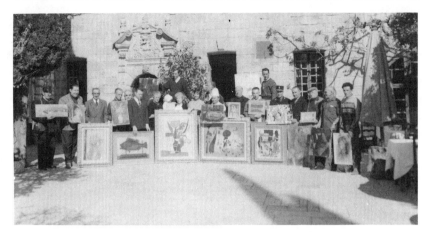

*The day the pictures came home to the Colombe d'Or. (Paris Match/Sartres)*

advocate-general both asked, would a Caïd like Giudicelli pick a bunch of amateurs when he had half the underworld of the Côte d'Azur to draw on? Not even the brilliant Paris lawyer, Maître René Floriot, could explain this in defending Louis de Coene. Most observers thought another gang boss had planned the operation, arranged Giudicelli's execution for tipping off the police, then pinned the theft on him. De Coene and Cardinali were both acquitted. Rouzé, Simoncini, and Paoli each got three years' imprisonment and Parsiani two.

But the Colombe d'Or case did not stop there. Months after Giudicelli's assassination, a rival gang boss, Piero Rossi, was also shot and the fifteen-year gang war among the Corsican Milieu started. Paoli eventually became a victim of this eye-for-eye justice, and many people saw his hand in the shooting of Giudicelli. At any rate, his real gangster career started with the Colombe d'Or. He joined the Bianchini gang and was given the nickname Lucky when he escaped two ambushes in 1964 in Nice and in 1966 in Bastia, Corsica. On May 14, 1969, he was entering a Bastia café when he met a volley from several sawed-off shotguns that killed him instantly.

With the Drouant and Menton thefts that preceded it, the Colombe d'Or case marked a new phase in art stealing; it opened up a new market for gangs that had hitherto lived off pimping and

prostitution, gambling, protection rackets, burglary, and drug pushing. Before the Colombe d'Or gang came up for trial, two further and even more spectacular thefts had taken place within a hundred miles. This time, the government of President Charles de Gaulle was forced to intervene between the thieves and their victims.

In the summer of 1961 Saint Tropez knew nothing of the tourist boom that transformed it from a small fishing port into one of the swinging resorts of the Côte d'Azur. Sparse summer vacationers might spot Brigitte Bardot and Françoise Sagan and Jeanne Moreau or the odd French politician and business leader along waterfront cafés and restaurants or on yachts in the harbor. But its barefooted fisherfolk in peaked caps, blue jerseys, and half-mast trousers still did not have to rub shoulders with hippies smoking hash or coachloads of gawkers come to stare at nude sunworshippers and rock musicians on the silver-sand beaches.

Yet the small port looking across a beautiful bay to Sainte Maxime had been discovered as long ago as the nineties — by artists. In 1892 Paris painter Paul Signac ran his sloop into the bay for shelter during a storm and woke next morning mesmerized by a chromatic sunrise and the later play of silver-blue light on the sea, the Provençal township and Maures mountains behind. Signac, avant-garde Impressionist friend of Seurat, Monet, and Pissarro and equally at home in top hat or Breton sailor cap, in salon or sloop, adopted Saint Tropez, and soon he and his painter friends were spending their summers in the port. One of them, André Dunoyer de Segonzac, stayed on after World War I to paint for the rest of his life. These painters found a friend and sponsor in George Grammont, millionaire industrialist and art patron; he collected Signac, Seurat, Matisse, Bonnard, Vuillard, and other modern artists. In 1937 he persuaded the town to give these paintings one floor of a sixteenth-century White Penitents chapel called L'Annonciade, sitting just off the old port in a quiet garden; eighteen years later, redesigned by architect Louis Sue, the chapel became a museum housing 101 of Grammont's pictures and five sculptures by Maillol, Despiau, and Wlérick. For the connoisseur it counted

as one of the most exquisite galleries in Europe. Dunoyer de Segonzac became its curator and guiding spirit.

There, at six o'clock on July 16, 1961, a fifty-six-year-old cleaning woman, Madame Incarnacion Olivarès, came to prepare the museum for its first visitors. She wondered who had left the iron gate to the patio open. Then she spotted the lock of the double door on the patio flagstones. Inching open the door, she saw the shattered plate-glass window. As she edged into the museum, she nearly fainted. 'Mon Dieu,' she gasped. 'They've taken the whole museum.'

On the ground floor hardly a single painting remained; upstairs in the exhibition rooms half the pictures were gone. In all the bandits had grabbed fifty-seven superb examples of impressionism, postimpressionism, and modern art. Ten paintings and watercolors by Signac, four Matisse canvases, four of Bonnard's finest works, two by his friend, Vuillard, four Derains, two Vlamincks, two Dufys, two van Dongens, one Utrillo, one Soutine, and a Segonzac watercolor — these and several other masterpieces had vanished. Estimates put the total loss at more than 8 million francs (over $1.5 million) but in reality the paintings would have fetched several times this figure in the auction rooms.

Few people in Saint Tropez went to the Annonciade or had the least idea of what Grammont's legacy was worth, just as nobody bothered about security. A recent suggestion to fit a simple burglar alarm still lay, vetoed, on the municipal council table; and although they had insured the chapel building against fire, no one had even considered insuring paintings that would have rebuilt the place a dozen times at present values. A forty-year-old council employee, Monsieur Armand Bardey, acted as part-time guard, but on the night of the theft he had gone to visit a sick relative, leaving the museum unattended. For the robbers nothing could have come easier; they had scaled a wire fence behind bushes, appeared to have opened the iron gate with a key, jimmied the flimsy French doors, broken the glass, and driven off with a truckload of art. A fierce mistral wind helped by keeping folk off the streets and quays.

Chief Inspector Jean Cabanne and four Marseilles inspectors found a cold trail; they circulated a description of the pictures in France and through Interpol and hoped for a break. What could

even organized thieves do with paintings as well known as Matisse's *Woman at the Window*, Derain's *Westminster Bridge*, Dufy's *Honfleur Jetty*, Bonnard's *Saint Tropez Harbor*? This time, the Marseilles Milieu was saying nothing, and even the Caïds seemed mystified.

Whoever committed the robbery had studied the chapel and its routine. They probably had a key for the iron gate, since Cabanne's detectives found that, for the so-called foolproof lock, the local locksmith, Henri Civallère, had cut no fewer than ten keys. They also had nerve, for one person heard their truck and another actually saw them. They woke a fifty-six-year-old tramp, Charles Cagne, who was sleeping off several glasses of wine in his summer quarters (a building site near the chapel), by gunning their van engine at three o'clock; just before, Madame Madeleine Sapet had stood on the quayside watching two men loading a van at the chapel entrance; one was tall, fortyish, with dark glasses and sleeked hair, the other ten years younger, smaller and lighter. 'I thought they were fairground people moving to the next town,' she told Cabanne.

Soon a stolen Citroën van was found abandoned in Saint Zacharie, twenty miles east of Marseilles; its owner remembered the odometer reading before the theft, enabling Cabanne to figure out that the paintings had ended up somewhere in the Marseilles area before the van was ditched.

Dunoyer de Segonzac hurried back from the Geneva exhibition of his own work. At seventy-six he was shocked and heartbroken at the theft of paintings by lifelong friends from his own museum. They formed part of his own history as well as the history of modern painting; he had painted alongside Signac and Matisse, had known Utrillo, van Dongen, Charles Camoin, Bonnard, Vuillard. Men who painted for art's or their own sake with no mercenary motive. To think their works had fallen into the hands of thugs who saw only money in them and would not hesitate to destroy them. Hardly had he returned than a handwritten note arrived at the town hall; it was addressed to him and demanded 500,000 francs ($100,000) for the paintings. "If you do not accept to pay the ransom, we are going to destroy the fifty-seven paintings," the note read. Saint Tropez could not meet such a demand; nor could

Segonzac hope to raise the money; out of his own pocket he offered $2,000 to start a public subscription.

But the thieves grew impatient. To emphasize they were not bluffing they sent their next demand attached to a fragment of a watercolor — Segonzac's own; each week he got another fragment until he had almost the whole of his watercolor of Saint Tropez. He was growing desperate, for his appeal had raised no more than $10,000, and the art pirates sneered at this. In any case, Chief Inspector Cabanne set his face against paying a ransom; from underworld sources they had gleaned some idea of who had planned the theft and realized that the Marseilles gang boss would find it impossible to sell such 'hot' paintings anywhere. So they played a cat-and-mouse game, believing the thieves would ultimately barter their loot against immunity from prosecution.

However, the Marseilles Caïd had other ideas. Twenty miles north of his own fief, in Aix-en-Provence, one of the most important exhibitions of Paul Cézanne's paintings, watercolors, and drawings ever assembled was being staged. Hadn't one Cézanne sold two years before in London for two and a half million francs, nearly half a million dollars? In Aix they had twenty-two canvases, nineteen watercolors, and nineteen drawings. And unlike the Saint Tropez paintings, these Cézannes all carried maximum insurance. If they could not be unloaded on the black market, the insurance company would pay.

In Aix-en-Provence, nobody appeared concerned about any threat to the exhibition. Early in August the mayor was asked whether, in view of the art-theft epidemic and the Saint Tropez scandal, he feared for the safety of the Cézannes. 'Of course not,' he replied. 'We have armed guards and police reinforcements.' At that point the exhibition had been running nearly four months and would close in another week.

For the first time since Cézanne's death in 1906, Aix-en-Provence was honoring one of its most famous sons. During his lifetime, the town he loved and immortalized in dozens of landscapes spurned him as a half-crazed dauber, its notables sneered, its children pelted him with stones. It took foreigners, mainly Americans who clubbed together, to buy and preserve his studio in Aix. But

not even there did a single painting or sketch by the master exist — or in the Granet Museum or anywhere else in the town. More than fifty years and several art revolutions went by before Aix stuck the name Cézanne to cafés, cinemas, and even schools.

Now at last, Cézanne had come home. His landscapes, peasant portraits, Montagne Sainte-Victoire canvases were all being shown in their natural environment. The exhibition had come from Vienna, where Professor Fritz Novotny, an authority on Cézanne, had toiled for months persuading private collectors and museums to lend works. His friend and fellow Austrian, Leo Marchutz, asked if he could 'borrow' the exhibition for Aix. Marchutz, a painter, had lived and worked in Aix for most of his life as a disciple of Cézanne. These two men and John Rewald, art scholar and historian, persuaded the town to let them have the ideal building to house the show for four months, the Pavillon Vendôme. An imposing, three-story Provençal mansion built in 1667 for the Cardinal de Vendôme, it sat on the outskirts of the old town in a mosaic of gardens, paved paths, and fountains. High walls and trees shielded the building, which experts considered needed no more than a few guards and a woman curator to ensure the safety of the sixty art works. Officials from the Union Stadt Versicherung of Vienna looked over the place, then offered nail-to-nail insurance coverage for an estimated $2 million.

However, the town took no chances. Especially since the exhibition came under the high patronage of the legendary André Malraux, art pundit, novelist, politician, philosopher, aviator, adventurer, resistance leader, and now President de Gaulle's Minister of Culture. Aix hired five extra armed guards to back up the usual *Pavillon* guard, André Rigaud; it had the gendarmerie assign policemen day and night to watch the grounds; Madame Martial-Salmé, the curator, lived on the second floor, a few yards from the paintings, with her husband. But the town also had door and window locks checked and renewed; it installed four powerful projectors to light the grounds and the *Pavillon* after sunset; a sensitive burglar alarm connected the building with the police station. Little wonder the mayor could boast his unconcern.

Yet within forty-eight hours of his declaration, eight Cézannes

had vanished — and but for a series of coincidences the whole exhibition would have been lifted bodily. It had every hallmark of the gang that had rifled the Saint Tropez museum. They had worked with such skill and audacity that detectives felt sure at first that it was an inside job, done with the cooperation or connivance of a guard or exhibition official. That holiday weekend, the Feast of the Assumption, the *Pavillon* had remained open until an hour before midnight on Saturday, August 12. At midnight precisely, Madame Martial-Salmé spoke to the guard and retired with her husband to their second-floor flat. Four hours later the relief gendarme noticed that a second-floor French window was ajar; but the guard had heard nothing, so the policeman assumed it was open to air the rooms on the hot evening. Not until eight o'clock did an auxiliary guard, Pascal Roubaud, discover the theft. Six paintings had disappeared from Room Five, next door to the curator's own flat! From the Van Loo Room on the same floor, two others were gone. Evidently the thieves had tried to unhook the large portrait of Cézanne's father, but its bulk had thwarted them.

For Aix it came as a shock; its more devout or superstitious citizens imagined Paul Cézanne was mocking them from beyond the grave. One artist remarked sardonically, 'At long last, Aix is taking an interest in Cézanne.' To crown the humiliation, some pictures belonged to private collectors. Sidney Simon, a New York artist, had lost the well-known *Seated Peasant*; Madame Beerlach of Laren, Holland, *Paysage Près d'Aix*; Madame Marianna Feilschenfeld, *The Deathsheads*; and Signore Giambalista of Milan, *Reflets dans l'Eau*; the others came from museums in St. Louis, Missouri, Cardiff, Zurich, and the Louvre. André Malraux had agreed, in fact, to lend the last of Cézanne's series of card players, on which he had labored for years. Into that picture alone, Cézanne had injected everything he had learned in a lifetime of painting. Over years, in different versions, he had reduced the group around the bistro card table from five persons to two solitary players, a bottle of *pinard* (rough red wine) between them. Cézanne had pondered every contour, every touch of color, every gesture to produce a picture from which painters and art lovers the world

over had drawn inspiration. At auction it would have fetched more than a million dollars.

That Sunday morning Chief Inspector Fernand Mathieux and his detective team began to piece the case together. Already, road blocks ringed Provence, Paris had set up a watch on seaports and airports, and Interpol had circulated descriptions of the masterpieces, rendering their sale virtually impossible. By eleven o'clock that evening, when detectives and *Pavillon* staff reconstructed the crime for the examining judge, Monsieur Bou, they formed a precise idea of how the thieves had operated. Everybody saw that those powerful floodlights could blind observers and create deep shadows to aid rather than impede burglars; a detective showed how easily any normal man could scale the window bars to the first floor, stand on the ledge, and use the ventilator slats to open the French windows. The raiders had gained entry that way. To prove they could have worked inside the house without disturbing the occupants, detectives moved around Room Five and the Van Loo Room, removing paintings and passing them through the left-hand window. Neither Madame Martial-Salmé nor her husband nor the ground-floor guard heard a thing through the massive walls. And that morning, the violent mistral was muffling all sound.

Bit by bit the puzzle unraveled. At two o'clock on the morning of the theft, a power failure blacked out a block of houses near the Pavillon Vendôme, and maintenance men discovered a cut cable. The thieves had hoped to douse the projectors and alarm system and enter by the back door. Failing to cut the current, they crept through the courtyard of the adjacent school, and with each footstep they left an indelible trail of mulberry skin and red flesh. The mistral had ripped berries off a tree in the courtyard; their pulp stuck to the gate the raiders had climbed, to the gravel paths, to the window bars, to the floors of the rooms; this mulberry trail suggested they had stood on each others' shoulders to make the climb and passed the paintings through the window.

But for three people, the gang might have cleaned out the whole second story. At three o'clock, Jean-Claude Eydoux, aged seventeen, was returning from a late-night dance when he noticed a van

parked in rue Célony, behind the *pavillon*; two men were loading it. Eydoux described one as middle-aged, about fifty, a rough type in leather jacket and tennis shoes. However, he went home thinking nothing of the incident until later that morning. Not so the insomniac Madame Yvonne Castinel, who from her window watched several men load the van, then draw away. Waking her husband, she whispered, 'They've just brought off a coup at the Vendôme.' He shrugged and went back to sleep. Octave Clavel, a housepainter wakened by the noise, threw up his window and berated the men, who immediately got into their van and drove off. All three witnesses described the Renault van, but it was never traced.

Mathieux and his inspectors, Antoine Sarocchi and Jean Gandin, had no doubt that the same gang had done both the Saint Tropez and Aix robberies. Indeed, their Milieu informants named the eight-man team that had ransacked the Annonciade and included the six who had made off with the Cézannes. Some were survivors of the prewar Paul Carbone mob that controlled Marseilles crime until ousted by the Guerinis. A week or two after the theft, one of these men approached a young inspector with an astonishing offer — for 20 million old francs ($45,000) they could have not only the Cézannes, but the gang would throw in the Annonciade paintings as well. They were scared of burning their fingers. But police chiefs spurned the offer, feeling certain they could arrest the men.

However, the position had altered. No longer could the police play a waiting game, since the gang had something to sell and a willing client in the Vienna insurance company. Their threat to destroy the paintings brought the omnipotent and charismatic figure of André Malraux into the rescue operation. Paris decreed the pictures took priority over everything. No arrests must be made, but, equally, no bargains must be struck with the gang.

In France, Malraux counted for more than just the Minister of Culture. His word carried as much weight as General de Gaulle's. Malraux symbolized the revolutionary intellectual in France; a familiar figure on TV, twitching and gesticulating like a badly-strung puppet, making oracular utterances in a croaking

voice bearing the rasp of a million cigarettes, he looked and acted like a cultural high priest. When he said, '*Il y va de l'honneur de la France*' (France's honor is at stake), everyone realized the art thefts were no longer just a police case. However, the French, who deflate legends as quickly as they create them, sniggered that if anybody knew something about art stealing it was Monsieur André Malraux himself. Hadn't he been caught with a load of looted art once? It was true. As a penniless twenty-two-year-old archeologist Malraux had gone to French Indochina with a loose commission from the colonial authorities to search for Cambodian sculpture in the Khmer jungles. With his young wife, Clara, and a companion, he roughed it for a year, dismantling statues, bas reliefs, and stone carvings round the royal city of Angkor. Smuggling these downriver to Phnom Penh, they ran into the French authorities and a charge of stealing ancient treasures. A colonial court sentenced Malraux to three years' jail, but eminent writers like Anatole France, André Gide, Aragon, and François Mauriac came to his defense and an appeals court changed the verdict to a one-year suspended sentence. Malraux used these experiences in his autobiographical novel, *The Royal Way*, in which his alter ego makes statements like these: 'You could say time doesn't exist in art. Look, what interests me is the decomposition, the transformation of these works of art, their most profound life, created out of the death of men. In effect, every work of art tends to become a myth.'

Now, forty years later, Charles de Gaulle's Minister of Culture Malraux had to save the country's face. Imagine world reaction if French thieves had destroyed sixty-five of the finest examples of painting in the last hundred years! He dispatched Henri Seyrigh, Director of National Museums, and others to Aix; in Paris they whispered that he had a through line to the go-between acting for the thieves.

At first, the gang demanded $100,000 from the insurance company. A Paris lawyer stepped into the negotiations to represent the insurers and to keep a watching brief for Malraux. A complicated four-handed poker game began between the lawyer, the anonymous go-between, Malraux's office, and the police. Malraux

said, 'We must have the pictures back whole.' Sûreté chiefs rejected ransom or reward payments. 'No money and you'll never see the pictures again,' said the gang. The insurance company, having already paid out $1.3 million to the victims, stood to lose the most. Finally, after attempting to sell several paintings to bent dealers and being balked by the police, the gang settled for $60,000 and a promise of immunity from prosecution from Paris.

On April 9, 1962, eight months after the raid, Chief Inspector Brieussel took a call from a man who informed him that two youngish men had just left a blue-green Peugeot 404 with a broken rear window and false plates in Camille-Pelletan Avenue, one of the busiest thoroughfares in central Marseilles. Without touching the vehicle, detectives verified the plates had come from another car, 904 BN 13. They watched the stolen Peugeot for twenty-four hours, then finally searched it and found three parcels, two wrapped in brown paper and one in jute sacking. They contained the eight missing Cézannes.

However, the gang nearly blundered. For although they had obliterated the recipient's address from the jute sacking, it had been registered by a Paris firm and postmarked March 29, 1962 — eleven days earlier. Soon the police discovered the parcel had gone to a man living in boulevard Vauban, Marseilles. An electrician — someone who might have cut the power cable at the Pavillon Vendôme. But it turned out the man worked for a shipping line and was at sea between Marseilles and Casablanca on the night of the theft. He still found it difficult to explain how his wrapping material came to bind those paintings. Detectives suspected he had hidden them for the gang but had to release him for lack of proof.

More pressing reasons dictated their action. If the eight Cézannes had been returned, fifty-seven Annonciade pictures still lay in the hands of the gang who might destroy them rather than risk being caught in possession. Already warnings were filtering through the Paris police that arrest and prosecution of any gang member would mean destruction of the paintings. But they still wanted their ransom. Poor Dunoyer de Segonzac had scraped together $10,000, but the gang spurned him. Not only did they want

$100,000, but assurance that no one would be charged. Malraux's office watched the horse-trading between their special delegate and the thieves, while the police stood by, knowing the culprits but helpless to act.

Although the Paris Sûreté promised de Segonzac his museum would recover the paintings, Marseilles detectives did not share this optimism. As one said: 'They'd already ripped one painting apart, and we knew they were prepared to burn the others or send them piecemeal through the post. Who paid? Whoever it was, we paid nothing, but that's not to say Paris didn't. Nor did we give any undertaking not to pursue the gang. No policeman can do that. The Annonciade and Aix cases are still on the books.' But Marseilles police did stipulate one thing: since Paris had taken over and such eminent men were handling the affair, they could arrange to retrieve the paintings in their bailiwick and not have them dumped like so much *merde* on Marseilles's doorstep.

On November 16, 1962, fully sixteen months after the theft, Malraux's private office received a letter directing the police to search a barn at Villier Saint-George, a village near Paris. There, to the astonishment of the farmer, fifty-six paintings were hidden under his hay with a message from the thieves. 'We beg forgiveness for having stolen these works of art. By giving them back we hope our crime will be forgotten.'

Nothing on the scale of these Riviera thefts occurred again in France for fifteen years, suggesting the police and that bunch of art thieves established some sort of truce. Yet the Caïds of Nice and Marseilles had set the precedent for many of the ransom and insurance thefts of later years; they also pointed the way to what became known as art-napping, the holding of a painting or a work of art as a hostage to extort money in exchange or to deliver an ultimatum to achieve political or social advantage.

# 4

## The Iron Duke, a Broken Dream, & a Failed Revolutionary

Unlike many other countries, Britain has never really taken her successful soldiers, however illustrious, to her heart. She prefers them in mufti. There is, however, one exception — the Duke of Wellington. Together with the head of the royal family and Horatio Nelson, greatest of British admirals, the Iron Duke has become a national institution, an untouchable hovering far above ridicule and criticism. Had he not after all trounced Napoleon at Waterloo and saved Britain and Europe? Foreigners shared this reverence. In 1812, while resting his armies in Madrid, Wellington, aged forty-three, sat for a half-length portrait to Goya, the great Spanish painter. Goya discerned not the proud victor of Salamanca but a tired and haunted face which contrasted strangely with the red coat and glittering medals and reflected war's grimmer side; he painted the man who wrote, 'Nothing except a battle lost can be half so melancholy as a battle won.' Wellington gave the portrait to his sister-in-law, the marchioness Wellesley, who left it to her sister, Louisa, wife of the seventh duke of Leeds.

It was this painting that stirred angry passions on June 14, 1961, when the American oil magnate, Charles Wrightsman, bid

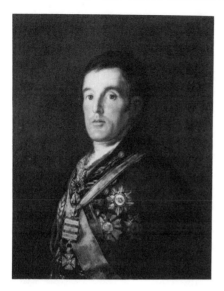

*Francisco Goya,* The Duke of Wellington. *(Reproduced by courtesy of the Trustees, The National Gallery, London)*

£140,000 ($336,000) for it at the auction sale of the Leeds collection. A public cry of sacrilege and national insult went up, echoing in the House of Commons and forcing the Chancellor of the Exchequer to push through a grant of £40,000 ($96,000) to keep the portrait in Britain. Another £100,000 ($240,000) came as a gift from the Wolfson Foundation, and Wrightsman generously handed back the prize he had intended for his own private collection. On August 3, the portrait went on special exhibition at the National Gallery, drawing thousands of people to gaze at it as a work of art or a national asset. But it stayed on its easel in the vestibule for only eighteen days. On August 21 — exactly fifty years after the Mona Lisa theft — the Goya vanished. Warders said they saw it at 7:40 P.M. on their rounds, but three hours later the night shift found the picture had disappeared. However, it did not enter their heads that after a hundred and thirty-seven years anyone had committed a theft at the National Gallery. No doubt a restorer or photographer or some gallery official had borrowed the painting. Nevertheless, the night sergeant reported the absence, and after a search by gallery staff Scotland Yard was called.

Not only did the Goya and the Leonardo disappear on the same day at a half-century interval, but their cases presented many

other strange parallels. No one believed it possible. Who would perpetrate such lèse-majesté? When finally convinced, most people blamed a crank or a joker before imputing the crime to a crook after a ransom or a wayward collector. Into Scotland Yard came the usual barrage of hoax calls, the sightings, the clues, the false trails — all reminiscent of the Paris Sûreté experience during the Louvre theft. As the days passed, it became clear the Goya had vanished just as surely as *La Gioconda*, and with even less trace. Scotland Yard had an even more difficult task than Lepine's police; for nearly 6,000 people had stopped to admire or gape at the Iron Duke on the day he went missing.

How did the thief do it? Surely not by picking up the $25\frac{1}{4}$-by-$20\frac{1}{2}$-inch painting and bearing it through the vestibule and down the gallery steps into Trafalgar Square without being spotted! No, he had probably hidden in one of the rooms, stayed behind when the gallery closed, and got out through a back window. That meant an intimate knowledge of the place if, as detectives conjectured, he had worked at night. How did he give the guards the slip? He must have known how to tread through that maze of infrared beams and photoelectric barriers that would set the whole of Scotland Yard ringing if anybody even looked at them. Squads of detectives went over every inch of the gallery, a labyrinthine structure covering two acres, with forty doors, two hundred and fifty windows, and more than a hundred and fifty rooms. They interviewed the guards and contractors' men working in the building. Gradually they formed a notion of how the thief had operated. He had probably hidden inside, taken the picture out through the men's lavatory window at the back, crept through two courtyards, and shinned over the wall by the rear gates. Scotland Yard concluded that at least two men, who, from their footprints, were young and agile, had carried out the theft. The thieves had luck with them, for the gallery backed onto a big, unlit yard used by the Ministry of Works and its contractors; two holes had been punched through two blocks of the building into one of the eight internal courtyards. That gave them access, and any thief could have used the contractors' ladders to descend with the Goya and get over the rear wall. But why the Goya and only the Goya?

The country had to wait ten days for an answer. Then an explanatory letter arrived at Reuters news agency in Fleet Street.

Posted in London, written in block letters on cheap notepaper, the note demanded a ransom of £140,000 for charity. To prove beyond doubt he had the painting, the writer described identifying marks and labels on its back.

> Query not that I have the Goya. It has a stick label on back saying F Gallais and Son — Date 22.8.58. It has six cross ribs each way (back). The act is an attempt to pick the pockets of those who love art more than charity. The picture is not damaged, apart from a couple of scratches at side. Actual portrait perfect. The picture is not, and will not be for sale — it is for ransom — £140,000 — to be given to charity. If a fund is started — it should be quickly made up, and on the promise of a free pardon for the culprits — the picture will be handed back. None of the group concerned in this escapade has any criminal convictions. All good people are urged to give, and help the affair to a speedy conclusion.

Scotland Yard detectives did not doubt the letter; they realized they were dealing with a new type of moral and social blackmail by a man who had a grudge and was demanding the selling price of the painting. Unlike other blackmailers he had not threatened to destroy the Goya if his scheme failed. Yard men decided to test the thief's patience. However, it seemed he too was lying low. Months passed without a word from him. He ignored the *Times*'s suggestion that he follow the example of Raffles, the gentleman thief, and return the *Duke* in a spectacular way. Why not immortalize himself by infiltrating the portrait into the Goya exhibition soon to open at the Royal Academy?

From the note police deduced that a solitary criminal was behind the Goya theft — someone interested in much bigger money than the £5,000 reward the gallery trustees proposed. That offer merely produced an avalanche of crank calls and hoaxes which squandered police time. Strange figures dropped into the Yard to volunteer information — con men, clairvoyants, old jailbirds, artists. A quaint old painter came to whisper, 'It was a fake, that Goya. I know, I painted it from the original.' A young detective heard him out, then asked, 'Then what happened to the original?' A

moment's thought and the old man mumbled, 'Alas, it was stolen.'
Public relations men seized on the sensation. Two policemen
stopped someone carrying a Goya; they were film men taking a
reproduction to their studios. As a final, sardonic commentary on
these stories, the Goya turned up in a James Bond film. Having
chased Doomsday Man Dr. No to his bunker on a Caribbean
island, Fleming's hero suddenly stops in his tracks before a paint-
ing — the missing Goya.

In fact, the police did have a theory — the writer of the genuine
note might be bluffing, sowing a false trail to allow him to smuggle
the painting abroad and sell it to some dealer who might sit on
it for years, or to some eccentric collector. However, on July 3,
1962, another letter arrived from the thief, written in the same
capital letters and this time containing a label from the back of
the picture to prove his possession. His note ran:

> Goya Com 3: The *Duke* is safe. His temperature cared for —
> his future uncertain. The painting is neither to be cloakroomed
> or kiosked as such would defeat our purpose and leave us to
> ever open arrest. We want pardon or the right to leave the
> country — banishment? We ask that some nonconformist type
> of person with the fearless fortitude of a Montgomery start the
> fund for £140,000. No law can touch him. Propriety may frown
> — but God must smile . . .

With that tantalizing statement, the thief went silent until De-
cember 30, 1963, when he surfaced with another note suggesting
that if the national newspapers paid five shillings (sixty cents)
for every thousand copies sold, he would return the Goya; the
money would go to charity.

> Terms are same. Rag [*sic*] students kidnap living persons for
> ransom — they are not charged. An amnesty in my case would
> not be out of order. The Yard are looking for a needle in a
> haystack, but they haven't a clue where the haystack is . . . I
> am offering three-pennyworth of old Spanish firewood [the
> Goya was painted on wood] in exchange for £140,000 of human
> happiness. A real bargain compared to a near million for a
> scruffy piece of Italian cardboard. [This referred to Leonardo's
> *Virgin and Child*, presented to the gallery in 1962].

66

Silence for another fifteen months until March 15, 1965, when the thief penned his fifth and final demand. Now he had another plan:

> I know that I am in the wrong, but I have gone too far to retreat. Liberty was risked in what I mistakingly [*sic*] thought was a magnificent gesture — all to no purpose so far, and I feel the time has come to make a final effort. I propose to return the painting anonymously if the following plan is aggreed [*sic*]. The portrait to be put on private exhibition at a five-shilling view fee for a month, after which it would be returned to the gallery. A collection box to be placed at the side of picture for good people to give if so inclined . . . The affair to be a true charity, and all moneys collected, minus nothing for expences [*sic*] given to the place I name . . . The matter to end there — no prosecutions — no police enquiries as to who has committed this awful deed. I do not think the authoritys [*sic*] need fear the feat being emulated by others — the risk is great — the material reward nil.

Analyzing all these notes, psychiatrists and detectives discerned the same character trait running through them. The Goya thief was an intelligent, imaginative man (even if he did massacre English orthography) who had a strong moral sense and now had a guilty conscience about his magnificent gesture. Eventually this feeling of culpability might compel him to return the painting, although his obvious frustration at having achieved nothing might cause him to change his mind and destroy it.

For four years this cat-and-mouse act between the thief and the police had intrigued the country; it might have continued for as long again had not a mass-sale newspaper thrown an escape line to the man who stole the Goya. The *Daily Mirror* reproduced the last letter in full, then referred the writer to its front page, where it made what it called a sporting offer. It requested the thief to return the Goya, addressed to its office in Holborn Circus, through any newsagent in the land. 'Alternatively, the *Mirror* invites the present holder of the portrait to deposit it in any safe place of his choice — then to inform the editor of this newspaper where it can be found. In return, the *Daily Mirror* will at once hire a hall

or other public place where the Goya portrait could be exhibited for a month to the benefit of any charity nominated by the present possessor of the painting.' However, the paper insisted it could not assure the man of immunity from prosecution.

Three days later, the thief wrote to the *Mirror* stating that if it could guarantee £30,000 for charity by showing the painting, he would return it to the newspaper.

> I will accept an obvious message in personal column of Daily Mirror, signed Whitfield. The morning after public or private message appears, you will receive a letter informing you to pick up Goya . . . If collected, direct charity money on instructions from FHC [deleted] TYA.

Two days later, on March 23, the *Mirror* printed a message:

> Personal. TYA (or FHC) Your letter received and being considered — Whitfield.

On the following day the paper repeated its sporting offer. Nothing happened for almost a month. Then, on May 21, the mail brought the newspaper a cartoon cut from its March 18 issue to prove the identity of the sender. More important, the envelope contained a receipt for a parcel left at New Street Station, Birmingham. Next afternoon, Detective Inspector John Morrison presented the ticket, paid the surcharge of seven shillings (about 85 cents), and opened the parcel labeled, 'Glass. Handle with Care.' It was the Goya, minus its frame. It had lain there for just over two weeks among suitcases, knapsacks, and other left luggage. That same day, Michael Levey, assistant keeper at the National Gallery, identified the portrait in a London police station; soon the Iron Duke was back on show, though now among the other Spanish pictures in Room XVIII. He seemed none the worse for his four missing years.

None of the detectives, psychiatrists, or graphologists who had examined the contents of the letters and the handwriting would have matched their mental picture of the thief with the young man who deposited the package. In his early twenties, clad in a blue duffel coat, he looked like an art student. Baggage clerk Ronald

Lawson recalled him as slim, well-spoken, with bushy hair. He gave his name as Mr. Bloxham, paid his shilling (twelve cents) fee, and took ticket number 244458. 'Be very careful with this,' he insisted on handing over the package. Somehow he did not sound like the intelligent and imaginative man who had outwitted the National Gallery guards and twitted the police for their impotence. Even in returning the painting, that man showed his wit. Lady Bloxham figured in Oscar Wilde's *Importance of Being Earnest* and the hero of the play, Jack Worthing, was a foundling discovered in a handbag at Victoria Station cloakroom. Had the fake Bloxham put pressure on the real thief to return the painting? Did he collect the £5,000 reward? His description and an Identikit picture went out, but all attempts to trace him failed.

However, the real culprit had not finished writing — this time a bitter remonstrance to the *Daily Mirror* accusing it of having betrayed his trust. In a final letter, he said:

> Goya. Extra Com. Lost — one sporting offer. Property has won — charity has lost. Indeed a black day for journalism. I wonder if he is worthy of £2,500 reward or should be drummed out. We took the Goya in sporting endeavour — you, Mr Editor pinched it back by a broken promise. You furthermore have the effrontery to pat yourself on the back in your triumph. Animal — vegetable — or idiot.

In justice to the *Daily Mirror*, it had tried to persuade the National Gallery to place the portrait on exhibition for charity but met with a blunt snub. To counter the thief's recriminations, the *Mirror* suggested its own happy ending to the whole affair: it advised the man who stole the Goya to choose this moment to vanish from contemporary history.

But he did not. Six weeks after the return of the painting, at eight o'clock in the evening of July 19, 1965, a bulky, round-faced man with a livid complexion, grizzling cropped hair, and steel-rimmed glasses walked into Scotland Yard and said to Chief Inspector John Weisner, 'I am turning myself in for the Goya.' Eventually he identified himself as Kempton Bunton, aged sixty-one, an unemployed bookmaker's clerk from Newcastle-on-Tyne. 'I've let something drop and I believe someone may turn me in

*Kempton Bunton. (The Press
Association Limited, London)*

to get the reward,' he said. 'Now make up your mind, are you
going to charge me or not?'

Ridiculous as it seemed, the police refused to believe Bunton
at first. Too many innocents came to seek notoriety by confessing
to spectacular crimes. And this man looked nothing like the part
— in his sixties, weighing 252 pounds, with a dreamy, artless
expression in his blue eyes behind thick lenses, he answered in a
ponderous North Country accent and spoke like a barrack-room
lawyer. Even his name, Kempton Bunton, sounded a bit comic.
Anyway, all the Yard inquiries, tests, analyses, and deductions
pointed to a young man — perhaps two young men — athletic
enough to scale several high walls and squeeze through a small
lavatory window. With all this in mind, a dubious Detective-
sergeant Frank Andrews had summoned Chief Inspector Weisner
who, skeptically, referred the matter to West End Central police
station, who sent Detective-sergeant William Johnson, who in turn
fetched Detective-superintendent Ferguson McGregor Walker. Pa-
tiently Bunton explained again and again how he had stolen the
painting, even taking them through the steps with the operational
file he had kept and showing them the pad from which he had

70

torn pages to write his notes. He had even done some of their work, preparing a handwritten confession. 'You'll make a big blunder if you don't charge me,' he told Detective-superintendent Walker. Their dialogue then went like this:

'When did you steal the portrait?'
'Nineteen sixty-one, the twenty-first of August.'
'What day of the week was that?'
'Monday . . . Monday.'
'Aren't you sure?'
'I think so.'
'What time was it?'
'Five-fifty, or thereabouts.'
'Was it dark at the time?'
'A bit.'
'As far as I know, it wasn't dark at the time. Are you telling me the truth?'
'It's a long time ago. I'm fairly sure.'
'Where did you take it from?'
'Opposite the main door entrance.'
'How did you get in?'
'They were building at the back and I took a ladder when the guards were having a cup of tea or were asleep.'
'How did you get round the back?'
'That was easy.'
'But how?'
'I went through the open toilet window and along a passage and took it.'
'Did you go up any stairs?'
'Only steps up to it.'
'How did you get out?'
'The same way, through the toilet and over a wall.'
'How were you dressed?'
'I can't remember. I sometimes wear a cap.'
'Were you by yourself?'
'Yes.'
'Did you go into the Gallery for this particular painting?'

71

'I wasn't after this painting no more than any other.'

'Why did you steal it?'

'To ransom it. I thought there would be an immediate collection for it.'

Early the following afternoon, Bunton was charged with stealing the picture and replied, 'Not guilty.' He had already told the police, 'The case will get thrown out, you know. Where there is no criminal intent there can be no conviction.' Nevertheless, on November 4, 1965, he went on trial at the Central Criminal Court in London on five charges: stealing the painting; stealing the frame; demanding money from Lord Robbins, chairman of the National Gallery trustees, with menaces; demanding money similarly from the *Daily Mirror* editor; causing a public nuisance. After Judge Carl Aarvold, Recorder of London, had thrown out the final charge, the jury dismissed the two accusations of demanding money, leaving Bunton to face the theft of both picture and frame.

In his shabby, off-the-rack suit, Bunton sat impassively in the country's most famous court through the twelve-day trial; he showed no emotion when Judge Aarvold summed up both him and his case in brilliant language peppered with sardonic comment. Bunton, the judge said, was an angry idealist with a strong moral conscience who became enraged because the government refused to exempt old-age pensioners from paying their TV license fees. To foil this injustice, he cut the BBC program from his TV set, then wrote to the post office saying he would not pay a license fee for a BBC program he did not receive. Early in 1960 he was fined, with an alternative of fifteen days' jail. He chose jail. Repeating the offense later that year he got a fine of £15 with fifty-six days' jail, and early in 1961 he served another twelve days in prison. Thereafter, he paid his TV license.

'Sometime before August he heard about the purchase of this Goya for £140,000, and again he felt very strongly about that,' the judge said. 'Here is a country that can afford £140,000 for a picture, and they are not prepared to spend any money on free television licenses for old-age pensioners. So, he formed the idea

that he would like to take that picture in order, he said, to raise £140,000. The price paid for the picture would [if invested] bring one hundred and forty-three licenses for old-age pensioners in the Newcastle district permanently.' Judge Aarvold went on to describe how Bunton planned the robbery. 'For the convenience of would-be intruders, the builders kept their ladders and stock-in-trade in the courtyard outside the window of the lavatory [in the National Gallery] . . . The defendant tells you that he managed to get in and he managed to get out. You have seen him, you know his age, and you have also heard him say he was suffering from a bad attack of influenza at the time; but somehow he managed to achieve that remarkable athletic feat, as you may well think it was. So far as we know there was only one person involved in this, and the defendant tells you he was there doing it himself with no one else helping him at all. As I say, you may think it was a remarkable feat by the defendant.'

Judge Aarvold finished his summing-up by explaining to the jury that if they thought Bunton meant to return the painting if his ransom bid failed, they must acquit him; if, on the other hand, they felt he would hang on until he got the money, they must bring in a different verdict. After seeking some guidance, the jury came back with their verdict: the ten men and two women found Bunton not guilty of stealing the painting, but guilty of stealing the £100 gilt frame, which was never found. Passing sentence, the judge commented: 'Motives, even if they are good, cannot justify theft, and creeping into public galleries in order to extract pictures of value so that you can use them for your own purposes has got to be discouraged. Taking all those matters into account, I can only sentence you to a short term of imprisonment of three months.'

Judge Aarvold clearly shared police skepticism at what he called Bunton's remarkable feat. Several Scotland Yard detectives involved in the Goya inquiry refused to believe that Bunton did not have an accomplice — someone like the mysterious and bogus Mr. Bloxham who, Bunton contended, was a complete stranger, someone he accosted casually to hand the Goya into the left-luggage office. Bloxham had no reason to remain silent, but he never came forward when Bunton surrendered.

Had Bunton told his whole story in court, it would have left the judge even more incredulous. For this classic crime was conceived by someone who had never committed even a simple housebreaking — by a penniless man who knew hardly anything about London and had never seen the National Gallery before attempting to outwit its guards and antitheft devices; by someone who played his whole mission by instinct, inventing tricks as he went and helped by a bit of luck. At the time of the theft, Bunton was living on £8 a week ($19) national assistance and unemployment benefit, having lost his last permanent job as a taxi driver three years before as a result of an accident with a bus. To his friends and neighbors he was an oddball, a dreamer. His wife saw him as a public library political philosopher and a dole-queue rebel, the sort of man who would starve or go to outrageous lengths to realize his ideals; she considered him above all a frustrated author who had written a novel and several plays without ever managing to get a line published. Even the narrative of his greatest coup, the stealing of the Goya, did not appeal to publishers when he came out of prison. Bunton's meager recognition had to wait until March 1977, after his death, when the editor of the *Liverpool Post* published some of the material he had written.

Bunton revealed that it took him more than two months to accomplish his mission, for his determination to steal the Goya dated from June 15, the day he read about the auction sale in London. 'A hundred and forty thousand pounds for a thing I wouldn't hang in my kitchen,' he thought. 'The government taxing old folk to view TV and at the same time wasting money on a useless painting. Who the hell was this Wellington anyway?'

Library books enlightened him. In Bunton's homespun ethics, the Iron Duke figured as a tyrant; a soldier who treated men as scum, so much cannon fodder to win battle honors for himself; a Prime Minister who starved the lower classes by tightening the Corn Laws governing the price and importation of corn. But, irony of ironies in Bunton's view, this villain, black-hearted in life, might yet serve the more noble cause of humanity in death. If he stole and ransomed that bit of painted wood it would pay for several score of permanent TV licenses for old folk. That idea

74

appealed to Bunton's sense of adventure and his missionary streak. 'What could I lose? — I had no job, nearing sixty, my time was running out,' he wrote.

To back this wild idea, he had no more than ninepence (nine cents) in his pocket. True, he would only need a few pounds, since he could hitchhike the three hundred miles to London from Newcastle. But nobody would lend him even that small sum. As a former bookmaker's clerk he knew his horses, but the five-shilling triple he had tried merely lost him his pocket money. When he was despairing, a thousand-to-one meeting with a distant relative, loaded with back pay and drink, clinched his scheme. He borrowed £10 ($24). After waiting to sign on the dole, he told his wife he was going fishing but hitchhiked to London by truck. At that moment he had the childish notion of snatching the picture — even in daylight — hopping a train with his prize, and arriving in Newcastle four hours after the theft, safe from pursuit.

His first glance inside the National Gallery chilled that idea. Black-uniformed guards patrolled everywhere, mingling with the crush around the Goya. Bunton cursed himself for a fool. He had money only for a few days before he had to return and sign on at the exchange or lose his week's dole. It seemed impossible to break in or out of this fortress in the heart of London. Nonetheless, he began to case the gallery the next day. Standing on a toilet bowl in a lavatory, he spotted building materials in a back court-yard. That meant access from the back, ladders, and a way into the gallery if this window stayed open. He wedged a twist of paper in the window catch and went out and bought some cellophane tape, which he stuck across the door lock. In his words he had 'boobed' both window and door. And the following day his 'boobs' remained there, untouched. As he reconnoitered the rear of the gallery, Bunton got chatting casually with a guard; in five minutes he learned how the night shift patrolled the corridors every twenty minutes, using keys at various checkpoints, how the cleaning women arrived at six o'clock; he ascertained too that every corridor and exhibition room had electronic beams which triggered burglar alarms if crossed.

'And how about the cleaners? Are they not going to set the bells ringing with the ray devices?'

'He looked at me and half-smilingly said, "Well, around that time, security is a bit lax." '

Bunton now realized that to get past both guards and electronic beams he would need a foolproof plan, which would mean at least one more trip to London. This time he would merely explore the place. From an upstairs window of the Westminster Central Reference Library he observed that the building contractors had breached the gallery walls in several places. Buying a sixpenny (six-cent) map of the gallery, he sited the lavatory window, pacing out the distance inside to locate its exact position. It lay fifteen feet up, overlooking an inner courtyard; but the breaches gave access to it. Once over that outer wall, into the back yard, through the building breaches, and across an open courtyard he had only fifteen feet to climb to the unlocked lavatory window. As he hitch-hiked back north, his plan had taken shape; all he needed were money and a bit of luck.

On Friday, August 18, 1961, he left again for London. Next day, he visited the gallery and found they had moved the *Duke* to an easel in the vestibule. In the lavatory his boobs had not been moved; he could start to refine his plan. At the Sunday street-market in Petticoat Lane, he paid five shillings for a frayed commissionaire's coat, brass buttons and all. Wearing that, he might look like a gallery guard at a distance. He picked up a peaked cap too. Yet he had misgivings about the whole venture. He boarded a bus for King's Cross and toyed with the thought of buying a rail ticket home. To do the job he needed to steal a car, and nowhere around the station could he find one with its ignition key in place. 'It was late on that fateful Sunday night — I was standing on the corner of Birkenhead Street, just opposite King's Cross, and by this time had practically given up all idea of the job. . . . Then suddenly something happened which altered everything. A car came veering along the road, clearly a drunk. He parked very badly outside a small hotel, staggered out of the car, half-closed the door and literally crawled into that hotel. I have always maintained that the drunk in question was solely

responsible for the missing Goya. Had that car not been left half-parked with the keys in the ignition, I would most assuredly have hopped onto a north-bound train that night. I took this incident as a sign from Heaven that I was to proceed with the job.'

Parked behind the gallery, he had to wait until after four in the morning before being able to edge his stolen car into a position where he could use it to climb the high wall in Orange Street. With a clothesline tied round his commissionaire's coat and a toy gun in his pocket, Bunton levered his 252 pounds over the wall into the builder's yard. Groping through the gaps, he stopped beneath the lavatory window. It was lit. As he propped the ladder against the wall someone inside pulled the toilet chain. Bunton waited half an hour before climbing the ladder and squeezing through the lavatory window.

'In a silent, half-bent posture in order to miss the electronic rays if they were still on, I proceeded along the corridor . . . I was past the cloakroom counter now, and yes, there was the picture. In a certain mood of foolhardiness, without which I should have been lost, I climbed a few steps and placing one foot inside the barrier of rope, quickly unhung the Duke and without wasting any time turned towards the way back.'

Back in the lavatory Bunton roped and lowered the portrait, then climbed after it. He got back over the outside wall just as dawn was breaking, planted the painting in his lodgings, then drove his stolen car to where he had found it. He doubted if the drunk ever knew he had one gallon less gasoline in his tank. 'I raced back to the lodgings. Taking the picture from behind the wardrobe, I stood it on the bed with the frame leaning against the wall and looked at it in triumph. Wellington returned my stare with cold contempt and I swear I saw his lips move, with the imaginary voice which said: "Thou low-born wretch, I'll break thee for this." And somehow I believed he would.'

Bunton had not anticipated anything like the outcry that followed his theft. With thousands of police and everyone else looking for the Goya, he had to leave the painting in his lodgings, go north to sign on the dole, then return to smuggle the *Duke* home. While he waited, he wrote the first ransom note. When the hue

and cry grew feebler, Bunton trussed the *Duke* inside hardboard and brown paper, rode home by train and trolley-bus, and pushed the portrait under the bed before his wife could greet him. 'Satisfactory lies to Mrs B as to the reasons of these mysterious comings and goings; and upon my word, nobody ever lied to Mrs B better than me at that period. I had a secret to keep and one just can't trust a gossipy old woman, bless her heart.'

Bunton kept his mouth shut for four years. All that time Goya's *Duke of Wellington* lay hidden in a top cupboard at 12 Yewcroft Avenue, Newcastle-upon-Tyne, until something persuaded Bunton to arrange for its return. Why did he confess? According to him, he had blurted out his secret to someone either when he was in his cups or to relieve his conscience, or from vanity or frustration. He feared the man would betray him for the £5,000 reward. Bunton had at least one accomplice, detectives concluded, but he refused to divulge that name. A perpetual misfit, a quixotic figure looking for crusades to wage, a dreamer and drifter, a romantic always reaching for the unattainable, Kempton Bunton accomplished one of the most remarkable of all art thefts only to see it end like everything else he did — in failure. However, he had the consolation of knowing that, just as August 21, 1911, created a landmark in art stealing, so did his coup on the fiftieth anniversary of the Mona Lisa abduction.

The Bunton case can be seen as a remote ideological ancestor of a unique robbery that exploded in the headlines a decade later, though the political revolutionaries who staged it would have scorned Bunton as a hopeless bourgeois idealist.

Art, as we have seen, had not only grown into a big-money industry for the criminal, but was also something that aroused the interest of the terrorist and revolutionary, who saw they could steal and use unique and famous paintings as bargaining counters to wrest concessions from governments. Ireland, with its background of IRA violence, became the scene for one of the first big political picture thefts, the Beit case — a curious Gaelic farce and a cautionary tale for terrorists everywhere.

It began on April 26, 1974, at 9:10 P.M., when someone rang the service doorbell of Russborough House, a one-hundred-room

Palladian mansion nineteen miles southwest of Dublin owned by Sir Alfred Beit, a diamond millionaire and former Tory Member of Parliament. Through the half-glazed door, a servant, James Horigan, and Patrick Pollard, the butler's fifteen-year-old son, noticed a woman of about thirty, dressed in a well-tailored suit. Patrick heard her say in French that her car (*voiture*) had broken down (*était en panne*). No sooner had the boy opened the door than two men barged past the woman, shouting at him, 'Lead us to them.' A third man entered and Horigan asked, 'Who to?'

'Beit and his wife,' the man replied.

Sir Alfred, aged seventy-one, and his wife were in the library listening to records when the three men burst in, brandishing pistols. Ordering both to lie on the floor face-down, the men bound them with women's nylon tights. Sir Alfred tried to look around and was hit over the head with a pistol butt. 'Capitalist pigs,' a man cried. 'You're walking on the working class.' Sir Alfred had inherited a fortune from his father, the South African financier who had collaborated with Cecil Rhodes to organize the gold and diamond mines in southern Africa.

Lady Beit was dragged downstairs and locked in a basement; other staff members were tied and thrust into different rooms. Only Patrick Pollard remained free to accompany the woman as she searched for the Beit picture collection. A brunette, she wore a light-blue costume and spoke with a French accent. She appeared to know her art, instructing gang members which paintings to take and how carefully to handle them. Knocking the stretchers out of the frames, they humped the paintings to a silver Ford Cortina outside. Altogether they seized nineteen master canvases, part of a collection of sixty left by Beit's father and uncle. They included Vermeer: *Woman Writing a Letter with her Maid*; Goya: *Portrait of Doña Antonia Zarzate*; Van der Velde: *Calm Sea with Boats*; Velasquez: *Maid in Kitchen with Christ and Disciples Outside Window*; Hals: *Man Playing Lute*; Ruisdael: *The Cornfield*; Gainsborough: *Landscape* and *Portrait of Madame Barelli*. Two Rubens canvases also were taken.

Before leaving, the gang rifled the study, stealing checkbooks and papers, including certificates for the paintings. Just after ten

*Sir Alfred and Lady Beit. (The Press Association Limited, London)*

o'clock they drove off, having committed the biggest art robbery up to that time. Ten minutes later Patrick Pollard, who had been tied up in his turn, wriggled free and pressed the alarm connecting the mansion with the local police at Naas. Within twenty minutes a national manhunt had started for the art pirates. A thousand extra troops patrolled the Ulster border, and alerts went to Irish airports and seaports, Interpol, and Scotland Yard, for detectives first thought a Frenchwoman had hired a bunch of Irish thugs to carry out the raid and might have a private foreign buyer for the paintings. Soon first editions of the Irish and British press carried photographs and descriptions of the pictures. Those nineteen masterpieces would certainly have fetched an estimated £8 million ($19.2 million) at auction and quite probably twice as much. Only nine of the works were insured. A reward of £100,000 ($240,000) was offered for their return.

Soon the Irish police had second thoughts, and several clues indicating political rather than venal motives. Next day, a Saturday, the Cortina was found abandoned on the main Dublin-Cork road at Thurles; fifty miles farther south on the same road another stolen car came to light. A professional gang would have gone underground or crossed a frontier; it would not have laid an obvious trail nor stolen such unsalable paintings. In Dublin the shrewd chief of the Irish Technical Criminal Police Bureau,

Superintendent Anthony McMahon, sensed a link between the Russborough House robbery and another raid two months earlier in London. There a gang had smashed through a window with sledgehammers to penetrate Kenwood House, an eighteenth-century museum on Hampstead Heath, and stolen only one picture, Vermeer's *Guitar Player*, worth between $2.4 and $4.8 million. Like the Beit gang, they had cut the electric cable, used violence, and left an evident trail. Two weeks later they had written to the *London Times* offering the picture in exchange for the repatriation of the Price sisters, two Irish girls serving life sentences in Britain for taking part in IRA bombing raids in London in March 1973. But the Home Secretary refused to send Dolours and Marian Price to Ulster to complete their sentences, and the Vermeer turned up two months later in a London graveyard.

McMahon's hunch proved right. A week after the Beit raid, a letter posted in Belfast and addressed to the director of the National Gallery of Ireland demanded that the Price sisters and two of their compatriots on hunger strike be moved to Ulster jails in return for five of the Beit paintings; all the others would be handed over on payment of £500,000 ($1.2 million). McMahon wondered who they were dealing with, feeling that even the most tortured Irish reasoning could never have inspired such a crack-brained scheme — asking the British government to yield up prisoners against pictures stolen outside its jurisdiction from someone resident in Ireland! 'There seemed to be at the very least muddled thinking.' wrote the *Irish Times*. 'And it did not seem to many to be muddled Irish thinking.'

McMahon shared that view. The woman gangleader intrigued him. She was obviously well-bred and cultured. But why give away her French accent when she could have said nothing or spoken with an Irish brogue that would have escaped unnoticed? He instructed the police (*garda*) to check hotels and holiday accomodations throughout Ireland to see if anyone with a French accent had hired a room or a cottage recently. On May 4, nine days after the robbery, two gardai, Sergeant Pat O'Leary and Constable William Creedon, visited a hamlet called Reenagreena, in County Cork near the southwestern tip of Ireland. There a farmer, Con

Hayes, informed them he had rented his wife's cottage to a French-woman, Mrs. Merimée, and her husband, who had given a London address, 11, Elveston Street, North London. Finding the address did not exist, Sergeant O'Leary kept watch on the cottage. He saw the young woman borrow Hayes's small Morris saloon car and drive off. When she returned, three hours later, his men surrounded the car; in its trunk they discovered sixteen of the Beit canvases. A search inside the cottage unearthed the three most valuable paintings; the Vermeer, Velasquez, and Goya. But their biggest prize was the woman herself — none other than Dr. Bridget Rose Dugdale, Maoist revolutionary, IRA terrorist, and gunrunner for whom the British and Irish police had been searching for months.

One of the most bewildering personalities in the history of art thefts, Rose Dugdale began life in a privileged, upper-crust English family, was educated in the best European finishing schools, came out as a debutante, and took degrees at Oxford and American universities; none of her friends ever understood why she converted to Marxism and turned her back on her wealthy parents and her own class to become a revolutionary who adopted the IRA cause and fought for a united Ireland. With her working-class lover, Walter Heaton, another IRA sympathizer, she raised funds for the IRA and helped smuggle arms and ammunition to IRA guerrillas. It was lack of money to buy these arms that led her to plan and carry out the theft of her own father's picture collection in June 1973. For this she got a suspended two-year sentence while Heaton, her accomplice, was jailed for four years. Rose Dugdale fled to Ireland to escape further investigation in Britain; she joined a small, freelance IRA group, which had raided and bombed police stations and public buildings along the border between Eire and Ulster. With these 'wild boys' she planned and executed the first-ever helicopter bombing raid in the British Isles, with four improvised milk-churn bombs. But, like so many other things Rose Dugdale tackled, this turned into a fiasco. One bomb came dangerously near to blowing the gang and the helicopter to pieces; the other three failed to explode. After this raid every police station in Britain and Eire joined the hunt for Rose Dugdale. Yet, despite seeing her face on posters

*Rose Dugdale. (The Press Association Limited, London)*

everywhere, aware she risked arrest and jail, she organized the Beit raid three months afterward, another abortive scheme to try to free the Price sisters.

In June 1974 she appeared in a Dublin court alone, since no other members of the gang were found. Her three judges sentenced her to nine years' imprisonment for the Beit and helicopter raids. She gave them the clenched-fist I R A salute as she disappeared.

But even the IRA, like her own class, had disowned her. A few years before, she seemed the girl who had everything going for her, and her friends predicted a remarkable career. But she became the woman with the anti-Midas touch, everything she tried coming unstuck, everything she ventured falling apart in her hands. After her experience, few people seemed tempted to steal paintings and use them like hostages to blackmail the authorities.

Shortly after she entered prison Rose Dugdale had a baby, which she said was the son of Eddie Gallagher, a former I R A comrade serving a twenty-year sentence. They were married in prison but not allowed to see each other again. Rose Dugdale was released from prison after serving six years of her nine-year sentence in October 1980. As a freed prisoner she is permitted to visit her husband once a week.

# Sally & the Tycoon's Stand-in

Who but a multimillionaire would spend a small fortune burglar-proofing his sumptuous house to protect nearly a million dollars in modern art — then walk out and forget to switch on the alarms? G. David Thompson, retired Pittsburgh steel baron and investment broker, did just that when he left his ranch-style house, Stone's-Throw, on Brownsville Road in the opulent South Hills suburb to take his wife to dinner with friends on July 28, 1961. Returning later that night he found the front door forced and ten paintings missing from two upstairs rooms. All the signs pointed to a crude break-in by thieves with no experience in stealing art. Judging by the discarded frames, every picture had suffered damage, having been sliced or torn away. Six good Picassos were gone, including *The Bathers*, a famous 21-by-32-inch canvas, two by Fernand Léger, a portrait by Joan Miró, and a Raoul Dufy landscape. In their haste the thieves had ripped holes in two other Picassos and left a Matisse in tatters.

Without waiting for his insurance company to act, and ignoring police advice, Thompson offered a no-questions-asked reward for the return of the paintings. He feared their destruction if the thieves discovered they could not sell them. A forthright man with strong tastes and convictions, Thompson wanted his pictures back regard-

less of what happened to the thieves. As a connoisseur of modern art and a man who had bought avant-garde painters like Picasso, Matisse, Braque, Klee, and Miró when conventional collectors scorned them, Thompson was better known in European art circles than in Pittsburgh. In fact, his hometown did not share his love for modern art. Tight-pursed mayors who refused to build museums or give grants and town-hall officials with tunnel vision had lost the city the fabulous Mellon hoard, which had gone to Washington, D.C., and the Frick collection. They had also snubbed Thompson when he offered them more than three hundred paintings if the city would house them in a public museum. He had just sold his splendid collection of works by the Swiss master Paul Klee — built up over forty years — to a West German state museum, knowing the futility of proffering it to Pittsburgh.

So Thompson ignored the Pittsburgh police. His reward produced the biggest crop of cranks and crooks and bogus thieves ever known in the steel capital — all lured by the $100,000 bait. But the offer also produced results. On August 10, two weeks after the raid, a call came from a man concealing his identity under the code name 'Sally'; he spoke to Judge Henry X. O'Brien, who had agreed to act as go-between for his friend Thompson. Sally told the judge some friends of his had the paintings and would return them on payment of the $100,000. At that point the FBI entered the case on the grounds that a gang had crossed the state line to commit the offense, thereby infringing federal law. FBI agent Bernard C. Brown in Pittsburgh had found links with a series of burglaries by a ring in the New Castle–Youngstown area of Ohio.

Since Sally insisted on dealing directly with Thompson, the part of the Pittsburgh steel magnate was taken over by FBI agent Joseph M. Chapman, head of the new art-and-forgery team. In this new role Chapman took and taped every call Sally made and conducted a dialogue of coded ads in the local Pittsburgh papers about the return of the paintings against the reward. However, in the bluntest Thompson language the FBI man told Sally he would never pay until he saw and handled his paintings. Sally bit on this. Thompson must therefore come to New York and book into a Manhattan hotel, where the exchange would take place. He must bring

cash in small, used notes. Sally had even provided Chapman with a password, taken from a popular comic-strip character. He would call the hotel and say: 'Is Ben Bolt there?'

Chapman, alias Thompson, would reply: 'Ben Bolt's not here. This is his manager, Spider.'

Chapman outfitted himself with a gray, wavy-haired wig and close-cropped, grizzled mustache and a suit like Thompson's and booked into the Manhattan hotel; in an adjoining room sat another FBI agent, in radio contact with thirty New York City policemen and half a dozen patrol cars. But when Sally called he obviously suspected a trap, even after exchanging the password. He began a lengthy cross-examination, wanting to know details of Thompson's family — where the paintings had hung and the layout of Thompson's rambling house and the burglar-alarm system. Some slip Chapman made frightened Sally; he told the bogus Thompson to go to the public library on Fifth Avenue and look in the Los Angeles telephone directory for further orders. His accomplices must have watched Chapman search the directory vainly, for a note left by the FBI man in the book disappeared soon afterward.

Chapman's associates had identified Sally by tracing his call while he talked to the FBI man; Chapman and his detectives tailed Sally back to Pittsburgh and his home in Morado Dwellings, a housing project in Beaver Falls. Sally was Ralph Charlton Hobbs, a forty-six-year-old, moon-faced, unemployed salesman and aimless drifter separated from his wife and four children. Hobbs had only one previous offense, for drunken driving. Chapman decided to do nothing but wait and watch the small hotel into which Hobbs had moved for his operation and to answer the cryptic ads Hobbs was inserting in the Pittsburgh papers.

Thompson still refused to pay until assured of the safe return of his paintings. On September 7, Sally made another call — intercepted by Chapman — instructing the steel baron to look in a public phone booth in the Greyhound bus terminal. He would find a locker key that would prove he was dealing with the man capable of returning his paintings. Still disguised, Chapman went and opened the locker to find the most costly of Thompson's missing painting — Picasso's *Bathers*, worth around $75,000.

Now, four months after the raid, Hobbs was growing frantic and Chapman guessed the gang was putting pressure on him to collect the reward. Thompson took call after call, and finally, in November, Hobbs rang his front doorbell and coolly asked to be paid for the restored Picasso. Thompson sent him packing, declaring he would pay only when he had all his paintings back. For a whole month after that, stalemate. At that point Chapman and Brown, the local FBI agent, decided to act, fearing the gang might destroy the rest of the collection. On December 13 they arrested Hobbs in Bridgewater, charging him with interstate transportation of stolen property. He pleaded that he had acted for two men who stole the paintings, but that they had since died.

Next day Chapman and Brown had a tip-off that took them to a Pittsburgh motel near the airport. In a room there, wrapped in a dirty mattress cover under the bed, lay the other nine paintings, all of them damaged and much the worse for their missing five months. Two men, calling themselves Roy Adams and Ken Phillips from Philadelphia and New Castle, booked the room and left the paintings; a third man picked them up in his car. None of these three men could be traced. In April 1962, Hobbs received a sentence of one and a half to five years in jail. It took another year for G. David Thompson to settle his wrangle with the insurance company over the restoration of his paintings and rehang them in his home.

While the FBI was trying to trap Hobbs and the Pittsburgh gang, another thief carried out an armed hold-up on the other side of the country in the California home of David E. Bright, construction millionaire and modern-art collector. His new Welsh maid answered a ring at the door of the Beverly Hills house on September 10, 1961, and saw a man holding a bunch of gladioli; before she could move he thrust a gun through his bouquet, pushed her into a lavatory, and locked the door. Disregarding the barking dog, he went downstairs and cut five of the paintings from their frames; he left a Dégas pastel on wood as too bulky and rolled up the others and walked out.

It had an expert touch, for the armed robber had taken the

cream of Bright's collection. Los Angeles detectives saw a strong connection between the theft and the recent exhibition of Bright paintings, which were valued at $2 million. Soon afterward Bright received a ransom demand for $100,000; if it was not met, the pictures would be destroyed. In this case the police were lucky, for the man they were hunting had left his fingerprints in the Bright house and he had a previous conviction. Within a week they had arrested Edward Henry Ashdown, thirty-nine-year-old real estate agent from Palm Springs. At first he denied the theft, but then confessed he had done it to attract attention to himself. Police recovered the paintings and charged him with grand larceny. However, Ashdown never appeared in court. Within a week of being allowed bail of $5,250 he disappeared. Alerted by Los Angeles police, the FBI discovered he had flown first to New York and then to Italy. Italian police joined the hunt.

On September 26 a gang broke into the country mansion near Palermo owned by Baron Gabrielli Ortolandi di Bordonaro and stole twelve old masters, some silver, and ceramics. They had obviously cased the Sicilian stately home and knew the baron was shooting half a day's drive away on another estate, leaving only an elderly and infirm caretaker in the house. Scaling the wall, the robbers jimmied a side door and went straight to the living room, where they leisurely slit the paintings away from their frames. A Titian, Rembrandt, Van Dyck, Mabuse, and other masterpieces valued at a very conservative $400,000 went with them. Baron Ortolandi di Bordonaro and the Sicilian police realized from the way the band operated that they were led by somebody who knew his art and were obviously working on orders from a crime syndicate or for a big and crooked dealer.

To handle their biggest art theft since the war, the Sicilian police sealed off the island, while mainland colleagues alerted Interpol and every airport and customs post linking Italy with France, Switzerland, Austria, and even Yugoslavia. Meanwhile, in FBI headquarters in Washington, someone reading his files wondered if Ashdown, an art thief on the run, might have traveled from Rome to Sicily. It was a long shot, but the Washington Interpol office wired Ashdown's picture, description, and finger-

prints to Rome. Within two days the Sicilian police had arrested him in Palermo. Exactly as he had done with the Los Angeles police, Ashdown admitted the theft, making the same plea and revealing where they could recover the stolen objects. Extradited to face the first offense, he stood trial at Santa Monica and received a sentence of from two to ten years in prison.

Ashdown obviously had acted on higher orders, for he had no way of disposing of his loot and could have known nothing about the Sicilian manor and its treasures. FBI agents could only assume that the Sicilian Mafia and its American connections had moved into art stealing and were using small-time crooks like Ashdown to commit their robberies. Ashdown gave no hint of who had masterminded the thefts, and the Mafia closed its ranks both in California and Sicily.

But Mafia bosses also had a hand in one of the most spectacular pieces of art pilfering in the New York area. It took seven years for a Mafia gang to deplete and disperse one of the finest collections of German and middle-European porcelain in the world. Yet so cleverly did they operate that their theft remained undetected until 1969.

In the twenties, Dr. Wolf G. Tillman, internationally renowned porcelain connoisseur, assembled a fabulous collection of antique Meissen figures and dishes, many of them priceless pieces by Johann Friedrich Böttger and Tschirnhausen; he had no fewer than two hundred and fifty examples of Viennese porcelain by Claude du Paquier, decorated by independent enamelers (Hausmaler). Numbering important pieces from all over Europe, the Tillman collection ranked even with those of national museums in variety and size. To keep it out of Nazi hands Professor Tillman shipped it out of Germany in the late thirties; he himself retired to Holland. After the war, in 1946, he transferred the whole collection for safe storage to a Lincoln warehouse in New York City. Its estimated worth at that time was $150,000 — but in the sixties it would have fetched perhaps ten times that figure.

In 1958 a complete inventory was taken of the porcelain and spot-checks were made until the collection was moved to another Lincoln warehouse in Hoboken, New Jersey. In May 1969 Pro-

fessor Tillman decided to place his porcelain in the Chase Manhattan Bank in New York City and sent his son to supervise the transfer. A Lincoln official advised him that the collection had gone to another company warehouse in New York City. When Tillman's son broke the seals on the twelve barrels in which the porcelain was stored, he discovered that each barrel contained no more than a top layer of his father's pieces over a collection of worthless junk as makeweight and camouflage.

New York City police and the FBI investigated the theft and concluded that the porcelain had vanished piecemeal between 1958 and 1965, when the first transfer took place. Several New York dealers are believed to have handled some of the Tillman items, perhaps unaware they came from his collection; but only three pieces have ever been recovered, all by the New York City Police Department. In 1975 the FBI closed its file on the case, as the statute of limitations had expired. Curiously, none of the Hausmaler pottery has come to light, suggesting that perhaps another connoisseur had heard of Tillman's treasure and commissioned the Mafia to steal at least a part of it, which he bought en bloc. If he is American, he may have to sit on his haul for twenty to thirty years to ensure that the Tillman family has lost all claim to ownership; other countries confer title after only three to five years. In art collections the whole almost always exceeds the sum of its parts, and the irony of the Tillman theft is that many of these rare pieces may have gone for next to nothing to people who did not realize their true worth.

Since crime, like most other social diseases, spreads by contagion, it seemed only a matter of time before the North American and Continental epidemics of art stealing infiltrated Britain. And if U.S. and French thieves devised forceful or ingenious ransom and extortion schemes, London gangs invented new and subtle variations that left them with a fortune, the art gallery and collector with their pictures, and Scotland Yard with the problem of a new category of crime that took eight years to beat. It all began at a small gallery with a raid that was in itself as much a masterpiece as the paintings stolen.

At dusk on the hot summer evening of July 11, 1962, late-night theater crowds were making their way to Mayfair restaurants or hotels like Claridge's and nightclubs were filling up when a gang of five men drove a van into Adam's Row, a quiet street around the corner from the O'Hana Gallery in Carlos Place. In the back of the van they got a final briefing from their two leaders. On at least a dozen previous trips to the O'Hana summer exhibition of impressionist and postimpressionist masters, these two men, posing as art lovers or collectors, had mapped every step and second of their route. They had observed that the gallery, a former squash court belonging to the duke of Westminster, gave onto a sunken patio which split the exhibition hall into two sections — one for oil paintings, the other for watercolors and pastels. The would-be 'collectors' had a choice of pictures — a good dozen Renoirs, a mixture of Picasso, Braque, Vlaminck, Utrillo, and other twentieth-century masters. They even had a fair notion of auction prices for such canvases. They knew Jacques O'Hana had insured his own paintings and those on commission. And they had read that O'Hana had described his gallery as 'a little fortress.' But on this occasion they had no intention of going through the fortified front door in Carlos Place; they would use the back door.

One of their men had slipped through the side door of Mayfair House, a block of flats, before the caretaker locked up at ten o'clock. Their van screened this side door as the man let them in and led them up the spiraling fire escape. Everyone wore tennis shoes. On the first floor they forced a door on a landing, giving them access to a flat roof; they edged past three skylight windows, then inched on their bellies along a parapet before dropping on to the gallery roof; from there, two gang members lowered themselves into the sunken patio level with the exhibition rooms. Even overlooked by hundreds of lit windows, the men worked methodically. First they wrenched open both doors leading to the right-hand gallery and identified the pictures from the catalogue they carried. They removed twelve pictures from their frames on the spot, while they took the other twenty-three as they stood. The gang ferried three or four paintings at a time over the roofs to

91

the van. The operation had lasted just under three hours when the men hoisted their two mates onto the parapet and slipped away.

From the precision with which the thieves had worked, detectives had no doubt they were dealing with top-class professionals. Twelve Renoirs had vanished, all valuable paintings — especially the nude, *Andrée Assise*, sold not long before from the Somerset Maugham collection. Two splendid landscapes by Monet and Sisley were gone, and a Vuillard, *Misia at the Piano*, recently auctioned for £23,500 at the Alexander Korda sale. Altogether the thirty-five canvases would have fetched more than £400,000 in public or private sales.

Aware of this, the thieves had handled the pictures as meticulously as a restorer, with not a hint of damage to the frames and glass panes. No fingerprints either. Nothing more than the impressions of tennis shoes. And no one, either among the public or underworld 'grasses' (informers), could help police trace the gang.

Jacques O'Hana, the sixty-two-year-old gallery owner, scoffed at the idea that the robbery had been commissioned by a lunatic collector with a private museum. However, he did fear his paintings might find their way to one of those locales where the British police and Interpol had little influence — South America, Cuba, or one of the Eastern Bloc states. For the first time in forty-two years of art dealing he had received a request for a catalogue from Prague, Czechoslovakia, which made him wonder if a new market in illicit art had started. Scotland Yard shared these misgivings, alerting all seaports and airports and circulating pictures and captions for the missing thirty-five canvases through Interpol.

O'Hana, born in Casablanca but a naturalized British subject, had spent most of his life moving around the art world — in New York, Paris, London. He knew all the big dealers and how the illegal art traffic worked, having recently unmasked a series of art forgeries in France. Well-known paintings like those Renoirs would never sell, even privately, and the same applied to Monet's *La Rivière Près de Moret*, Boudin's *Dunkirk Quay*, and Sisley's *Banks of the Loing at Moret*. But the Vlaminck landscape and the

92

*Renoir Nude taken in O'Hana raid. (The Press Association Limited, London)*

Picasso (he had painted so many hundreds), the Chagall, the Roussel — they might lie in a Swiss bank vault for several years until forgotten or beyond the law, when such-and-such a shady dealer might filter them into the private market or try them at small, inconspicuous auctions.

Since the raid bore some resemblance to the Saint Tropez theft, Scotland Yard thought it was a ransom job. So did Laurence Grayston, head of the insurance adjusters handling the loss. He issued a reward of £20,000 for information leading to the recovery of the missing art works and the arrest and conviction of the thieves. This broke the silence. Just two weeks after the operation, when the police trail had gone cold, a whisper came to Grayston, who passed it on to the police. Of course, detectives had heard something like the informer's pitch before; and over the years it would become something of a refrain. Invariably it went something like this:

> I'm sitting in this pub, like, the King's Arms, minding my own business and having a quiet jar tonight when in come these couple of geezers and order two large nips and two chasers and plank themselves down the other side of the glass screen from me. I hear them chayacking about this and that — the gee-gees, the pal they have doing eighteen months in stir. Then one of them drops something about this tickle they've just pulled with a couple more pals. It's about pictures . . . art pictures . . . and since I read about that gallery in Mayfair that was done I bend an ear. They're talking soft, like, but from what I catch they've left a couple of pals looking after the loot in the East End in a loft at such-and-such an address. What'd they look like? They drank up quick and left before I could size them up or get even a quick shufti. But they were . . . well, just two ordinary blokes. Nothing much I could say about them.

On July 27, following up the tip-off to the assessors, two Scotland Yard men went to a house in the East End of London; there, on the top floor, two men were guarding three bulky packages that lay under a divan bed. Unwrapping the blankets around them, the policemen found the thirty-five O'Hana Gallery paintings. Both men denied knowing what the packages contained. One of them,

a thirty-five-year-old wholesaler, said to the detectives, 'Do you think I have the money to buy these?'

'Were you minding them for somebody?'

'Look, it's my responsibility,' the wholesaler said. 'I don't want to say anything about that. I have an idea who it was, so leave it to me to fix it up my own way.'

Questioning the other man, an unemployed laborer aged thirty, one of the detectives asked, 'Did you bring the paintings here?'

'What do you expect me to say? We're both in trouble. Do you think I'm going to make it worse?'

Neither man would name members of the gang that had landed them with the hottest pictures in the art world and a charge of receiving stolen property. Unwittingly, both petty crooks had helped the Mayfair raiders complete the ingenious plan they had concocted long before the robbery. Unless somebody 'narked,' who could connect the informer with the robbery? And since the police had arrested and charged two men, they could not object if the insurance loss adjusters paid that same informer the £20,000 reward. It was foolproof. A chef-d'oeuvre.

However, at their trial a judge and jury agreed that if indeed they did not have the purest intentions, both men had acted in ignorance, duped by the gang. They walked out of court free, considering themselves lucky. As for the art stealers, they had devised a painless way of extracting money from insurance companies while keeping within the technical meaning of the law; but this slippery method became too much of a good thing for the Scotland Yard fine-arts squad, for the Director of Public Prosecutions, and for the House of Commons, which eventually had to counter the scheme by placing a new Theft Act on the statute book.

# 6

## Madonna among the Playboys

So much din did the open truck make going uphill through the vineyard on a gunned engine that it woke several families in Volkach village. Deaf as he was, seventy-two-year-old Philipp Jäcklein, sexton of the Maria im Weingarten chapel, heard the noise and stirred. Five o'clock on his bedside clock. Who would kick up such a row at that time in such a quiet district? Yet he did not connect the noise with his church. Anyway, the mongrel sleeping at the foot of his bed would have barked at any unusual movement next door. He went back to sleep, though not for long. His daughter, also roused by the revving engine, came to shake him, saying the thing worried her. Sexton Jäcklein rose and dressed, thinking he had, in any case, to prepare the church for early-morning mass. Entering through the side door, he first noticed the main door ajar. His eye went to the huge bare patch by the window behind the altar. Their Madonna was gone! The most sacred object in the church had vanished! On the flagstones round the altar he even spotted a few fragments of the carved rose garland that surrounded the Madonna and the infant Jesus. Calling his daughter, the old man pointed mutely at the vacant space. Neither could believe it. How could a relic that attracted thousands of people from every part of Germany and abroad just disappear?

96

Together they began to search and found other bits of the sixteenth-century wood sculpture — a broken angel's wing, half an arm, and more fragments of the wreath. At that moment the sexton realized that two other treasures had been stolen with the *Madonna im Rosenkranz* (Madonna with the Rosary). Another wooden sculpture dating from the same period, representing St. Anne, the Virgin and Child, and a Pietà by an anonymous fourteenth-century French sculptor. Jäcklein sent his daughter, Frau Gabelmann, to ring the police; he sat down in the church and wept.

For nearly four hundred years the *Madonna im Rosenkranz*, that marvelous limewood sculpture, had hung over the choir stalls. Oval in shape, more than nine feet high by six feet across, it depicted the Virgin Mary, surrounded by angels and holding the infant Jesus in her arms; in the baroque garland framing the holy pair, five carved medallions portrayed New Testament scenes. One of the latest and best works of the great German Renaissance sculptor, Tilman Riemenschneider, it was revered as a superb piece of art as well as a sacrosanct symbol. Throughout devout Catholic communities in southern Germany its loss would be felt like a family death.

Within an hour detectives arrived from Wurzburg and began their investigation. Obviously it had taken more than one man to

*The floor of the chapel in Volkach after the theft. (Süddeutscher Verlag Munich)*

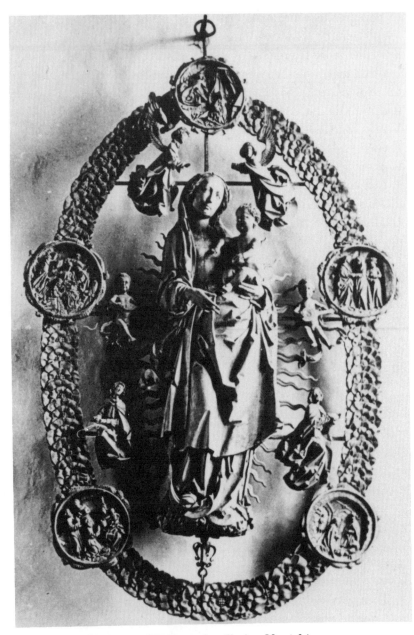

*The restored Madonna. (Süddeutscher Verlag Munich)*

lift and transport those heavy objects. An open back window suggested that someone had climbed through to let his accomplices in at the main door. To dismantle those heavy wooden carvings must have involved carpentry skills, a ladder, and several hours of work; to transport them, the thieves must have used a truck of some sort. And from their choice of relics it looked as if some careful planning had gone into the raid, which might mean the gang had a ready market for the religious carvings. But where in Germany could anyone dispose of a rare masterpiece like the Riemenschneider *Madonna*, known to every churchgoer? Even altered, no one would buy it.

Such logic led the detectives to hunt for foreigners. Soon they picked up two Scotsmen, a student and a scientist, carrying what they claimed were tools for geological research. Moreover, they had tickets for the Maria im Weingarten church, and witnesses had spotted them there with a tall, well-built man who had studied the *Madonna* at length. But laboratory tests proved they had nothing to do with the theft. Neither they nor their car bore traces of the chemicals used to treat and preserve the wooden statues. On August 11, 1962, four days after the theft, the police offered a 3,000-mark reward (about $1,600) and the town 10,000 marks ($5,400) for information about the stolen objects or the thieves. Christian communities all over Germany prayed for the return of the *Madonna* and the other relics. A well-known clairvoyant, Milo Renelt, aged fifty-eight, came from Hamburg to sit in the church, eyes shut, fingers exploring pictures of the sculpture. He felt they had already crossed the frontier. 'Their buyer lives beyond the mountains,' he murmured. 'Perhaps in Switzerland.' He drew sketches of a town and described three men by age, profession, and appearance. They had used a flat truck, dark-gray, with no number plates. They had made a lot of noise.

'Then why didn't the dog bark?' someone asked.

'I don't know. I hear only their noise in the church,' he said. 'The statues will be returned within a month.'

Two statues did turn up seventeen days after the theft, discarded in a Frankfurt cathedral square 120 kilometers from Volkach;

but these sculptures had so little value that the church authorities had overlooked their loss with the other relics. It confirmed police suspicions that they were dealing with a professional gang who knew the worth of their haul and were trying to throw them off the scent. Every sign pointed to a band of men who specialized in robbing small churches and chapels in southern Germany, concentrating on medieval carved-wood statues. For some years churches had reported pilfering of their art works and relics; but not until the Bavarian and Hesse police began hunting the Riemenschneider thieves did the scale of these church thefts become evident. Six weeks after the Volkach raid, in the same area and from a similar church — the Walpurgis Chapel in Forchheim district — four more religious statues worth more than $20,000 were stolen. It appeared an organized gang was trafficking in these church treasures, stealing and altering them so that they could be filtered into antique markets in Central Europe or even exported through France and Belgium to Britain and the United States, or east through countries like Yugoslavia and Greece to Turkey and the Near East. German police discovered that the gang had bases in Bayreuth and Nuremberg, where expert workmen took and converted stolen religious statues to disguise their origin and fool amateur collectors and antique dealers. A skilled cabinetmaker could transform a St. Peter into a St. Francis, split up groups of figures and doctor them to sell separately, or even amalgamate faces and heads of different saints. Wood sculpture lent itself to such treatment more than other art works, so police and church authorities feared the garlanded *Madonna* and the other missing religious objects had perhaps fallen into the hands of men who would not hesitate to compound their original crime by committing artistic vandalism and sacrilege.

Henri Nannen, editor in chief of the mass-circulation Hamburg picture magazine *Stern*, was one of the men concerned for the *Madonna*'s survival. After two months, with the police obviously getting nowhere, Nannen decided to act alone. He realized the gang had limited room for maneuver, for no one would buy the *Madonna*; and, since it was uninsured, they could not demand a reward. Therefore Nannen offered them a straight, no-questions-

asked deal — 100,000 Deutschmarks ($54,000) against the *Madonna*'s return.

At 2:30 A.M. on October 25, nearly three months after the theft, Nannen's telephone rang, and his wife picked up the bedside receiver. A polite voice said, 'My name is Leininger. Excuse me for disturbing you so late, but if you give your husband the phone he'll agree it's important.' Leininger's whispered message jerked Nannen out of his sleep. He offered nothing less than all the Volkach booty for the 100,000-mark reward. However, he threatened that if Nannen refused the offer, the thieves for whom he was acting as go-between would smuggle the three art treasures abroad and sell them. They had already thought of Switzerland or America. If Nannen agreed, they wanted two lots of old notes — half the reward for half the stolen articles, the rest when they handed over the *Madonna*. Any attempt to contact the police or identify the thieves and no one would ever see the relics again. Nannen agreed to the terms. An experienced editor in his middle fifties, he understood the risk of consorting with crooks; it might land him in trouble with the police and federal prosecutor for aiding and abetting criminals and as an accessory after the fact. But what a scoop! When Leininger called him again a few days later from Munich they arranged the handover.

At just after midnight on October 26, one of *Stern*'s editors, thirty-nine-year-old Reinhart Hofmeister (he called himself Herr Holl) walked down Stresemannstrasse in the center of Hamburg to a steamroller. In its right-hand front wheel he placed a bundle of notes. Then, following Nannen's instructions, he walked to a furniture van parked nearby. On the driver's seat lay two of the three art works stolen from the Maria im Weingarten church.

However, the *Madonna* still remained in the thieves' hands. Again Leininger rang the *Stern* editor, this time from Nuremberg. Hofmeister set out on another trip, to a spot in open country outside Nuremberg. With him he had the second payment, 50,000 marks, wrapped as instructed in a white sheet. His flashlight picked out a pile of cabbages, under which he placed the money. Crossing the open field to a prearranged spot he found the *Madonna*, wrapped in another white sheet.

*Henri Nannen and the Rev. Simon Himmel before the restored Madonna, holding one of the five medallions of the rosary. (Süddeutscher Verlag Munich)*

On Leininger's orders, *Stern* had to wait two weeks before announcing the news of the *Madonna*'s return. When the magazine did, it set church bells pealing and convoked prayer meetings throughout Germany. Only the police and the justice ministry did not join the celebrations; they read the magazine account of the robbery and recovery of the statue with bitterness sharpened by the fact that Nannen had made the most of his part in saving the *Madonna* and neither could nor would tell them anything. Rhineland magistrate Joachim Suchland charged the editor with abetting criminals, affirming that the reward money would enable them to commit more and bigger crimes. And it did seem that their success had emboldened the church thieves. After the *Madonna* theft and its sequel dozens of churches were ransacked and their relics, statues, ex-votos, and altar gold and silver stolen. Public concern over the Volkach raid and church pillaging forced the federal police to establish special squads to prevent or track these art crimes. Chief Inspector Karl Berger became head of the Bundeskriminalamt art squad. In his office one file stayed open — the Riemenschneider *Madonna* case. It might take time, but they would find those thieves.

In fact, it took five years before they had the slightest hint of breaking the case and nine years before Berger could close that file. His team had little to help them. They had one clue.

102

When the *Madonna* was returned, her wooden figure as well as that of the infant Jesus had been covered with a mixture of shoe polish, beeswax, and gelatin to protect it from the damp when the thieves had buried it. Like the dismantling of the statues, this appeared to be the work of a skilled craftsman or sculptor — someone clever enough to know medieval wood carving, perhaps to doctor statues and figure in the illicit traffic of religious objects.

Another clue came to the attention of Berger and other detectives hunting the church thieves. Two police inspectors, Eduard Schmitt and Gerald Vorg, reported that strange things were happening in the Bavarian town of Bamberg, not far from Volkach. A mob of about a dozen men, who did not appear to have regular jobs, were living it up like millionaires. One of them, a thirty-five-year-old sculptor and painter, Franz Xavier Bauer, had just paid a hefty fine for being drunk and disorderly. Where did a freelance wood sculptor get this sort of money? Also, he kept curious company with the living-for-kicks crowd. Indeed, Bamberg's hard-drinking, high-living, big-spending playboys kicked up such a racket that local burghers filled the police complaints book with their exploits involving local call girls and prostitutes, wild parties, and midnight prowling after sexual and other adventures in Buicks, Chryslers, and even Cadillacs. Several of these playboys called themselves car dealers, car salesmen, and car hirers; yet their drinking sprees and sex parties cost more in a week than they could have earned in a year in the car trade.

In August 1965 a raven-haired Polish call girl, known in Bamberg as Black Ilona, came to lodge a complaint with the police. Already they knew that Ilona's nubile figure and accommodating ways had made her quite a reputation in the district. But at some things she drew the line, she said. She had allowed several of her customers to persuade her to pose for pornographic action pictures and blue films. Most men kept these to themselves; but this Bamberg gang was passing the photographs around, selling copies and holding film sessions with her as the reluctant star. One name among those of Ilona's clients intrigued the police — Franz Xavier Bauer. He kept company with another free-spending client, Manfred Röschlaub, a salesman known to the police for having served

three and a half years in jail on charges of incitement to perjury and procuring an abortion. Their names and several others came up during what was known as the Bamberg Playboys case, in which Ilona played the star witness; her graphic narrative of the gang's sexual activities made headlines in the national press and interested Chief Inspector Berger and detectives hunting the Volkach raiders.

From that moment they stepped up their surveillance of the Bamberg playboys, who seemed to take orders from two men — a flint-eyed but handsome thug called Lothar Geheb, a glutton for schnapps and women, and the gangleader, a wavy-haired man-about-town called Alfred Vogler. These two were first suspected of masterminding a racket in smuggling stolen cars with false papers across Europe, through Greece into Turkey, where they were sold. That accounted for the proliferation of car dealers in Bamberg. Turkish police suspected them of smuggling small arms into the Near East. And their names appeared to be linked with several post-office and savings-bank robberies in the Bamberg district, including the Gaustadt branch of the Bamberg savings bank. But the detectives lacked proof of these crimes; they also wondered about the activities of Bauer, Röschlaub, and another man, Wilhelm Kreyer, a carpenter turned car salesman, all of whom had associations with Geheb and Vogler. Only when two burglaries occurred in the district council offices of Ebermannstadt and Bamberg did the police gather enough evidence to hunt for Kreyer, who fled across the frontier into Italy. Arrested by police in Trieste, he confessed his part in the Ebermannstadt robbery, then blabbed to the Hamburg sailor who shared his cell about the *Madonna* theft in Volkach. With that information the sailor gained his liberty, and Kreyer was brought back to Bamberg and interrogated with little ceremony until he named the men who had committed the *Madonna* raid and their accomplices — nine altogether.

One by one, detectives picked up the gang. All except Vogler. Somehow he had got wind of the leak and, using two of the passports, in the names of Herr and Frau Stocker, stolen from Ebermannstadt council, he had fled to Turkey with his wife and child.

Already, he and Geheb had formed a car-sales company there. Besides Geheb, Bauer, Kreyer, and Röschlaub the police arrested a young hoodlum named Hermann Sterr, aged twenty-three, who had figured in several burglaries, Otto Popp and his wife, Rosemarie, who had handled some of the gang finances, Neinz Höffman, thirty-five, and Hubert Cwienk. Several of them, like Geheb and Kreyer, had been trained as cabinetmakers before Vogler recruited them. Working to Bauer's designs, they converted and sold the church relics and statues stolen by the gang. And this V-gang — so-called after Vogler — probably numbered two or three times as many as were arrested. With Vogler, the others went into hiding.

Several days before the first trial in March 1968, Hermann Sterr created a sensation by breaking out of Bamberg prison and crossing the frontier with stolen papers. Two hundred people crammed into the small courthouse to gaze at the seven men and one woman in the dock, and the *Madonna im Rosenkranz* with the two other sculptures. Six TV cameras and two dozen reporters covered the event for a whole week.

Geheb described how he and Vogler had committed the robbery. Before driving to Volkach he had entered a Bamberg winehouse and, in one hour, drank nearly a liter of white wine, four brandies, and four or five glasses of beer. 'Then you couldn't carry out the crime since you were blind drunk,' Judge Georg Dotterweich remarked. Geheb denied this. He had climbed through a window to open the door for Vogler; it took both of them working flat-out four hours to dismantle the statues. When they got back to Bamberg and met their accomplices, Bauer, the sculptor, gave one look at the Riemenschneider *Madonna* and cried, 'God willing, you'll never sell that anywhere.' That day's newspapers bore him out. Flaring headlines and pictures of the statue made it so hot that nobody in Germany or beyond would touch it. Bauer pleaded with Vogler to return it, but the gangleader dismissed the idea. He would find an American buyer. 'No, dump it somewhere,' Bauer insisted.

'I'd rather burn it,' Vogler replied. 'If I don't get a million [marks] for her I'll saw her in pieces.' He meant it.

105

'I'll hang it in my living room,' Röschlaub suggested.

Vogler did not find this amusing. 'We can smuggle it to South America and sell it there,' he said.

Bauer the painter-sculptor-restorer had another idea. 'I can rig a cloak round it to disguise it,' he said. He had transformed dozens of other stolen figures like this.

Nannen's offer saved the *Madonna*. Geheb contacted the editor, giving the name Leininger, then with Bauer and Röschlaub collected the 100,000 marks which they divided. At the same time, he sold his story to *Stern* under the pseudonym Leininger. Nannen, a balding, bespectacled figure had an uncomfortable session in the witness box; but finally they dropped the charge of abetting criminals. One concern alone motivated him — saving the *Madonna*. 'Recovering the work of art meant more to me than betraying the police,' he told the judge. Leininger had at first demanded 300,000 marks, but came down. Hofmeister, who wrote Geheb's story, told how the gangster had drunk most of his cellar dry, then threatened his family, hinting that one word to the police would endanger the journalist's daughter.

All eight persons were found guilty, and most received heavy sentences. Geheb got six years and one month; Röschlaub, who confessed to other crimes, six years; Cwienk, three years and nine months; Kreyer, two years and six months; Hoffman, a year; Otto Popp, one year and six months; his wife a 700-mark fine; and Bauer, nine months.

Two and a half years later, Turkish police carrying out a routine passport check on camping sites around Istanbul came across Herr Stocker. They discovered that Interpol was looking for him under the name of Vogler and reported this to the German police. Within a week Vogler was back in Bamberg, and in January 1971 the *Madonna* trial took place all over again, most of the gang appearing with Vogler. As the long court case proceeded, it became clear that Vogler had organized in Bamberg a crime syndicate reaching into every part of Germany, with ramifications abroad. From church thefts like the Riemenschneider *Madonna* they had netted more than two million marks (about $1 million), stealing and faking every sort of religious object. Bauer tipped off Vogler and

106

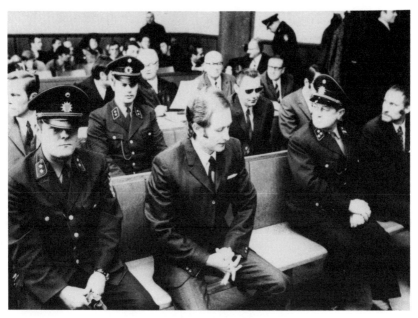

*Alfred Vogler in the dock. (Süddeutscher Verlag Munich)*

Geheb about the churches and items to steal, then remodeled them for seemingly legitimate sale through German and foreign antique dealers. Vogler's versatile band tried everything; they held up savings banks and burgled council and passport offices to steal personal and car papers and official stamps, which they used for their smuggling racket along with cars, weapons, and ammunition. Had they not overreached themselves and ransacked the Volkach chapel, they might never have been caught.

Vogler got nine years and Geheb had his sentence lengthened to nine and a half years. Bauer too drew a longer sentence — three years instead of nine months. However, Röschlaub was released after serving two years, his accomplices testifying he had taken little part in most of their crimes.

That trial embarrassed hundreds of German and middle-European antique dealers who had unwittingly bought religious statues doctored by criminals like Bauer and others who were never caught. For years afterward, people stumbled across church statues obviously dumped by thieves following the Bamberg trial. To the devout — or superstitious — it seemed the Madonna with the

Rosary had offered herself as a hostage and made some divine intervention to put an end to criminal sacrilege. Even hardened crooks like Franz Bauer, who had perverted his talents as a sculptor, discerned something ominous in the violation of Riemenschneider's Virgin and Child, revered by so many millions.

Now protected by the latest electronic sensors and burglar alarms, the *Madonna* is back in Volkach, where she has hung for nearly four centuries.

# How a Dali Duped Dali & Other Artful Dodges

In Salvador Dali's fantastic and visionary world anything can happen. But not even the Spanish master could ever have imagined the strange convolutions in the story of one of his own paintings. It started toward the end of May 1970, when Dali was sitting in the lounge of the Hotel Meurice across from the Tuileries Gardens in Paris. A man approached and introduced himself. He gave his name as Howard S_____, with addresses in New York and Jerusalem. He spoke good English, French, and a little Spanish. In a small package he carried a painting on an eleven-by-fourteen-inch wooden panel, which he had just bought. He showed this to Dali, remarking that the artist had not signed it. Would Señor Dali assure him the painting was authentic? And, if so, would he sign it? Dali perceived nothing unusual in the man's request. Dealers and collectors often had him verify and sign paintings they had acquired, for so many daubers tried to counterfeit his masterpieces! And this Howard S_____ spoke with polyglot eloquence about the genius of Dali and the painting he had admired for so long.

Dali took the painting and looked at it with obvious pleasure. It showed two grotesque, misshapen women confronting each other on a barren terrain with its lines fleeing to infinity; behind them

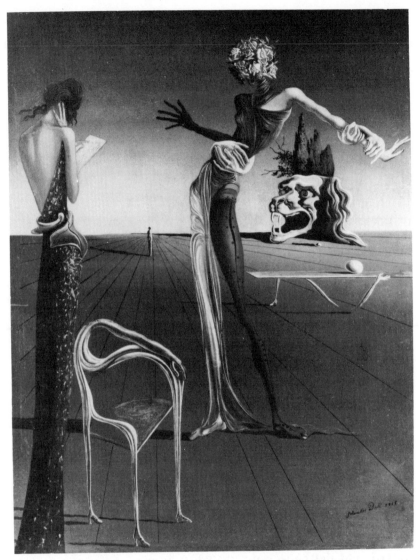

*Salvador Dali,* Femme à la Tête de Roses. *(Kunsthaus Zürich)*

stood a grinning ogre. One of these bizarre women had her head and face completely obliterated by roses. Dali's famous mustache quivered like an antenna as he gazed at the scene. He had painted the picture in 1935 and called it *Deux Femmes* (Two Women) but had later changed the title to *Femme à la Tête de Roses* (Woman with Roses for a Head). He confirmed it was his work, then sighed, saying he had always regretted parting with it. It was his favorite painting. But then all Dali's paintings were his favorites, as Howard S____ probably knew only too well. He immediately suggested that if Señor Dali felt that way, he would sell him the painting for no more than he had paid — $20,000. All the sales certificates establishing the pedigree satisfied Dali and his manager, so the artist bought back his own painting. Nobody noticed the strip of wood missing from the upper-left-hand corner.

Eleven months later a new gallery opened in avenue Matignon, center of the Paris art world. Wally F. Findlay had decided to exhibit Salvador Dali's art jewelry for his first show; but Dali also arranged to lend one or two paintings, among them his *Femme à la Tête de Roses*. For the occasion, *Vogue* sent a photographer who took celebrity pictures, which appeared in its issue of June–July 1971. On June 16, Frau Frieda Grandjeans, a woman professor who lived in Zurich, was leafing through *Vogue* when her eye caught the blurred outline of the Dali painting; she recognized it immediately, for fifteen years previously she had owned that Dali. Furthermore, she knew that it had been stolen from the Zurich Kunsthaus and belonged to the Zurich Art Patrons' Association. She phoned the gallery and soon the Swiss police were looking at the vague outline of the Dali.

They too knew the story. On November 10, 1968, a man had walked into the gallery during the afternoon, pressed the panel out of its frame, and walked out with it under his brown velvet jacket. An Interpol notice described the thief as a tall, young man with long, blond hair, wearing blue jeans and suede shoes and appearing nervous. But this publicity and a reward of 10,000 Swiss francs (about $5,000) had elicited nothing. Now, with this new lead, the Zurich police contacted Interpol, who in turn alerted the Paris art squad; its head, Commissaire Jacques Mathieu went

111

## OBJET VOLÉ

**Objet : Vol d'un tableau.**
**Date du vol : 10/11/1968.**
**Pays : Suisse.**

Dans l'après midi du 10/11/1968 à Zurich (Suisse), un inconnu a dérobé un tableau signé Salvador Dali 1935, au préjudice de l'association zurichoise des amis de l'art. Le tableau a été sorti du cadre en bois par une légère pression de la main ou au moyen d'un outil indéterminé.

Il s'agit d'une peinture à l'huile (voir photo ci-jointe) surréaliste "Femme à tête de roses" 27 × 35 cm. sur plaque en bois de 6mm. d'épaisseur signée Salvador Dali 1935. Sa valeur est évaluée à 90.000 F suisses. L'auteur présumé du vol en question a le signalement suivant : Homme, âgé 22 ans environ ; taille 175-185 cm, corpulence svelte, cheveux blond-clair, ondulés enroulés sur la nuque, tombant sur les épaules, nez légèrement argué, moustaches et barbe naissantes, visage mince, probablement porte une veste de daim ou de velours brun (western style) ou manteau gris et brun court, façon vague, probablement chemise blanche ou bleu-clair, ihitialesbrodées "CM" ou "MC", éventuellement "GM" ou "MG", pantalon très étroit, éventuellement blue-jean bleu, chaussures de daim brunes à semelles en caoutchouc brut; allure nerveuse.

Prière d'aviser : GALERIES, SALLES DE VENTES, ANTIQUAIRES, MAISONS DE PRET SUR GAGE, MUSEES, SERVICES DES DOUANES ..

*MOTIF DE LA DIFFUSION :*

Effectuée à la demande des autorités SUISSES en vue de découverte ou de renseignements. En cas de découverte ou de renseignements concernant cette affaire, prière d'aviser : Bureau Central Suisse de Police, 3003 BERNE (INTERPOL SUISSE) ainsi que l'O.I.P.C.-Interpol, Secrétariat Général, 26, rue Armengaud, 92 / SAINT CLOUD (INTERPOL PARIS)

*O.I.P.C. PARIS*
*Janvier 1969*
N° du dossier : 1234 | OV | 706 | 68
N° de contrôle : B. 1028

## STOLEN

**Subject : Theft of painting.**
**Date of theft : 10th November 1968.**
**Country : Switzerland.**

During the afternoon of 10th November 1968 in Zurich (Switzerland), an unidentified person stole a signed oil painting by Salvador Dali (1935) from the Zurich Art Patrons' Association. The painting was removed from its frame with an unknown instrument or slight pressure of the hand.

It is a surrealist painting entitled "Woman with head of roses" oil on 6mm-thick wood, 11" × 14", signed "Salvador Dali 1935". It is valued at 90,000 Swiss francs. The person suspected of stealing the painting answers the following description : 5'9" to 6'1", slim build, wavy blond hair, curling round back of neck and falling on shoulders, slightly hooked nose, hint of moustache and beard, thin face ; he is thought to have been wearing a suede or brown velvet jacket (western style) or a short flared grey and brown coat, white or pale-blue shirt embroidered with initials "CM" or "MC" or possibly "GM" or "MG", very narrow trousers or possibly blue jeans, brown suede shoes with crepe soles. Looks highly-strung.

Please inform : GALLERIES, SALES ROOMS, ANTIQUE DEALERS, PAWNBROKERS, MUSEUMS, CUSTOMS AUTHORITIES etc ...

*REASON FOR THIS CIRCULATION :*

Done at the request of the SWISS authorities for recovery or information. If found or anything be known of this matter please inform : Bureau Central Suisse de Police, 3003 BERNE (INTERPOL SUISSE) and also the I.C.P.O.-Interpol, 26, rue Armengaud, 92 / SAINT CLOUD (INTERPOL PARIS).

*I.C.P.O. PARIS*
*January 1969.*
File N° : 1234 | OV | 706 | 68
Control N° : B. 1028

*Interpol circular on the Dali theft.*

to the Findlay Gallery where at first no one would believe they were exhibiting a stolen painting, and certainly not that painting. Madame Simone Karoff, director of the gallery, assured the commissaire that Dali himself had procured its loan, having recently sold it to an American publishing house. But soon a Zurich lawyer and a restorer who knew the picture flew to Paris with a missing fragment from the upper-left-hand corner which fitted the wood panel exactly. When they returned, the painting went with them for restoration and restitution to the Kunsthaus Gallery.

Painstakingly, the Zurich police tried to piece together the real pedigree of the painting. All the papers produced by Howard S_____ were faked, like his own credentials. Dali's painting had belonged to Swiss collectors between 1942 and 1968, when it vanished. Swiss police circulated descriptions of the thief and the mysterious Howard S_____ of New York and Jerusalem. But like so many objects and subjects in the chiaroscuro art world, they had disappeared. Salvador Dali was the loser, having paid $20,000 for his own stolen picture only to part with it for nothing. He badly wanted to see *Femme à la Tête de Roses* again at the huge retrospective exhibition which filled the top floor of the Pompidou Center in Paris during the first months of 1980. But wheedle as he might the organizer of the exhibition, Daniel Abadie, could not persuade the Zurich museum to part with the painting a second time.

Howard S_____ showed that touch of genius many art thieves and dealers employ in unloading their stolen loot on the unsuspecting; they know most artists have a weakness for their own work. Others play on the fact that almost everybody has a collector's instinct and few people can resist a bargain. Corot painted about four hundred pictures in his lifetime and (as a cynic remarked) eight hundred of them are in the United States. So wealthy Americans become targets for the con man. Those making the rounds of the Paris art galleries or better antique shops often find themselves conversing with a glib-tongued, well-groomed young man who knows all there is about art, ancient and modern. Now, if he had the money — the young man will sigh — there's the art snip-of-

the-year at So-and-so's château. You've heard no doubt, his son's having to sell to meet estate duties, taxes, and debts. Before the day is out, the American is viewing a gallery of good paintings by Modigliani, Vuillard, Vlaminck, Bonnard, and maybe even Manet. Why should he doubt their provenance since he's looking at them in a rundown château complete with a valet and other retainers and fitting his guide's description? Moreover, he can call his own expert to authenticate the art works. As often as not he buys because the price is low, only to discover to his cost the paintings were stolen. His go-between or a crooked dealer has hired the château for the occasion and assembled a few 'extras' to play various parts in the charade.

An interesting variation on the hard-up aristocrat who is selling his art collection has caught several rich amateur collectors with a double bluff, revealing just how artful the art stealers are. Again, one of a ring of middlemen picks up the sucker and drives him to the château or stately home. Once more, the spiel hardly alters — an owner fallen on hard times selling piece by piece. On the walls hang not only a Blue-Period Picasso or an early Matisse but something superb like a Poussin, a Chardin, Le Nain, Frago-nard, or Georges de la Tour. Of course, the price seems steep, but for a quick cash sale only half what such art would realize at auction or along the avenue Matignon. Finally persuaded, the collector prepares to pay, but there is a slight pause in the trans-action. 'You see, Monsieur, there is this little snag. Les douanes — the customs — they will arrest this famous painting as part of the national patrimony. And even if they let it go it will cost millions in export tax . . .'

'Then why the hell try to sell it to me?'

'Ah, but there is a way. You see, we change the gilt frame for something modern. Then we have one of our artists overpaint this chef-d'oeuvre with, let us say, the portrait of General de Gaulle. Even the customs know who he is. They let it go as contemporary art. You have your own restorer peel away the paint, and you have your Poussin.'

In so many ways, the game appeals. Maybe it's the risk of giving the law and customs the runaround or the idea of poking

a finger in the eye of authority. Anyway, it's worth a bit of cold sweat to save a hundred thousand dollars. And what a yarn when the masterpiece is snugly back in Dallas! Moreover, as the middle-man has said, the ploy works. General de Gaulle in his cheap frame gets no more than a passing nod from the French customs at the airport. Back in Dallas, the millionaire takes his picture to the restorer and watches him remove the paint, inch by inch. And as the veneer of paint vanishes beneath the solvent, he does see another portrait emerge — not the Poussin he thought he had bought, but the portrait of one of de Gaulle's successors, Valéry Giscard d'Estaing. Complain and he is confessing to having tried to break French law as well as making himself a laughing stock. Hundreds of wealthy amateur collectors have fallen for this trick.

Professional crooks have no monopoly on ingenuity. Paris art circles talk with bated admiration of the private collector who sent a fine Cézanne to be cleaned and restored; it came back too clean and his sharp eye noted that the restorer had pulled an old trade dodge, substituting a fake for the real thing. However, it gave him an idea. Why not twist the bent restorer's arm to copy all his collection. When he threw a big party or went on holiday and feared theft, he would hang them and place his originals in a bank vault. But these reproductions fooled even his connoisseur friends, and as the years passed he felt almost disappointed that art stealers shunned his fake paintings — so he arranged to have them stolen, collected the insurance, and kept his originals in the bank.

A more transparent trick brought Lady Portarlington's chauf-feur into court, charged with theft and fraud. In 1973 the chauffeur, Mitchell Henry, took advantage of his employer's great age (eighty-seven), ill health, and fading eyesight to substitute two cheap reproductions for the Canalettos in the bedroom of her Ascot home. Pretending they were a gift, he auctioned them at Sotheby's for nearly £80,000. Two years later, when Winnafreda Lady Portarlington died, the theft was discovered. Henry, self-styled descendant of Patrick Henry, the revolutionary orator who helped ignite the American Revolution, was jailed for two years

115

and ordered to pay £40,000 (about $100,000) compensation.

Detectives run out of credulity when someone claims to find an exquisite Rembrandt while rummaging through junk shops in a flea market. In 1977 a verger at one of London's most famous churches gave his boy friend an old painting he had picked up in poor condition for fifty pence (about $1.20) at a church jumble sale. Noticing the gallery label, the friend went to Christie's, where he was informed he had acquired an early van Gogh, *Paysanne Béchant*. Only it had been stolen in March 1975 from an O'Hana Gallery consignment of pictures and was going for sale at £35,000. Verger and friend spent several uncomfortable weeks before a court leniently dismissed charges of receiving stolen property.

Through vanity or cupidity, unwary collectors fall for other artful dodges. Confidence tricksters single out, say, a collector of ancient Chinese pottery, sending one of their own men with a mixed batch of goods which, however, contains some genuine jade and Persian pottery as bait. Of course, the collector's interest focuses on the glazed Ming vase; he observes how its traditional design has been painted on the glaze, how age has crazed the delicate porcelain without bleaching its colors, how it carries the Hsüan Tê mark. In his car the man, who looks like a gypsy, has other pieces — a Wan Li incense bowl and several rectangular vases, all genuine. But for those he already has customers. How much for the Hsüan Tê vase? One thousand dollars, the man says. If the collector queries its origin, the man has friends of friends among Peking or Nanking mandarins who have survived the Mao purges. Stolen? Smuggled? From Communist China, who cares? As often as not, the collector buys. Several weeks later, two men call, having heard he collects Ming. Can they see it? They admire everything, but particularly the Hsüan Tê vase. If he'll sell, they'll offer $3,500 . . . well, even $4,000. If he sells and makes a killing, the collector will find his gypsy again and buy his whole stock of Hsüan Tê and whatever; if he does not sell he'll still find the gypsy, unable to pass up such bargains. And he will finish with a whole shelf of Hong Kong Ming that has cost him a thousand times what Chinese potters are paid to make and age it in the British colony. There, dozens of small, clandestine factories spe-

cialize in copying ancient pottery, jade, and ivory antiques, which are sold for not much more than modern ornaments to gangs practicing this type of fraud. Their skill at creating and aging these fakes, coupled with the talent and cunning of the confidence men who sell them, have fooled hundreds of European and American amateur collectors and even antique dealers. One French police commissaire with a beat between Marseilles and Nice described to me how dozens of wealthy Riviera families had been duped for as much as $100,000 by these oriental gypsies with their made-to-order Ming vases and jade statuettes.

Ogden Nash made one of the wittiest and most telling comments on art rogues and their victims in his poem, 'The Collector':

> I met a traveller from an antique show,
> His pockets empty, but his eyes aglow.
> Upon his back and now his very own,
> He bore two vast and trunkless legs of stone.
> Amid the torrent of collector's jargon
> I gathered he had found himself a bargain,
> A permanent conversation piece post-prandial,
> Certified genuine Ozymandial
> And when I asked him how he could be sure,
> He showed me P. B. Shelley's signature.

With so much stolen art in circulation, auction rooms have to check their sale articles carefully. Sometimes they have their own listing of missing works, or they check with police computer records; often, however, an expert eye lights on something suspicious. Like the day in June 1969 that David Carritt, Christie's authority on old masters, was studying four small canvases, thinking their seventeenth- and eighteenth-century labels looked odd. Obviously they came from a large collection. He recognized one of the subjects, flipped through reference books, and discovered that all four canvases came from the Queen's collection. Once hung in Hampton Court and Kensington Palace, they had vanished two years before from the Lord Chamberlain's office in St. James's Palace, with two others. A dealer in Sutton, Surrey, bought them either from the thief or his middleman a few months later; he too realized they had come from someone's collection, but the police informed

him they had no record of such stolen paintings. He had expected about £700 for them in Christie's saleroom; in the end, of course, he got nothing, since British law invests the original owner with permanent title.

Another salesroom employee fell for a clever trick by three Australians, who bid nearly £9,000 (about $20,000) for four paintings; they asked the auctioneer's clerk if he would take a check for the paintings since they were flying back that night. Dubious, the man demanded proof they could cover the check. One of the Australians phoned his bank, which duly confirmed that his account contained more than £9,000. Off went the Australians with the pictures, receipts, and customs clearance forms. When the salesclerk presented the check, the account had nothing in it. Another gang member had waited for the call, then cashed another check for the £9,000 they had deposited the day before.

No auction room personnel or police computer could have detected anything amiss about the thirty-odd pictures by Edvard Munch, the great Norwegian master, as they filtered slowly through London salesrooms between 1961 and 1968; all of them bore certificates issued by no less an authority than an official of the Munch Museum in Oslo. No Munch catalogue existed to check who owned which paintings, but the Oslo certificates were considered final proof. Then, in 1968, a staff member of a London salesroom had doubts about a painting and returned it to Oslo for authentication; the deputy director of the Munch Museum perceived with amazement that it belonged to his own museum collection. So had the other thirty paintings which had netted the fraudulent official something like £500,000 (approximately $1.2 million). Had the official not gone on vacation, his crime might never have been discovered. Imprisoned for five years, he left the Norwegian government with the complicated task of tracing the buyers and persuading them to sell back the Munch masterpieces.

Most stolen art has its ancestry suitably doctored and disappears into some limbo that may have a Swiss bank number on it or turn out to be the vault or safe of some crooked dealer waiting for

the statute of limitations to expire before marketing it. Yet so much art never again breaks surface that people have speculated about a mad megalomaniac — a sort of South American Dr. No — sitting in glorious isolation gloating over a fabulous treasure of art, ancient and modern, reveling at possessing and depriving the world of this underground pantheon of masterworks. Such a man exists only in the more sensational press; if he were real he would lay himself open to a lifetime of threats and blackmail from the crooks who furnished his museum. Perhaps there are crime bosses who have a pile of stolen art — but they are waiting to dispose of it for money.

Another myth surfaces frequently — that of Paintbrush Ted (Edouard le Pinceau to the French underworld). According to legend, Ted has a special Interpol file devoted to his exploits; he is always one or two canvas-lengths ahead of the international posse, a sort of Raffles or Arsène Lupin of the art world. Ted is an American connoisseur and painter of counterfeit masterpieces gone to the bad. From California, where he began operations, he fled to Europe in 1958, leaving a fake Raphael still dripping on the easel in his luxury Beverly Hills flat. Ascribed to his mastermind are European thefts totaling more than $10 million between 1959 and 1961. He has turned up everywhere, even in South America to offer *the* stolen Goya, while it was missing (his own copy presumably), to another millionaire with a clandestine museum. But so elusive has Paintbrush Ted proved that Interpol has never even got him on file — and probably never will.

In the world of art pirates no one need invent picaresque characters like Paintbrush Ted, since so many flesh-and-blood villains exist. People like Dr. Xavier Richier, who spent his working hours palpating the livers and auscultating the chests of French and immigrant Polish miners in the Pas de Calais — and his weekends and holidays looting stately homes, mansions, churches, and museums and selling their treasures for a fortune. Quiet and diffident, Richier might have continued his Dr. Jekyll and Mr. Hyde routine until his retirement from the French state coal board had not a bulky parcel arrived, on May 15, 1964, at the magnificent St. Julian Cathedral, Le Mans, addressed to the canon and marked 'Express

Delivery.' On opening it, the clergyman discovered — to his delighted astonishment — the missing Gothic tapestry from the five-part series depicting the story of St. Gervais and Protais, the two saintly brothers martyred at Milan under the Roman emperor Nero. Perhaps some good Christian had restored this unique work to the cathedral for its saints' day on June 19? In fact, the person who dispatched the parcel from Austerlitz Station in Paris had less spiritual motives: he merely wanted to get rid of a bundle that had become too hot to handle. In doing so, he gave Commissaire Chevallier and the Paris anti-gang squad their first real clue about the crime commando who had been systematically stripping stately homes, country houses, and churches for years. That parcel wrapping led police eventually to the person who had acquired the tapestry before discovering no one could sell it or the four other pieces worth at least 5 million francs ($1.25 million). Following the trail backwards, Commissaire Chevallier finally put a name to the leader of the Manor House Gang.

On April 7, 1965, an unassuming little man strolled from the plane bringing him from his Easter holiday in Tunis. Myopic eyes behind rimless glasses, white hair, and a lined face made him look older than forty-three. Dr. Xavier Richier, son of a French cavalry colonel and physician at the nationalized coal mines in Liévin, merely shrugged when Commissaire Chevallier warned him he was under arrest for theft. Even case-hardened detectives found it difficult to believe that this tranquil, little bourgeois had organized thefts amounting to between 7 and 30 million francs ($1.5 to $6.6 million). Their exact value will probably never be known.

With Dr. Richier the police arrested his brother, Jean Richier, and his friend, Claude Mabillotte, both describing themselves as decorators. Another Paris decorator, André Huré, was arrested later. When Commissaire Chevallier and his detectives went with Dr. Richier to his small villa in Liévin, heart of France's northern coalfields, even they got a shock. In that unpretentious house — a bungalow with a mansard room stuck on top — piece upon priceless piece lay piled on each other. It looked like the storeroom of a rich but overstocked museum. A tapestry belonging to the basilica of Avesnières (and the French nation) at nearby Laval hid some

tooled, patterned leather coffers made in the sixteenth century for Henry III and Diane de Poitiers. Louis XIV and XV tables, chairs, and other furniture from mansion houses, religious statues from various churches, Napoleon vases, eighteenth-century flowerpots from museums — on and on went the list. It took a squad of policemen a full day to make the inventory and record the scene with two hundred color photographs. Who could guess how much stolen material the Richier gang had already disposed of?

Dr. Richier did not attempt to deny he had come by these treasures illegally. In his defense, he offered the Elgin Marbles gambit — he had appropriated them to preserve them from ignorance, neglect, and temporal ravages. He might only be a little civil-service doctor earning 400 francs ($800) a month for treating pit workers and living frugally in a rented house in rue Thiers, but he was a connoisseur, an art lover. These arguments left Commissaire Chevallier skeptical. He might have believed that a doctor living in a dreary, misty plain surrounded by miners' row houses, his horizon broken by dozens of black coal-slag pyramids, had developed a magpie instinct. But even that reason did not stand up. Like 99 percent of art thieves, Richier was doing it for money. His brother and Mabillotte committed the burglaries with him and on his orders; as trained cabinetmakers they then altered the best pieces and obliterated identification marks to disguise the original source and infiltrated them into the Paris art market; those priceless objects that might be traced they smuggled abroad and sold.

Who knows how much the Richier gang stole, or how long they operated? On his admission, the gray-faced little doctor had robbed and pilfered throughout northern France — in manor houses, churches, cathedrals, and museums — for two years; he had stolen furniture, statues, tapestries, clocks, vases, chairs, chests of drawers, silver, and jewels. A cool customer, he even described how he had carried off a piece of antique Marseilles pottery from Arras Museum under the curator's gaze, posing as a member of the TV crew shooting a program on the museum. He confessed to having operated in the duc de Luynes's country house, La Cerisaie at Montsoult, in the château of Corbeville belonging to Madame Jacques Fath, and many others. He filled his little Renault at week-

121

ends with chandeliers from churches or statues from cathedrals and cased mansions and religious buildings for himself and his accomplices.

However, like so many thieves, he overreached himself; his eye fastened on the St. Julian Cathedral tapestries in Le Mans; he thought they would never miss one, since they lay in the cathedral vault between exhibitions. In December 1963 he burgled the cathedral and stole a tapestry. But this theft led to a nationwide police hunt, and Richier held on to the prize for six months before selling it to a Paris antique dealer. Identifying it as the lost Le Mans tapestry, this man took fright and posted it back — and Richier was lost.

It took years to unravel Richier's malpractices and restore some of the stolen goods to dozens of owners by publicizing descriptions and reproducing pictures in the press. In the dock at Pontoise, the gang confessed to eighty thefts — but eventually they had lost count. Of an estimated $6.6 million of stolen art works only $1.8 million worth were recovered. Much of this loot had gone abroad, where antique dealers and collectors had brought a fair proportion in good faith.

Richier and his gang were only one of many bands pillaging châteaux and churches throughout France. Such thefts, increasing since the war, became epidemic in the sixties, an era of prosperity under Gaullism when bourgeois and businessmen, with ready cash and their traditional terror of inflation, bought expensive period pieces without asking too many questions. Country-house gangs took full advantage. They ransacked the Château de Broglie belonging to a Gaullist cabinet minister; they literally crammed a furniture van full of Renaissance art from the de Gallifret stately home near Deauville. Moving south to the Paris region, they robbed Madame Hubert Menier, of the chocolate family, and the count of Villefranche. In the two years that Richier admitted carrying out his thefts, more than a hundred stately homes and manor houses fell victim to the château gangs.

In southern France too, the gangs were active. At Aix-en-Provence, a well-known antique dealer came up for trial after years of

dealing in stolen merchandise. This local celebrity, André David, holder of the Légion d'Honneur, Croix de Guerre, and Medaille Militaire, had gathered a band of secondhand dealers from whom he bought the proceeds of their robberies; moreover, he pointed out which stately homes and rich mansions contained the sorts of pieces he could sell. Again, Monsieur David produced the Elgin Marbles plea: his love for art was surpassed only by his contempt for those who owned it and did not understand its language. What was he doing but rescuing such precious objects whose language he spoke? Why then, asked the judge, had he sold some of these precious objects for which he felt such empathy? And why were three of his junk dealers making their way to his shop in his car, which was loaded with rare antiques stolen from the marquis of Castellane's château when they were arrested? Monsieur David faltered. He had the impression (he said) the three men were knocking at the front door and buying these things and did not know they were going through the windows. Age — he was in his late seventies — and the benefit of doubt told in David's favor, and he walked out of the Palais de Justice in 1972 with a suspended sentence and a $15,000 fine.

French police files bulge with the identity and activities of various châteaux gangs. One man used his job as an auctioneer and valuer of art work to catalogue the contents of stately homes, then tip off a gang of burglars to steal the best items. He was arrested in Lyon in 1976 and imprisoned. A Dutch teacher from Eindhoven set his wife up in an antique shop in Brussels; on his holidays in France, he assiduously visited churches and stately homes, guidebook in hand; his Dutch accomplices did the housebreaking, and his wife filtered the booty through her shop. Two Germans, Walter Stanek and his mistress, worked in Alsace, Lorraine, and the Jura, robbing churches and crossing the Swiss or German frontier within hours of their crime; it took months to nail them. Four police forces — in France, Belgium, Luxembourg, and Germany — hunted a band of gypsies, the Van Nieuwerkes, for more than a year before catching them red-handed. They specialized in everything from religious idols and statues to period furniture and

jewelry and darted back and forth across frontiers to avoid pursuit; once, when stopped, they opened up with rifles, revolvers, and shotguns on the Luxembourg police, then fled.

Britain has had its share of stately home thefts, one of them the strange case of the couple who stole to enjoy looking at art works themselves. Charles Garrett, a butler aged fifty-two, and his Austrian-born wife Margarethe, three years younger, had filled their house with rich possessions — all stolen. In their Roehampton home, on the outskirts of London, detectives found about £30,000 of property taken mainly from National Trust houses. One picture came from the Queen's collection at Hampton Court. Scotland Yard believed they were dealing with an organized gang when the thefts began in 1969 — but Garrett was no more than a weekend thief. He admitted forty-five offenses, pleading he had no intention of selling the stolen art, only enjoying it. He got four years. His wife had a heart attack and died soon after her arrest.

Some of the booty from these stately home thefts in Britain was thought to have found its way to the United States — perhaps in military aircraft. Two thefts took detectives to USAF bases in Britain: in 1968 more than £20,000 in Georgian silver was stolen from a country house, and a similar raid was made on the marquess Townshend's mansion in Norfolk. Two thieves admitted handing over silver to USAF personnel at one air-force base in southern England. In both these cases, police suspected the proceeds of the thefts were smuggled in the kits and belongings of the U.S. servicemen flying home in military aircraft; but they could do no more than accept assurances from the American authorities that they performed their own spot checks against such smuggling.

On the Continent and in Britain the yearly haul from stately homes and country houses runs into scores of millions of dollars; so many of these places contain valuable furniture, jewelry, and art and have little defense against the skilled housebreaker; even when the police finally catch the thieves, most of the stolen goods have already vanished to swell the illicit art and antiques market.

# The Rubber-boned Rembrandt Thief

On the last day of 1966, just after nine o'clock, Detective-superintendent Charles Hewett was sitting in his CID headquarters at Southward police station toiling over his annual crime report for the Home Office. It might have run to several volumes, for Superintendent Hewett handled one of the roughest districts in Metropolitan London; in its ten and a quarter square miles, covering part of the Thames south bank, Camberwell, and Dulwich, he met every type of crook and every brand of felony. Three rival gangs — the Krays, Richardsons, and Henneseys — controlled all the rackets, from prostitution and protection to armed robbery. And murder did not frighten them. When these mobs indulged in internecine bloodletting, Superintendent Hewett had to pick up the broken bits. As he often remarked, he had ten square miles of filth. On his books for 1966 he had no fewer than eleven murders, three of them unsolved, several big armed robberies, and more petty crime than he could describe.

Scotland Yard had good reasons for assigning Charles Hewett its turbulent M Division; it needed a detective trained in the toughest school, a murder specialist, a man above suspicion, someone who had gained the respect of hardened villains. Hewett, a Berkshire man, came from four generations of policemen and now, at

*Detective Superintendent Charles Hewett. (The Press Association Limited, London)*

fifty-three and the height of his skill, he had a distinguished record of rooting out crime without using strong-arm tactics. Dapper, of medium height, he had a volatile temperament and did everything at the double; he also had an instinctive eye for the small but significant detail that might unlock the most puzzling crime.

As he wrote his report, a knock came at the door. Detective-sergeant Reg Hazeldean entered. 'You can drop that, chief,' he said. 'They've just nicked a million and a half quids' worth of pictures at Dulwich College.'

'You're joking.'

'The gallery curator's just been on the blower. They've lost half a dozen Rembrandts and Rubens.'

Hewett tossed down his pen. 'You sure it's on our manor?' he asked, uttering the invariable heart cry of the policeman who hates crime on his own beat — and even half-hopes it has happened just across the divisional boundary on somebody else's manor. But no, Dulwich College lay on the southeast fringe of M Division. Pulling on a heavy tweed coat and a trilby hat over his thinning hair, Hewett called for a squad car; within a quarter of an hour they had broken out of the slums into the open spaces around Dulwich village; near the red-brick college they turned along Gallery Road to stop at the museum, a low Georgian structure in yellowish brick-

work that lay beside the original chapel of Dulwich College. And at first glance Hewett realized he was dealing with no ordinary gallery and no ordinary crime.

Although few people knew it, Dulwich College had the oldest public art collection in Europe and the oldest picture gallery in Britain, opening in 1814 and predating the National Gallery by ten years. However, the original collection went back nearly two centuries before that to the time of the founder of Dulwich College, Edward Alleyn (1566–1626), contemporary and rival of Shakespeare. Actor-manager of his own theater company on the south bank of the Thames and ranked as one of the finest actors of his era, Alleyn created the roles of Marlowe's Tamburlaine and Dr. Faustus. He scorned to play in any of the great Shakespearean roles; Shakespeare responded by lampooning his strut and stage swagger in several of his plays. The two men quarreled bitterly.

Acting made Alleyn's fortune, and he acquired farmland around Dulwich to become lord of the manor; in 1613 a heavenly vision inspired him to provide an almshouse for poor illiterates, and he constructed a chapel and hospital to teach twelve poor boys and house twelve poor men and twelve poor women. Known as Alleyn's College of God's Gift, this later expanded into Dulwich College, which has turned out some distinguished men, including P. G. Wodehouse, A. A. Milne, Raymond Chandler, and V. S. Pritchett. Alleyn bequeathed twenty-eight paintings to his college, among them some by Richard Burbage, the actor in Shakespeare's company who created Lear, Hamlet, Othello, and other roles. Another actor, William Cartwright, left more paintings, and the collection grew.

But suddenly, at the beginning of the nineteenth century, the collection acquired some of its finest masterpieces — all because the Poles threw out their king, Stanislas II. He had commissioned Noel Desenfans, a London art dealer, to assemble paintings for a Polish national gallery in Warsaw. Desenfans, an expatriate Frenchman, bought the best, including Rembrandt, Rubens, Canaletto, Tiepolo, Veronese, Poussin, Gainsborough. When the king abdicated, leaving Desenfans with the paintings, he had to sell many to pay his debts; yet he kept the best which, on his death,

went to his friend, Sir Francis Bourgeois, landscape painter to George III and an art collector. Bourgeois died in 1811, making a gift of his whole collection to Dulwich College which then possessed several hundred paintings, half of them masterpieces. Sir John Soane, architect of the Bank of England, designed and built a classical gallery with rooms giving off an arched central hall, lit by glazed cupolas. However, beyond that southeast London suburb, only art initiates knew about the fabulous collection. Charles Dickens obviously did, writing in the *Pickwick Papers*: 'Mr Pickwick is somewhat infirm now; but he retains all his former juvenility of spirit and may still be frequently seen contemplating the pictures in the Dulwich Gallery or enjoying a walk about the pleasant neighbourhood on a fine day.'

Charles Hewett had little time to contemplate paintings and — with three murder inquiries running — few men to spare; but he drew off half a dozen detectives and his talented Chief Inspector Ken Oxford the moment he had sized up the job. Eight pictures had been taken from three exhibition rooms; several frames lay on the floor or against the divan, showing that the thieves had taken their time; they had unscrewed a wooden batten off a wall to remove three paintings. When Hewett had looked around the gallery, the curator, Rex Shaw, gave him a list of the missing art works. Three important Rembrandts had disappeared: *A Girl at the Window*, one of the most famous, done in 1645 when the artist was experimenting with chiaroscuro; then, one of his many versions of *Portrait of Titus*, his son, another masterpiece; third, his portrait of fellow artist, Jacob de Gheyn III, an exquisite small canvas. Three Rubenses had vanished: *St. Barbara, Three Women with a Cornucopia*, and *The Three Graces*. With those the thieves had taken pictures by two minor masters, Gerard Dou's *A Lady Playing on the Clavicord* and Adam Elesheimer's *Susanah and the Elders*.

'How much do you reckon they're worth?' Hewett asked.

'The Rembrandts would probably fetch two million or more in the auction room, and the others at least half a million,' Shaw replied.

'Blimey, it's bigger than the Great Train Robbery,' the superintendent muttered. Three years before, in August 1963, an armed

*Rembrandt,* Girl at Window. *(By permission of the Governors of Dulwich Picture Gallery)*

*Elsheimer,* Susannah and the Elders. *(By permission of the Governors of Dulwich Picture Gallery)*

gang had hijacked the Glasgow-London postal train, overpowered the guards and got away with £2.25 million ($5.3 million) in used banknotes. However, Hewett knew he had a tougher job than hunting armed robbers; he had to recover the booty intact, to prevent the thieves from destroying unique art work that might incriminate them. It was the nearest thing to a kidnapping case.

As Rex Shaw walked around with the superintendent, he wondered how such a man handled a rough district like Southwark; beside the towering Ken Oxford he looked frail. But soon the curator realized how Hewett had solved so many murder cases and helped ambush a bullion gang at London Airport. 'He had a quick mind, enormous will power, and a great capacity for concentrated hard work,' he remembered.

Hewett saw how meticulously the gallery raid had been planned. Raymond Chandler, thriller-writer, scenarist, former Dulwich College boy who had frequented the gallery, might easily have scripted the theft and called it *The Big Steal*. It had beautiful simplicity. A gaping hole where the left-hand panel of the side door had been showed how the raiders had entered without triggering the burglar alarm. 'They must all have been rubber-boned men to get through that,' a detective commented as he peered through the gap measuring no more than eleven by twenty inches. Hewett noted that not only had they avoided all doors and windows wired with alarms, but their shuffling footprints told how they had crouched to keep below the electronic eyes in the three rooms visited. From the door they had first gone to the Rembrandt Room, Number Eleven, then Room Nine for the Rubenses, and finally to Room Ten to take the other two; they seemed even to have calculated that most of the paintings would pass diagonally through the eleven-by-twenty-inch hole. Both big Rembrandts would not go through, so they had cut out the canvases with a razor blade, but cleanly, professionally.

As Charles Hewett viewed it, most crime had an unoriginal, even monotonous stamp, the bent mind seeming to follow the same twists and borrow many old tricks; yet every job had its unique touch, like this one where the thief had cased the gallery like a professional burglar but had a connoisseur's eye for the best and most valuable pictures. Motive too followed a pattern, and here it was

money. But who could sell such masterpieces? They had not been stolen for reward, since out of its tight budget Dulwich College could not afford to insure its collection. That left two possibilities: they would soon demand a king's ransom; or they had been stolen as a commission for some crooked dealer. That probably meant smuggling them abroad.

That thought sent a shock wave through the Royal Academy, and eminent figures like Sir Charles Wheeler, its president, Sir Kenneth Clark, and Sir John Rothenstein foregathered to seek ways of recovering the pictures. Dulwich College chairman, Lord Shawcross, offered a token £1,000 reward for the return of the masterpieces. Sir Gerald Kelly, past president of the Royal Academy, now aged eighty-seven, expressed something of the deep sense of loss. He said, 'I don't want to talk about it. I am a very old man. I have known these pictures since I was ten years old. I have loved them and adored them and I have been in charge of them and I am feeling absolutely rotten.'

In the gallery Hewett was getting little help from fingerprint experts and forensic scientists. Tidy thieves, they had cleaned their prints off the frames, wooden batten strip, and door panel. They had, however, used a jimmy on the picture frames and on the batten, and a tool like that left its trademark. Beyond the eight-foot wall surrounding the gallery stood a plank and step-ladder, revealing how they had scaled the wall. Footprints indicated they had parked a van about a hundred yards away in Gallery Road, and that meant several people to ferry the pictures from the museum. And whoever had bored more than a hundred holes around that door panel and used a carpenter's knife to sever it knew what he was doing. He had daring too. For thirty yards away lay Rex Shaw's house. He had heard nothing. Nor had the chaplain, who lived fifty yards away. Near the doorstep someone found a two-inch, small-diameter drill bit from a battery drill, not a common tool then. Hewett sent one or two detectives round the local shops and do-it-yourself stores in case anybody had bought such a drill and quarter-inch bit recently.

It had rained the day before the crime and the soft turf round the side door bore several types of footprints, suggesting that three

131

or four men had taken part in the raid. Mud lay inside, on the wooden floor, some of it thick. Muddy tracks leading to and from the rooms were already drying. Pointing to them, the superintendent asked the forensic scientists to give him an estimated drying time for the mud to help him fix the hour of the crime. He could expect little eyewitness help. Dulwich prided itself on preserving its village character, keeping old toll gates and forbidding buses and other heavy traffic. At night hardly anything moved. So a gang of thieves could work undisturbed even a few yards from two major roads. They must have known the area and the layout of the gallery intimately. They had obviously studied the alarm system, realizing the door was connected directly to Scotland Yard, and if they forced it a squad car would be on top of them in three minutes. They knew too what to pick. It struck Hewett as an odd crime. It had the smell of a local man, yet something whispered that it carried a Continental imprint.

One of the scientists brought him the report on the mud. In winter conditions inside the gallery, they estimated, the mud had taken twelve hours to dry. Twelve hours. That meant the theft had taken place before nine or ten o'clock the previous evening — between four o'clock, when it grew dark, and those times. So the gang had a day's start — ample time to smuggle the paintings abroad. Within minutes of getting this report, the superintendent had circulated a full description of the missing pictures to police stations and customs and immigration offices throughout the United Kingdom; it went also to Interpol offices worldwide. Police and authorities at seaports and airports began to check passengers booking late flights and sea passages. Hewett, who never belonged to the lockjaw school of detectives, realized that the bigger the headlines the better chance he had of 'bringing off' his job, so he fed the press what he could. At midday, he saw with satisfaction, the London evening papers were leading with the story, illustrated with pictures. That would bring in local information and alert dealers.

For the rest, the superintendent had to fall back on old-fashioned police work. His men made a door-to-door check to see if anyone had spotted anything unusual between four o'clock and midnight the previous night. A man had heard a car revving in the early

hours and noticed a dark Ford Consul pulling away from Gallery Road. But the time did not correspond with the forensic estimate. Hewett's detectives 'turned over the drum,' seeking out known criminals and quizzing them as well as police informers; every local man with a criminal record had to alibi himself. But among known gangs nobody was grassing and everybody could vouch for his movements. Could it be an amateur thief who had stolen the paintings, as some academicians suggested, to gloat over them in splendid isolation? A man with no criminal record and almost impossible to trap? That particular worry ended next morning; in the early hours the secretary of the Royal Academy received an anonymous call from a man who demanded £100,000 ($240,000) for the paintings; otherwise he would destroy them. Dulwich College had no way of raising that sort of money.

This ransom demand and several other factors mystified Hewett. A job with a professional stamp by men who must have known Dulwich could not afford to pay big money; men who must have figured the risk of collecting a ransom; men who probably meant to get the pictures out of the country after the theft. What had stopped them when they had a twelve-hour start and could have flown or caught a boat? Hewett smoked another dozen cigarettes and again backtracked over the evidence, trying to answer the riddle of motive and behavior. Once more in the gallery, studying the chalk marks round the muddy prints, he noticed that the mud he and his policemen had brought in that morning was drying; he also felt too hot in his heavy coat, even with raw air blowing through the broken door panel. He had a sudden thought. 'How is this place heated?' he asked the curator.

'We installed underground heating to keep the paintings at a constant temperature,' Shaw replied.

'Underground heating!' That was the answer. Immediately, Hewett ordered the forensic team to repeat its sums, using the new temperatures. Now they found the mud dried in four hours. They were eight hours out! And that had thrown the whole inquiry out of kilter! It meant the burglars were still operating in the gallery in the early hours, too late to smuggle their loot abroad. A hunt began for the car spotted in Gallery Road, now a vital clue. Detec-

tives made the rounds, quizzing local people, while Hewett sifted through statements and alibis of known criminals to seek flaws. He now felt convinced he was looking for local criminals who lived within minutes of the gallery, who knew everything about it, from staff movements to burglar-alarm systems. Although neither he nor Chief Inspector Oxford nor any of their men had left the scene for even a few hours' sleep, Hewett realized he must keep up the pressure, scare the thieves, and prevent them from smuggling those Rembrandts and Rubenses abroad. His tactics were working, for no more ransom calls were received.

On the third day they found the stolen car. In its trunk lay a crowbar with fragments of gold paint from the picture frames sticking to its prongs; forensic men matched the tool with indentations on the wooden batten that had held the Rembrandts together against the gallery wall. With a description of the car and the clues it yielded, Hewett kept the Dulwich story on the front pages of the press and the radio bulletins, hoping this would crack the thieves' nerve. Reaction came swiftly. From West Kensington a frightened bookseller called. If Superintendent Hewett came to a certain flat, he might find what he was looking for. Hewett and Oxford went to the address. Under a folding divan they found the small Rembrandt and two other paintings wrapped in sacking. Both men sharing the flat denied involvement in the theft: someone had handed them a package to keep for several days; they got suspicious, examined it, and discovered the missing pictures. Hewett believed them.

Although they named the man who brought the paintings, the superintendent did not arrest him straightaway; he swore Rex Shaw, who identified the pictures, to secrecy and said nothing to the press or TV, reasoning that the thief would unload the other paintings rather than burn them or leave them on his own premises. He was right. Within twenty-four hours an anonymous caller informed Scotland Yard that the other five paintings lay in a spot called the Rookery at Streatham Common. There they were, none the worse for their missing three days, wrapped in newspaper.

That newspaper, plus the crowbar in the stolen car and other evidence, brought about the thief's downfall. A print from a left

forefinger on the newspaper matched one in the criminal records office belonging to Michael Hall, aged thirty-two, an unemployed ambulance driver who had a record of petty theft. That print and other forensic evidence confirmed Hall's connection with the Dulwich paintings. He was a thin, pliant man capable of squeezing through that small gap in the door; he knew both the gallery and the district, since he lived no more than half a mile away. At the Central Criminal Court he pleaded guilty to the theft and drew a sentence of five years. Did he act alone? Although Hall always denied having had accomplices, Hewett suspected at least two other men of participating in the theft. He also thought one picture — the small Rembrandt portrait of Jacob de Gheyn III — was destined for Belgium, where a buyer had perhaps commissioned the theft.

In four sleepless days, Charles Hewett had recovered paintings worth £2.5 million ($5.75 million), solved the puzzle of the rubber-boned man, and secured his conviction, something rare in picture thefts. In his last entry in the 1966 annual crime report and his first in 1967 for his manor, he marked down the Dulwich robbery as just another case of theft.

Rembrandt seemed to fascinate not only the millionaire art lover and investor but every type of thief and even vandals, maniacs, and madmen. As Rembrandts changed hands for millions of dollars in the auction rooms, they earned grimmer notices in the press and police dossiers. An insane student burned the Dutch master's vast canvas, *The Anatomy Lesson,* in the Rijksmuseum, Amsterdam; several years later another crazed art lover walked into the same museum and began slashing at one of Rembrandt's most perfect art works, *The Night Watch.* Fortunately the restorer made good that damage. In the Cooper-Hewitt Museum, New York, someone ripped a Rembrandt etching from its frame, though luckily it was returned.

In the winter of 1971 it was the turn of the quiet, provincial town of Tours in the Loire Valley. There the municipal museum had a rare treasure, Rembrandt's *Flight into Egypt.* Though an early work, it was considered by scholars vital to understanding

the master's chiaroscuro experiments and it was frequently borrowed for exhibitions. Tours took no special precautions with this or their other masterpieces by Rubens, Mantegna, Fouquet. In several rooms of the gallery, a seventeenth-century mansion formerly an archbishop's palace, they hung uninsured, unprotected by guards or alarms. Only the high palace wall discouraged theft.

On the morning of December 22, 1971, using a ladder borrowed from the cathedral next door, a cat burglar climbed over the outbuildings between the museum and its wall, broke a high window, and crept into the Dutch Room. He took only two paintings — the Rembrandt, measuring nine inches by ten, and a seascape by Jan van Goyen, master of Dutch landscape painting.

To Superintendent Jacques Mathieu, head of the Paris art-theft squad, the thief seemed an amateur — someone who would mistake van Goyen for van Gogh. Patiently he did his routine work, questioning staff and neighborhood families, searching for fingerprints, footmarks, and other clues. He circulated a description of both paintings in France and gave it to Interpol, for he suspected the thief, like most of his kind, would attempt to cross at least one frontier with his prizes within twenty-four hours. He had no doubt about the motive: money.

Two months went by before Interpol's West German office in Wiesbaden had a tip from a Berlin art dealer. A man, thought to be Czech, had offered a Rembrandt and a van Goyen to another dealer in the city and later to a Heidelberg collector for a ridiculous price. Interpol added that the paintings had since disappeared and might finish up in South America, a road taken by much stolen art and a blind alley for European and U.S. police. From that vast terrain hardly anything ever resurfaced. However, federal German detectives came through with more information. Had Paris ever heard of a Karel Whitman, aged twenty-two, carrying Czech papers and calling himself a sculptor? His name cropped up in connection with the two stolen canvases. Mathieu soon verified that Whitman had lived in Tours during 1971, vanishing around the time of the theft. Acting on this information German police interrogated Whitman, who admitted living in Tours and traveling to Berlin but denied having anything to do with stolen paintings. He

136

was released for want of evidence. At this point art-squad detectives always face a dilemma. Lean too heavily on a suspect, or place him under too tight surveillance, and they risk forcing him to destroy the incriminating evidence — in Whitman's case, the paintings. So although the police advised Interpol they believed Whitman guilty, they relaxed their watch on him.

Superintendent Mathieu's hopes of finding the Rembrandt and van Goyen had taken a knock. They had gone the way of so much stolen art, into a foreign underground market. For the international police 1971 ranked as a disaster year. In France alone some dozens of masterworks had disappeared, along with tapestries, sculpture, rare jewels. Three Rembrandts were still missing a year after their theft from the Bonnat Museum in Bayonne; a famous Masaccio, *Virgin and Child,* and Hans Memling's *Portrait of a Gentleman* had disappeared from the Palazzo Vecchio in Florence; Titian's *Holy Conversation* had been grabbed from his home town near Padua; a vicious thief had ripped Vermeer's *The Love Letter* from its frame at a Brussels exhibition; and these formed only the foam atop a deep wave. In his own files Mathieu listed hundreds of missing art works. What hope did he have of retrieving a small Rembrandt when the Paris press had barely mentioned it and the foreign press not at all? With the passing months his hopes grew fainter.

However, that disastrous year brought action. Interpol and the International Council of Museums (ICOM) put their heads together to invent a new antitheft device: on a police notice they displayed twelve stolen masterpieces under the headline, THE TWELVE MOST WANTED WORKS OF ART; captions in English and French described the art works and the date and place of theft. In June 1972 the first of these bulletins went to Interpol's 126 offices and from them to national police forces which duplicated it for internal circulation and listed the stolen art in their own gazettes.

If the Interpol poster lacked the color and artistic touch of a gallery catalogue, it proved a landmark in fighting art thieves, and it had impact. Newspapers and radio and TV stations talked about it, making the quest for missing art a public event. More-

over, it alerted not only police forces but the shady dealer or the entrepreneur who might have been tempted to buy hot goods. For the casual thief it meant few dealers would touch any picture on that list and even fences would hesitate. So successful was the first 'Wanted' notice that Interpol made it a permanent feature.

In November, more than ten months after the Tours theft, the second Interpol sheet listed the missing Rembrandt with a Bruegel, two Rubenses, a Gainsborough, and a Hals. Within two weeks the Tours curator had a phone call from a woman who offered the picture for 30,000 Deutschmarks (about $16,000). From this Commissaire Jacques Mathieu deduced that the Interpol publicity had balked the thief by scaring off dealers or fences. It indicated too that the Rembrandt and van Goyen remained in Germany, where Whitman had originally offered them. Finally, the criminals were risking arrest by negotiating a ransom and therefore had no intention of destroying the painting. On Mathieu's instructions, the Tours curator arranged to meet the woman go-between in the Saarbrücken Station restaurant on December 2 at six o'clock. To identify herself the woman would wear a brown leather coat and carry a French newspaper, *L'Aurore*. She would discuss the ransom and return of the Rembrandt.

Meanwhile the German police arrested and charged Whitman for another theft. Although denying the Tours theft, he admitted having received the paintings from someone else; earlier that year he had handed them to a Düsseldorf go-between to sell. A Berlin dealer had bought the van Goyen but considered the Rembrandt too hot to resell. According to the German police, the middleman had asked 100,000 Deutschmarks ($54,000), a quarter of the estimated value but a stiff price for a dubious art dealer. When this deal fell through the middleman decided on a ransom.

For the Saarbrücken meeting the German police stage-managed everything; in the station restaurant detectives with their wives or policewomen were drinking, while others posed as travelers for the 5:51 French train. They knew that train would bring Mathieu's man, acting the part of the Tours curator. Police photographers had mounted a film camera and another with a telescopic lens on the roof. Yet everything seemed to go wrong. At

5:30 a young woman in a brown leather coat appeared and asked for *L'Aurore* at the station kiosk, only to learn it had sold out. As she made for the restaurant a man accosted her and escorted her from the station. They picked up a car in town and shook off the police who were tailing them. However, later that evening a man called Saarbrücken police to explain that he and his wife were handling the Rembrandt ransom, but he suspected an ambush when he bought *L'Aurore* and the newsvendor asked if he were a policeman. He did not know who owned the paintings or where they were; he was going to receive a commission on the deal. Before hanging up he agreed to meet the Tours curator in Berlin on December 11. Any attempt by the police to intervene would squash the arrangement and the Rembrandt would vanish forever.

That meeting never took place. Instead the middleman tried to unload the Rembrandt on the original Berlin dealer. By then the German police had identified the middleman and set a trap for him; they seized not only *The Flight from Egypt* but persuaded the dealer to surrender the van Goyen. Mathieu's bogus curator learned of the Rembrandt's recovery as he was boarding a Paris-Berlin plane to keep the rendezvous. Whitman, the thief, served his sentence in West Germany before being extradited to serve another eighteen months in France.

Another Rembrandt, stolen from Bayonne in southwestern France, had an even more interesting itinerary. In March 1971 burglars broke into the Léon Bonnat Museum, overpowered a guard, and snatched Rembrandt's *The Rabbi* and three other paintings conservatively valued at $250,000 by French experts. Until December 1976 nothing was heard about the Rembrandt, one of four studies by the master for his large canvas, *St. Matthew Inspired by Angels*; then a whisper came from the underworld to a fence in Buffalo at the western end of New York State. Since June 1976 this fence had paid good prices for a number of stolen paintings with no questions asked; he also channeled art thieves to shady dealers when he himself lacked enough money to buy high-class merchandise.

Soon the middleman negotiating the sale of *The Rabbi* had con-

139

tacted the fence in his basement antique shop; his friend wanted $100,000 for the painting. Asking that sort of money, the seller needed to be a patient man, the fence said. He had a buyer, but he would have to see the painting. To this the middleman agreed, but only if the buyer paid a $10,000 viewing fee. It took months for the fence to find such a client, pay the fee, and fix the meeting. Eventually both the middleman and client met in the basement shop and the Rembrandt was unrolled. It was a tough bargaining session, the shady dealer examining the Rembrandt with an expert eye, peering at the markings on the canvas through a magnifying glass. For a hot picture like this, known to connoisseurs the world over, he could pay no more than $10,000 in addition to the 'front' money he'd tabled to see the picture. He flashed two wads of fifty and one-hundred dollar bills and this decided the hesitant middleman. As the dealer counted out $10,000, he suddenly pointed to the back of the canvas. 'What are those marks?' he asked.

'Oh, that! That's glue. To smuggle it across the Canadian border past the customs both sides we had to glue it into a suitcase lining.'

As the middleman left with his cash two FBI agents picked him up, charging him with transporting stolen goods across state boundaries, a federal offense. Later the middleman saw that whole basement scene played over in court, recorded on videotape; only then did he realize how the FBI had trapped him. In fact, the knowledgeable dealer was an FBI special agent, Thomas McShane, from the New York office; he had handled dozens of art-stealing cases and had become something of a connoisseur. Another FBI agent had set himself up as the Buffalo fence to lure thieves and middlemen into their net. From June 1976 to July 1977, the FBI, in collaboration with the New York State Police and Erie County district attorney's office, ran the bogus fencing operation and recovered $800,000 in stolen art, made forty-five federal and local arrests, and secured more than thirty convictions. Operation Tepee, as they called it, caught art stealers crossing the border near Niagara Falls from Canada into the United States. Many of those

pirates were smuggling pictures from countries like France and Italy.

As for Rembrandt's *Rabbi*, it went home — but not until April 1979. It became Exhibit A to convict several middlemen in a Buffalo courthouse, then had to languish for two years in a fireproof FBI vault to prevent a premature leak on Operation Tepee. Now it hangs where it belongs, in the Bonnat Museum near the Franco-Spanish frontier.

# 9

## A Quick-change Artist & the Mafia Man

To devise the name of the undercover man involved in the follow-
ing case I had to discard at least a dozen surnames because Henri
Collet has used that many aliases. Moreover, he has identity cards
and passports bearing official stamps to prove he has acted legiti-
mately, not to mention wigs, mustaches, glasses, and other props
to go with his trade. Picking the wrong false name for him might
alert thieves who would not hesitate to beat him up or finish him.
Collet belongs to those twilight men of the art business who try
to recover stolen pictures by treading precariously between thieves,
middlemen, insurance companies, and the police. More times than
he can recall, Collet has flirted dangerously with the Paris Milieu.
Why? It earns him good money, though not enough to risk ending
up a cripple or a dead man. A more basic motive emerges when
you talk to him and become aware that crime and criminals fasci-
nate this man, that he really feels but for the grace of God he
might have gone their way himself. You only have to look at his
wispy figure and nervous gestures and listen as he relates his
adventures to realize that something else just as deep drives him
— the hunting instinct that sends men chasing everything from
butterflies to big game.

From the age of fifteen, Collet did undercover work for the

142

French Resistance and intelligence service and got to know his way around the Paris underworld. His interest in art thefts began with a spell as an antique dealer. Never had he imagined the mountains of stolen paintings and antiques circulating among dealers and finding their way to the wary or unwary collector, or even into the legal market. He studied the thieves' methods — how they would first sell a genuine article, follow this up with several stolen items, then graduate to stealing on commission for fences or bent dealers. It infuriated Collet that honest dealers had such a hard time while their crooked colleagues made fortunes out of their rackets. So began his campaign to recover some of the more valuable art works. But naturally, like anyone risking his life, he demanded high fees. Looking at him in his many disguises and roles, no one would connect those strange characters in wigs, sunglasses, beards, and mustaches with the dapper, fastidious little man in his early fifties, dressed like any self-respecting Paris bourgeois; nor would anyone believe him to be capable of the dangerous game he plays until he switches in midsentence from cultured Comédie-Française speech to raw Parisian slang.

I met him in his elegant office, sitting under a reproduction of Picasso's *Harlequin's Head*, which he had chased to Italy and recovered for the Knoedler Gallery in 1972. Collet could fill a book with exploits that no pulp-fiction writer would dare try on his credulous readers. Once a band of picture thieves accused him of narking to the police, searched him for weapons, stripped him naked, and dumped him, bound and gagged, in a Paris graveyard on a freezing night. On another occasion he kept a restaurant rendezvous with a go-between acting for picture thieves. Instinct told him the man was no crook and soon he confessed to Collet he had given up his business in Nice to join a gang of drug pushers and art stealers to try to trace his daughter, embroiled with Paris drug addicts. Collet double-bluffed out of that situation, knowing the gang was watching from one side while his police contacts were waiting to pounce on an innocent man. Later he informed the man his daughter had been murdered during a drug orgy, but no one would ever be persuaded to testify against the wealthy and well-connected young men who had done or witnessed the deed.

Another time Collet heard himself described by two gangsters as a police spy — though fortunately under another name and in one of his many disguises. Then there was the time a Mafia thug walked in and caught Collet with his blond wig askew . . . but why don't I let Collet recount the story himself, changing only the names of his alias, the gallery, and the Mafia man?

'First inkling I have about the case is from the papers one morning in September 1972. A gang of thieves cut through a thick party wall to get into a well-known gallery in the heart of the Paris art world; out they walked with eleven canvases by modern masters, including Picasso, Pissaro, Derain, Vlaminck, Sisley, and Utrillo. Two million francs' worth [$400,000]. For two whole months not a smell. Then suddenly the art-theft squad in the Interior Ministry gets a buzz. That comes from the U.S. narcotics bureau in Paris and says: "We hear from one of our undercover agents that an Italian-born shirtmaker, a small-time Mafia villain called Jeannot Bonacelli knows about the M—— Gallery job. This Italian acts as a post box for drug pushers and he's cute. The customs have had their eye on him for ten years without ever nabbing him." That's as far as American cooperation goes since they don't want to "blow" their agent. Anyway, what are eleven pictures compared with several million dollars' worth of "hash" [Indian Hemp] or "horse" [heroin] and the damage that can do to junkies, to say nothing of their own undercover operations that have lasted five years already?

'Just after this tip-off I receive a call from the Interior Ministry. Can I help them trap Bonacelli? Before deciding, I wait until Matt gets back from an assignment. Matt is Inspector Jacques-Paul Mathieu, head of the art-theft squad and a good all-weather friend. He's a top man. Former Foreign Legion officer with two men's appetite for living. A mind like a computer. If I meet trouble, I know Matt will bail me out. In his office, number three, rue des Saussaies, we study the Polaroid pictures of the canvases taken by the crooks and passed to the narcotics bureau agent. No question, they're the M—— Gallery paintings. "Well, how're you going to handle it?" Matt says.

' "That's my business," I reply. "But I'll need cash. I'm cleaned out and for this job it'll mean big spending."

' "If you're banking on the police kitty . . ."

' "No, but there's the insurance. Nordstern will shell out a few thousand francs to try and cut their loss."

'Of course, Nordstern sees it my way. They insure hundreds of galleries and private collectors and their director, Raymond Schmit, knows everything, written and unwritten, about the art business. He raises no objection to paying me to recover the pictures. Only he thinks it's simple. Somebody knows where the pictures are. So all the police have to do is spring a trap. Matt has to explain patiently the Americans have spent five years trying to bust a drug ring; they can't wreck the narcotics job for a minor picture snatch. Which is why they've called in Henri Collet. Anyway, he doesn't have enough detectives to devote full time to the M—— Gallery raid.

' "Can you get us out of this hole, Monsieur X?" Schmit asked.

' "I've one or two ideas. I might."

' "He's got to watch his step," Matt puts in. "These are dangerous crooks like all the men who push drugs."

'With a Nordstern cheque for 15,000 francs [$3,000] in my pocket I get down to work. First, I buy a wig and dyes. I tint my hair and eyebrows blond and put on the wig which is as tight as a bad hangover. I have some passport pictures taken and throw these on Matt's desk.

' "But it's straight out of James Bond," says Matt, laughing his head off.

' "Maybe, but I have to look after myself."

' "On that point, if they smell anything you get out quick and I'll handle it another way."

'I walk out with a new identity card as Philippe Dalou. I'm now a Frenchman living in the Middle East, in Lebanon. I'm in Paris to buy pictures and other art works for rich Lebanese. I have to choose a plush hotel and I pick the Lutetia on the Left Bank — it was taken over by the Gestapo during the war — because I know its ins and outs. When I've settled in I phone Matt to say I'm making the connection that afternoon.

145

'Jeannot Bonacelli has his shirt shop behind the Gare Saint-Lazare, with an elegant front and fancy prices for hand-made shirts. I make for a bistro called the Paris-Rome a step or two away. I'm a bit edgy but I see Matt's man, Jean-Paul, sitting nibbling a beer and reading *L'Équipe*. Soon I'm chatting with the bar owner, telling him how Paris has changed in the three years I haven't been there and I need two or three decent suits of clothes. Oh yes, and some shirts. Does he know a shirtmaker? He does, just a few yards from his bar, the place with the striped awning. I can mention his name.

'Bonacelli looks like the photos I've studied. Swarthy, heavy-set, fortyish, with a ring-a-ding Italian accent, he looks me up and down while I give him my spiel and ask if he can make me six shirts. Under my blond wig my head's tight and itching. He gobbles my tale. We look at samples and he tots up the cost — 92,000 old francs [about $200]. I pull the whole Nordstern bankroll out and throw him 100,000 francs and wave aside his suggestion of a receipt. I can see my casual way with money rocks him on his heels. A day or two later, when I get to know Bonacelli better, I ask if I can use his phone — in private. I ring somebody who knows my game. Bonacelli has his ear to the partition. I say I've been authorized to go to 450,000 new francs [about $100,000] for the Renoir. But not a centime more. Bonacelli has bitten on that, too. As he shows me more shirt samples, he suddenly says, "So you're in the art business."

'He's given me my lead. Bit by bit, I let him draw it out of me. I normally operate in Italy and Germany for rich Arabs who are investing their oil money in art. One thing about them: they don't look too hard at the merchandise or ask too many questions. And they have "ready" by the wheelbarrowful.

' "What sort of pictures do they buy?" Bonacelli asks.

' "These days they go in for the Impressionists and the moderns."

'Bonacelli chews on this for a minute. "Maybe I've got something that would interest you," he says. "Can you come by tomorrow morning?"

'I make a date for eleven o'clock and walk out a bit lightheaded.

Now Matt's detectives have to rubberheel me every step, for if Bonacelli rumbles my game they might have to pull me out before I lose blood. So, at eleven next day, I spy three of Matt's men round the shop as I enter. Bonacelli pushes a scrap of paper over his cutting-table. On it, the complete list of the eleven paintings stolen from the M—— Gallery. "I don't believe it," I exclaim. "They're not genuine."

' "Look, I know the men who're offering this stuff, and it's good," Bonacelli replies.

'We decided to adjourn to a bistro to talk conditions and money. I can see Bonacelli eyeing Matt's men. He turns to me. "Sure you're here on your own?" he asks, a hard rasp to his tone.

' "What do you mean?"

' "I don't like some of the faces in this bar."

'For a minute I think I've had it, that he's on to me. "We'll find another bar," I say, then shoot back at him, "Are you certain nobody's tailing you?" He simmers down at that. Over a whisky in another bistro I outline my conditions. I deal with one man, and only one. I need details of the canvases and photographs if possible. When we agree a price and how it's paid I have to see the merchandise for myself.

' "I'd want guarantees," Bonacelli says, quizzing me if I know anybody in the Paris Milieu and even wanting to see my identity card.

' "See here, Monsieur Bonacelli," I snap back. "I came to buy shirts in your shop, not paintings. I didn't mention the paintings. You did. I didn't say a thing."

' "All right. Can I call you at your hotel any time?"

' "Any time but Sunday. It's my day for relaxing."

'Obviously they're cagey about me. That Sunday, Bonacelli calls at the Lutetia and leaves his identity card in my room — a twenty-centime coin under the door. When I meet him again, his masters still insist I name a contact in the Paris underworld. Otherwise, how do they know I'm not a police undercover man or a canary? I threaten to pull out of the deal, but the smell of my Arab money is too strong in their nose. Bonacelli shows me colored prints of the pictures. Still, he lays down conditions: his friends will make

the exchange in two parts, selling me four paintings, then the other seven. I understand their game; they're testing me. After that, it becomes a grisly hide-and-seek between Bonacelli and me. They're tailing me and Matt's men are keeping an eye on all of us. And I also have Raymond Schmit of Nordstern wondering why we aren't getting results. What bothers me is how Bonacelli's gang means to prove I'm on the level. While I'm filling Matt in on my progress it comes to me. On quitting the shirt shop, the Italian asked me too casually if I'd be in my hotel on Friday morning and I'd said yes without thinking.

' "Matt, it's for Friday," I exclaim, explaining my reasoning.

' "We can't take chances," Matt says.

'He fixes with Commissaire Pierre Ottavioli, tough Marseillais head of the flying squad, to draft extra bodies into the assignment and they make a plan. I take Bonacelli to the bank to collect the cash. If he has the pictures with him I whip off my sunglasses and the police will swoop. A good scheme, if it works. I have my doubts. That night, lying in bed at the Lutetia I hardly sleep a wink. Every tread along the hotel corridors is making for my door; every movement and I imagine Bonacelli and his heavy mob. My ear on the pillow seems plugged into my beating heart. I'm scared. I think of next day's ordeal and curse the police for their lack of support. One of Matt's detectives asked me, "Aren't you frightened?" And like a silly bastard, I said no. What a job! Why do I do it? For ten per cent of the stuff I salvage. Just what they'd offer a traveling salesman!

'Bonacelli arrives at seven. Too impatient to finish breakfast, he hustles us by car out to a Paris suburb where he chooses a bar-tabac near the station. Full of everything from spivs and pimps to hitmen and underworld barons. Bonacelli listens to my scheme for settling the deal in the Paris bank, but he doesn't buy it. Instead, he escorts me to his car. On the rear seat in our absence somebody has placed four packets marked Pissarro, Vlaminck, Utrillo, Utrillo. Back in the bistro, Bonacelli tells me his friends will never agree to taking the pictures back to Paris. Too dicey. I have to bring the cash and make the exchange in the country.

' "You're crazy," I say, then I really tear him off a strip. Does

he think I'm clot enough to hump half a million new francs to some hole in the country? That way I finish without money, without pictures, and without any future. When we get back to the car, the pictures have disappeared. I say goodbye to Bonacelli at Port Maillot. That day I book out of the Lutetia and take a couple of days off to recover my wind and let Bonacelli cool off.

'Three days later, I choose another hotel at Port Maillot. I ring Bonacelli and discover he's been trying to contact me. Now I have an idea how to break the deadlock between us. I take several tube trains, a few taxis, and slip into Matt's office with my scheme. If Schmit and Nordstern "lend" me 450,000 new francs [$100,000] in notes that I can put into a strongbox at my bank, I think I can get both the pictures and Bonacelli. Matt phones Schmit and we go and see him. No need to spell it out. He sees the point straight away. "I'll arrange for you to have the money this afternoon," he says.

'So, we trundle to the bank, two of Matt's men and myself with Schmit's secretary. Solemnly, we sit counting all this cash, stuff it into an attaché case and transport it to my bank. Know something? They didn't even ask me for a receipt or an I O U!

'Bonacelli is limping round his cutting room when I get there unannounced. A sprained ankle. I tell him what's what and we get a taxi and make for my bank in the heart of Paris. I sign myself Philippe Dalou and we drop into step with a bank official through one steel grill after another to the strongroom. I open my strongbox, bring out the attaché case, and motion Bonacelli into a private room. There's so much cash in it, the case springs open when I unlock it. Never have I seen anybody look at money the way Bonacelli did. He picked it up, ran the bills between his finger and thumb, smelled it, checked to see if they were all five-hundred franc [$100] notes. He was so amazed that the effort of pretending showed in his face.

' "You see, Bonacelli, I keep my word and so do the men I work for. I give them a list of the goods and the money's here without any daft questions asked." I bang the case shut, lock the money away, and we go for a drink. We still don't agree about the handover and obviously he and his friends have their doubts

about me. I give him my hotel phone number and room number.

' "You'll be there tomorrow?" he queries as we part company.

'Next day, nothing. Bonacelli's ankle has packed up and he's in bed. I have the insurance company worrying about its money and Matt fuming that he's only interested in making arrests and to hell with the pictures. Me? I'm the meat in the sandwich, and I feel like chucking my hand in at that moment. To take a breather, I visit some pals and sit up until five o'clock in the morning playing poker. I return to the hotel and sleep until eleven, when I have to ring Bonacelli.

' "Can you come to the shop now?" he asks.

' "No, it's not on. I didn't get any shut-eye until five and I've just woke up. Give me time to have a croissant and coffee and dress and I'll be with you this afternoon. Say two o'clock."

' "Fine — see you at two," Bonacelli confirms.

'As soon as he hangs up, I jam on my wig, unbolt the door, and order breakfast to be sent up. I shave quickly and I'm sitting on the edge of the bed talking to a friend on the phone when there's a knock. ' "Entrez," I shout, thinking it's the waiter with breakfast. It's Bonacelli. I don't know what to do. That wig seems to be sitting on my head like an ice bag. Has he noticed it's askew and I'm twitchy? I feel sick at the notion he might have caught me without it. "You gave me a scare," I say. He looks pleased at the effect he has produced. His friends have agreed to make the handover in two lots in two days' time. "You'll be free tomorrow as well?" and I nod. When he leaves, I call Matt. "This time it's on for sure and I think it'll be tomorrow." Again, Matt arranges with Commissaire Ottavioli to cover me during the critical stage of the operation.

'That afternoon I contact Bonacelli. "I've just got orders to make only one handover. It's too dangerous to do two runs, so we'll settle the deal on the four paintings and leave the others." I'm hoping their greed will cause them to change their minds and try to sell all the pictures.

'Bonacelli follows his usual pattern, turning up a day early for his rendezvous at 7:30. He cannot wait to get going and drives out northwest to a small village. During the trip he tells me

if the deal doesn't go through as planned his friends won't give much for my life. This time I'm pretty certain we're being followed by one or two cars. Finally, we stop beside a cemetery where a car is parked. Bonacelli lifts the boot lid and I glimpse the four packets I'd seen before. If anything, Bonacelli's more nervous than I am. Before letting me see the paintings he searches me for weapons. I examine the canvases closely. No doubt they're from the M—— Gallery. I hide my disappointment they haven't brought the lot.

'About 10:30 we're back on the Paris road and now a black Citroën is following us, driven by a swarthy character that I take for Bonacelli's accomplice. We crawl through thick Paris traffic towards the bank. Now, we've lost the black car. As we reach the bank I can't spot any of Matt's or Ottavioli's men. Panic. Then I suddenly see one of the antitheft squad cars parked, nose outwards and two rear wheels against the curb. My panic evaporates. Especially when Bonacelli draws in beside the police car.

' "I'll squat here while you go and get the money," Bonacelli says.

'That suits me. "All right, wait here, I won't be long," I reply.

'As I enter the bank I whip off my sunglasses. Out of the corner of my eye, I catch three detectives converging on Bonacelli's car. I slip out of a side door of the bank and leave them to make the arrest.'

Bonacelli was given a prison term. His accomplice, the real gang-leader, was caught when he returned from Spain. Five more paintings were recovered in this way; two have never come to light. For Henri Collet it ranks as just one of dozens of cases where, not always successfully, he has baited the trap for art thieves. Aware, however, that he was running the double risk of being discovered and liquidated during an operation, or becoming the victim of gang revenge, Collet decided to put his wigs, mustaches, beards, and other props in mothballs and lead a quieter life. His friend, Inspector Jacques-Paul Mathieu, went to work in the commissariat of a northern provincial town and this too had something to do with Collet's decision to phase out his undercover assignments.

Now, from a Paris office, he runs the Bureau de Prévention et de Défense contre le Vol, an antitheft organization working closely with insurance companies and cooperating with the French fine-arts squad. He laments the lack of security in museums, private galleries, and houses where art worth millions of dollars offers a permanent inducement to thieves; he criticizes the law that hands out sentences of a few months to people who steal masterpieces, or largely ignores receivers and dealers who carve fortunes out of stolen art. In his view, thousands of pictures and other art works will continue to lie hidden until thieves and their backers can devise ways of infiltrating the legal market with them, disposing of them privately or selling them openly once the statute of limitations has expired. All this discourages even a determined and dedicated man like Collet, leaving him feeling the game is not worth the candle. However, having talked at length to him, I would not be surprised if his wigs, beards, glasses, and other undercover accessories reappeared were another case like the M—— Gallery to materialize and a call come from the Ministry of the Interior.

# *Sir Roland Penrose:*
# *Refusing the Racket & Risking the Loss*

In the late sixties it had become apparent that several syndicates of art thieves were operating in Britain. One gang in particular had adopted and perfected the O'Hana Gallery 'tickle' for extorting money painlessly from insurance companies. Concentrating on ancestral homes, country mansions, and lavish town flats, they pillaged whole art collections with no thought of unloading them on the crooked dealer, the fence, or a foreign buyer. Neither did the ransom money interest them. They seized pictures worth a fortune merely to reap the official reward — 10 percent of insured value — offered by the insurance companies, a game with such legal subtleties that it taxed the minds of criminal jurists. To play their hand in, the gang did two small London jobs: first, they lifted two eighteenth-century paintings from a Chester Square flat, dumping them in a Victoria Station locker after pocketing their reward. Next, Vasco Lazzolo, the well-known artist, lost three paintings worth £6,500, which reappeared under a gas stove in a Hackney slum once the reward had changed hands. Those successes emboldened the gang. On the last week of January 1969, Sam Jaffe, the Hollywood actor returned to his Eaton Square flat

153

from an evening at the cinema to find himself robbed of seven fine paintings by Chagall, Dufy, Léger, Picasso, Rouault, a Henry Moore sculpture, and jewelry adding up to £110,000 ($265,000). That haul turned up shortly afterward, no more than three hundred yards away, in an empty Sloane Square flat. When the gang raided Lord Rockley's flat in Connaught Square and stole £135,000 ($320,000) in seventeenth-century Dutch paintings, they added a macabre touch, depositing the bundle in a London crematorium.

With mounting irritation, Scotland Yard watched this reward racket. It could not stop insurance companies from paying a 10 percent reward to recover paintings and save themselves from having to meet the total loss if the criminals carried out their usual threat to destroy their loot. Of course, detectives realized that the information invariably came from the underworld and from sources close to the thieves. Sometimes too close. They knew too that the reward money had been paid by a loss adjuster acting for the insurance company, for in almost every case these professional men informed the police about reward payments. Provided that a loss adjuster satisfied himself that neither he nor his informant was dealing with the criminals, he was not breaking the law. After all, no one could prove that an informant had done any more than pick up snippets of information from underworld sources, either accidentally or by frequently drinking or gambling haunts used by various gangs, which is no crime. Such informants might be making a perilous living by gleaning and selling such information either to insurance companies or to the police, who planted their own informants among the gangs.

Even so, rewards could only be paid under certain conditions, which included the arrest and conviction of the thieves as well as the recovery of their stolen goods. But how could they, the police, prevent loss adjusters from doing what they had to do in many criminal cases — pay dubious characters for underworld information? Especially when the loss adjusters were often tapping the same sources as the police themselves — only offering more money. This small, professional fraternity frequently had a better network of narks than criminal investigators. Their doyen, Cecil Hart, admitted in court to having contacted more than a thousand

informants when inquiring into the Great Train Robbery of 1963. But even loss adjusters had to step more warily, for the 1968 Theft Act brought in the new offense of dishonestly handling stolen property, thus giving the police much wider powers to charge people who had not physically handled illicit goods.

Now the spate of art thefts — not only paintings but jewelry, silver, stamps, and other objects — had compelled Scotland Yard to forge a new weapon, a fine-arts squad. From 1962 one detective-inspector had worked on these crimes under Superintendent Fred Gerard, but with little official backing. At the beginning of 1968 Chief Inspector Ray Peeling picked three trained detectives for special duties. For if art theft did not differ fundamentally from other crime work, it did demand some knowledge of painting, sculpture, antiques, old jewelry, stamps, and other valuable objects; it also meant close cooperation with auction houses like Sotheby's and Christie's as well as private galleries and museums throughout the country. Peeling's three men took crash art-and-antiques courses at London University and gradually built up contacts with the legitimate art market and those dealers and fences who might traffic in stolen art, a move that paid off.

Soon Peeling and his detectives had information about the art gang, everything except red-handed proof against its members. The gang had a boss, Bert X, who had used a term for robbery in Parkhurst Prison, Isle of Wight, to recruit some of the best housebreakers and safecrackers in the country. A high liver, Bert X sported a Daimler and several flashy, mink-clad women; moved easily between the smart West End and slummy East End of London; thought nothing of gambling up to a thousand pounds ($2,400) on one dice throw; and invariably booked his holidays at five-star Riviera hotels. He had hand-picked his gang not only for their professional talent but because they were loners, a caste apart from the rest of the underworld and police narks. He had a middle-aged man nicknamed Ratto, a former naval telegraphist and telephone engineer and now a ham radio enthusiast who had done time for fraud; he cased any houses or galleries for 'bugs' in the form of electrical or electronic devices and kept them on the police radio network during and after the job; a young Cockney

155

one-time taxi driver acted as 'wheelman,' with the job of stealing and driving not one but two or three cars to cover the gang's tracks on operation night. Two other men, both expert burglars, completed the nucleus of the gang; one had served two years for a bullion robbery, and the other boasted he could pick any lock or crack any safe either with numbers or nitro. Bert X did all the planning himself, spending weeks checking routines and movements in the chosen house or gallery, briefing his men with catalogue pictures of the paintings or antiques to steal, insisting they handle the merchandise like nitro, as any damage cut their profit. Unlike other art thieves who had to sell their haul, Bert X did not need a receiver and had thus removed a potential threat, since fences often turned police informer to save their own necks. However, he did need a 'bagman' — somebody to shuttle between him and the loss adjuster, collect the reward, and keep up to 5 percent, depending on the amount. Bert X knew his law as well as his auction prices. To stick you with a charge, the police had to catch you with the goods. Therefore, he had to set up a man with no 'form' in the criminal records office to provoke police suspicion and who would operate delicately enough to keep Scotland Yard off his back. It had worked in half a dozen jobs. No reason why it shouldn't go on working.

In fact, Bert X had a nice little 'hustle' lined up that would net them anything between £20,000 ($48,000) and £30,000 ($72,000) at present salesroom prices. A quiet, red-brick, late-Victorian house in a tranquil Kensington backwater. No burglar alarms to bother him and his screwmen. Empty every weekend when the owner and his wife took off for their farm near Lewes in Sussex. Empty, that is, except for those Picassos and other canvases by Braque, de Chirico, Chagall, Mirò. They had sentimental as well as market value, for the owner had actually known all those artists and had painted alongside them in Paris. An artist like him wouldn't crib even about a ransom, he'd be so keen to get his pictures back. When his gang did the job on Sunday morning, April 7, 1969, it turned out easier than Bert X had imagined.

His victim, Sir Roland Penrose, arrived home with his wife,

156

Lee Miller, from their Easter weekend to find their front door jimmied; inside their flat in Hornton Street, Kensington, they saw that twenty-five of the best canvases had been taken. Empty frames stood neatly in the living room, two bedrooms, and kitchen of the small flat, proving the gang had taken their time and expertly cut away the canvases; they had touched nothing else, left no mess. Neighbors in the peaceful street had heard nothing between Saturday evening and noon on Sunday, when the thieves were operating. It appeared that while they were robbing the house, a stray cat — called TC — the Penroses had adopted was sitting watching them. Besides the paintings, they had taken a gray candlewick bedspread, evidently to wrap the larger canvases, and a suitcase for the smaller ones.

Sir Roland Penrose reacted the way Bert X and his thieves had expected. 'I feel shattered,' he said. 'It is like a death to me. It has taken thirty years to build up this collection. These things have grown up with me.' He made this comment too. 'They were obviously taken by someone who knew about pictures. I would say a mastermind was behind it.' To Sir Roland his pictures represented much more than money; they were a part of himself. He had resisted every suggestion of fitting bars and alarms to his home and converting it into a form of prison; indeed, he had insured his art for no more than a third of its value. In the salesroom, his twenty-five missing paintings would have fetched at least £300,000 ($720,000). One of them alone — Picasso's *Woman Weeping* — would have sold for £80,000 ($192,000). Sir Roland did not regret the money lost. Like every one of his masterpieces, those stolen paintings belonged to his own past; he had bought or acquired his art not as a collector or investor but because he knew and admired those who had created it. *Woman Weeping* was the most famous Picasso portrait of his mistress, the Yugoslav painter and photographer Dora Maar. Sir Roland had bought it off the easel with its paint still wet from his great friend Picasso. In Cubist manner and garish colors that contrasted with her tears, the Spanish artist had made what some critics felt was an ironic comment on feminine grief through the distorted face of the woman

157

*Picasso*, Woman Weeping, *1937. (Collection of Antony Penrose)*

he loved. Exhibited all over the world and considered a landmark in Picasso's work, it was a painting no auction room, dealer, or private buyer would touch.

Each of the other twenty-four paintings had a personal history. Besides *Woman Weeping*, three more Picassos had been taken, as were three works by Giorgio de Chirico, including the famous *Uncertainty of the Poet*; three by Max Ernst, another intimate

friend; several others by Miró, Braque, Chagall, Henry Moore, Magritte.

A tall, bespectacled, soft-spoken man, Sir Roland looked more like a country squire than a poet and painter. No one would have taken this diffident, unassuming figure for a revolutionary. Yet he was. As a young man he had cut his moorings to live and experience many of the convulsive art movements that his individual collection represented. He was born in 1900 into a wealthy Quaker family, his grandfather being a banker and philanthropist who became the first Lord Peckover and his father a conventional artist and member of the Royal Hibernian Academy. Roland Penrose could have chosen a safe seat in the family bank and made his fortune; instead he listened to another Quaker, Roger Fry, apostle of Cezánne and other post-Impressionists. Doing what one of them — Paul Gauguin — had done, he gave up the easy life to live rough and paint. In Paris between 1922 and 1934 he met all the modern masters — painters like Max Ernst, de Chirico, Man Ray, Miró, Magritte, Picabia, all of them inventing surrealism and other new art forms; he made friends of André Breton, high priest of surrealism, and poets like Paul Eluard, who introduced him to Picasso. That began his lifelong friendship with the Spanish genius. At a time when cubism and surrealism provoked sneers or ribald jokes, Penrose exhibited with them and organized the first International Surrealist Exhibition in London in 1936; there several of his own pictures hung along with those of his Paris friends. A poet and biographer, he wrote a standard life of Picasso and the development of his art; as a Tate Gallery trustee, he mounted the great Picasso exhibition in 1960 and procured the artist's famous painting, *Three Dancers*, for the museum. Founder of the Institute of Contemporary Arts, he became its president for more than twenty years.

It seemed a wicked injustice for thieves to pick on a genuine artist and art lover and trade on his fear that his paintings would be destroyed. No one, not even Scotland Yard's newly constituted art-theft squad, would have blamed Sir Roland had he submitted to demands for reward money or a ransom to recover his collection. But no one, including the gang, realized that when it came

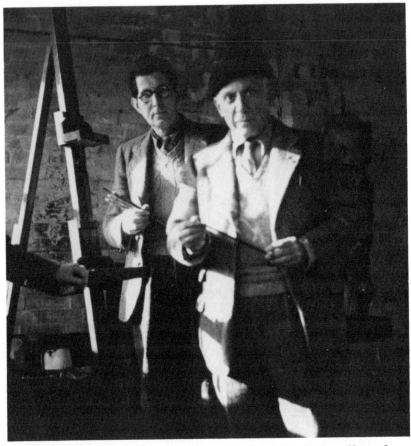

*Picasso with Sir Roland Penrose in the latter's studio, Sussex, November 1950. (Lee Miller)*

to art Sir Roland Penrose never compromised. To the press that day and on television that evening, he stated bluntly, 'I shall never make a deal with such men. By making a deal you are just encouraging other kidnappers. Anyway, they'd probably come and do the same thing again.'

That statement did much to change the whole pattern of art crime in Britain. At last Chief Inspector Ray Peeling and his squad had someone who would collaborate with them to catch the thieves or smash their racket. The loss adjusters, Tyler and Company, issued a reward notice offering £7,500 for return of the paintings, stipulating that the money would be paid only after

arrests had been made. After his statements Sir Roland found himself summoned to Scotland Yard to hear a briefing by Chief Inspector Fred Lambert. 'All this was very strange,' Sir Roland told me later. 'Never in my life had I done anything like this, but I agreed to whatever they said.'

Scotland Yard revealed as little as they had to. They had secured the cooperation of a man they and Sir Roland would call Charlie. This man would contact the thieves or their go-between, posing as Penrose's agent and acting for the reward he would receive on recovery of the paintings. Charlie would first sell the go-between the story that Penrose did not believe they had the paintings; he thought they were bluffing and must see the paintings himself or let his agent, Charlie, inspect them and vouch for the fact that the thieves really had them. Sir Roland had never met Charlie; nor did he ever guess that Charlie was a fringe art dealer known to detectives for certain minor transgressions which they had agreed to overlook in return for his cooperation.

Charlie had obviously made contact, for a few nights later Sir Roland had a call from the thieves themselves, probably Bert X. 'We hear you don't believe we got your pictures,' the voice said.

'No, I don't believe it,' Sir Roland replied.

'All right, then to prove it we'll send you the labels from the back.'

'I don't want the labels,' Sir Roland said. 'That would be like sending me the bootlaces without the boots. In any case, you must deal with my agent.'

At that moment, the thief heard a click. 'Your phone's tapped,' he said.

'No, it's only my wife in the other room picking up the extension, Sir Roland assured him. But immediately the line went dead. For someone who had never before tangled with the underworld, Sir Roland had not done badly. However, the gang decided to frighten him. In the post a day or two later a fragment from one of his paintings arrived; it bore the signature 'Picasso' and had probably been cut from the right-hand corner of the artist's *Negro Dancer*.

When neither Sir Roland nor the loss adjusters reacted to this

arm-twisting, the go-between again approached Charlie, who had further demands. To ensure against a double cross, the gang must furnish him with details of the picture sizes and a full description of each canvas. He rejected their offer of a single painting as proof they had the whole collection. His patron, Sir Roland, would never buy that one.

'Then go and talk to your boss now,' the gang instructed him.

That put Charlie in a pother. For although he had affirmed close friendship with Penrose, he hardly knew where he lived, let alone how to call on him. He bluffed and played for time. When he had the address, he went and knocked on the door, marching inside and introducing himself when it opened, knowing one of Bert X's gang had followed him every step. He knew the gang had become suspicious; but now they were playing for big money, for the adjusters had increased the reward from £7,500 ($18,000) to £30,000 ($72,000). Charlie was proposing ransom money of £10,000 as bait to catch the thieves. Now they wanted guarantees from Charlie, who spent an uncomfortable and nervous three hours in a pub with the middleman and two gang members who interrogated him about his background and relations with Penrose. Outside the police were waiting to raid the place and pull Charlie out if the interview turned sour. But Chief Inspector Lambert realized the gang was quizzing Charlie before setting up the exchange operation.

For eight weeks the game went on between Lambert's men, Charlie, and the gang. Underworld contacts tipped off the art squad that the thieves, suddenly scared, had dumped the paintings in disused sandpits at Staines. A search yielded nothing. Was the gang probing to find out how much Scotland Yard knew? A day or two later, informed by the go-between that the gang was cooling things, Charlie went home for a rest. Out of the blue he had a call at the end of June; this time the gang had arranged for him to view all the paintings, now lying in a cache somewhere in Ealing. He managed to postpone the rendezvous for three days to allow the art squad to set up an ambush.

On the afternoon of July 2, Charlie had to meet the gang at an antique dealer's, ten minutes' drive from where they had hidden

the Penrose haul. Chief Inspector Lambert had already placed a dozen men around the rendezvous point. As soon as Charlie gave the sign they would swoop and catch the thieves red-handed. Within a hundred yards of the antique shop, a detective stepped forward and asked Charlie for a light. He had time to whisper, 'They've found the paintings. It's all in the *News* and *Standard*.' Charlie had to play the game through, but he walked into the shop wondering if he would get out alive. Deciding to take the first of the gang, he angrily accused them of double-crossing him and losing him his reward. They'd been bluffing all the time about their nonexistent loot. Bert X got so enraged at this, Charlie hoped the plainclothes policemen were ready to come to his rescue. 'All right, send somebody out to buy a paper,' he suggested. A gang member ran to fetch an evening paper. There, in massive head-lines they read confirmation of Charlie's story. Before they could recover from the shock, Charlie had cursed his luck and theirs and taken his leave. He considered himself fortunate to have gotten away with a whole skin.

At about that time Sir Roland Penrose walked into the Institute of Contemporary Arts in Carlton House Terrace near Trafalgar Square. One of his friends said, 'So they've found your paintings, Roland.'

'I don't believe it.'

'But it's in the *Standard*,' the man said, showing Sir Roland the front-page headlines in the early edition. Mystified, the painter read the account. From Chief Inspector Lambert he had a whisper that they were going to recover the pictures. But not like this.

Bert X and his gang had actually told the truth; they had planted the paintings in an empty shop near the meeting point in Ealing. But the gang had never reckoned on a million-to-one accident. On July 2 — the day of the handover — workmen had started demolishing the derelict shop. Indeed, the twenty-five paintings came within a whisker of ending as ashes on the bonfire the demolition men had lit. Two men, a thirty-year-old carpenter named Eddie Mitchell and a forty-seven-year-old housepainter named Aubrey Warman were clearing rubble in the shop when they hit a dirty bedcover and a small suitcase. 'Careful with that,'

Mitchell shouted as his mate threw both bundles onto the heap for the bonfire. 'Might be a bomb.' Cautiously, with the point of his shovel, he explored the bedspread to reveal several rolled-up canvases; he levered open the suitcase to discover another lot of paintings. 'You're a painter — what are these worth?' he asked Warman.

Warman glanced at them. 'We might get a few bob for the ones that are framed,' he answered.

But the owners of the junk shop next door laughed at them. 'Not worth a nicker [$2],' they said. Undaunted, the men took the pictures to an art shop run by Leonard Taylor, a seventy-four-year-old photographer. He recognized Picasso's *Woman Weeping*, connected it with the theft, and rang Scotland Yard. Taylor did not realize that had he delayed his call for half an hour there would have been an interesting confrontation when Bert X and his gang, accompanied by Charlie and a score of detectives, converged on that derelict Ealing shop — to no purpose since the pictures had already been removed. However, Taylor's call came in time to warn the police undercover man.

At five o'clock that evening Sir Roland Penrose reported to Chelsea police station, where Chief Inspector Lambert and Detective-sergeant Leonard Silk had taken his paintings. Never had he seen his pictures exhibited to worse effect as in that drab, dingy little interview room; but never had he viewed them with such pleasure. 'You know,' he told me, 'those splendid policemen were standing over them for all the world like big-game hunters over a fresh kill.' Sir Roland rewarded the men who had found the paintings, then took the damaged *Negro Dancer* to Picasso's home at Mougins on the Côte d'Azur, where the artist signed it again. That ended the incident for Sir Roland. Modest and mild-mannered, he did not appreciate that the stand he had taken did the police and the art world a greater service than he could ever imagine.

On the face of things, the police had lost that round, and only by a long shot had they recovered the paintings. However, they now had two leads on the gang: instead of contacting Tyler and Company, who had offered the reward, the thieves wished to nego-

tiate with another firm; second, their go-between knew his loss adjusters and exactly how to handle the delicate and intricate business of collecting rewards and vanishing. Now they had identified him, Chief Inspector Ray Peeling and the art squad kept the middleman under constant watch, aware it might be months before the gang struck again and that they might use another negotiator.

In fact, it took just over a month before Bert X made another hustle, this time on August 3 at the Bryanston Square home of Lord Sainsbury, the food-stores millionaire. Again, a nice clean job in which they took pictures valued at £12,500. Since these included Bonnard's *Figures dans la Rue*, Vuillard's *The Bridge Game*, two Picassos, a Sickert, and a Sutherland, the Sainsbury collection would have fetched many times the police estimate at auction. Once more the pattern repeated itself: a go-between materialized, contacted the loss adjuster secretly, collected the reward, and disappeared. Lord Sainsbury redeemed his pictures, which were left at Gerrard's Cross Station half an hour's drive from central London.

Next month the victim was Sir James Colyer-Fergusson, who lost paintings, drawings, and lithographs worth £35,000 from his house in Onslow Square. Though not insured, Sir James offered a reward through Hart and Company, the loss adjusters. Only this time the police joined the cat-and-mouse reward game. For more than five months they had kept surveillance on the middleman who acted in the Penrose case; now, in the second week of December 1969, Chief Inspector Ray Peeling and Detective-sergeant Silk followed him out of London, along the fringes of Richmond Park to Kingston Hill; there they stepped in and arrested him as he was receiving £2,500 ($6,000) in ten-pound notes from a loss adjuster as part of the reward for the Colyer-Fergusson paintings. The loss adjuster was none other than Cecil Victor Hart, doyen and most eminent member of his profession; the go-between turned out to be a thirty-five-year-old Folkstone salesman called Bernard Oxley.

So involved and lengthy were the police inquiries that Oxley did not appear on trial until January 1971. By then the Metro-

politan Police Commissioner, Sir John Waldron, had sounded a warning to insurance companies and their loss adjusters against making irresponsible payments to recover stolen property. Rewards must follow successful prosecution, he said. Thieves were now operating solely for the rewards. 'In this way, the criminal benefits from his crime without the added risk of finding a receiver for the goods he has stolen,' Sir John said. That warning and the trial of Bernard Oxley put an end to the reward racket.

Oxley pleaded not guilty to five charges of dishonestly handling fifty-three paintings, three sculptures, three engravings, silver, and other articles throughout 1969. It was the first of these cases brought under the new Theft Act, voted through the House of Commons. Hitherto a criminal or a go-between had to be caught in possession of stolen property. Now the new act made it an offense to 'dishonestly handle stolen property' even though no physical contact had been made with the goods. Therefore, the police could charge any intermediary, and even informants, if their tip-offs did not lead to arrests and convictions of criminals. Loss adjusters too could pay only for information that led to arrest and conviction. It was alleged that Oxley received £16,500 from Cecil Victor Hart, the loss adjuster, for information leading to the recovery of paintings worth £500,000 ($2.48 million); he was also alleged to have acted as a confederate of thieves under as many as five aliases to contact Cecil Hart. Oxley admitted the same gang had committed the robberies, but said in his defense, 'Mr. Hart knew I was dealing with the thieves, but he told me he had taken legal advice and I have not been doing anything wrong.' He claimed all his information came secondhand and at no time did he know the identity of the thieves. Oxley appeared to have led a double life, for a police witness testified on his behalf that several times he had given information leading to arrests.

Cecil Victor Hart, aged seventy, a dignified figure with forty-five years' experience in his profession, said in evidence he had made it plain to Oxley he would not deal with him if he had direct contact with criminals. He had paid Oxley £12,000 for the Jaffe pictures, £1,600 for the Sainsbury collection, and smaller amounts

for the Lazzolo and other paintings. In each case Hart had informed senior police officers who, if they did not sanction the deals, could do nothing within the law as it then stood to stop the loss adjuster. Hart told the judge, 'I always wanted assurances from Oxley he was not dealing with thieves or receivers. He assured me he had nothing to do with thieves.'

Several other prominent loss adjusters took the stand as prosecution or defense witnesses to answer questions about their ethics and methods of operation. Although by paying for information in good faith in no sense had Cecil Hart broken the law, or even his own ethical code, and although Oxley was acquitted, that trial spelled it out to insurance companies, middlemen, and art stealers that the reward industry as the Penrose gang envisaged it had ended. For Scotland Yard's art-squad detectives it had closed one more loophole; it had also convinced other theft victims to let the police handle the recovery problem and catch the thieves.

Another man did much to boost the reputation and morale of the art squad. Lord Radnor had just inherited the family ancestral home from his father, the seventh earl. At the beginning of May 1969 he spent his first night as new earl in Longford Castle, a four-hundred-year-old Tudor mansion, one of the finest in England, on the banks of the Avon. As he was breakfasting the following morning, his butler came to announce six pictures had been stolen from one of the downstairs rooms. A broken pane and open window showed how the thief had entered. Neither the forty-one-year-old earl nor his wife nor their staff had heard anything during the night.

Longford Castle had one of the finest private picture collections in the country, built up slowly over generations. It included the great Velasquez *Juan de Pareja*. (Lord Radnor would create a sensation by selling it in 1972 for £2.3 million — $5.5 million.) Two other paintings in the collection, Holbein's *Henry the Eighth* and a Jan van Eyck, had been acquired by the National Gallery; two other Holbeins had been sent to the Victoria and Albert Museum on loan. When they began their investigation detectives suspected a commissioned theft, presuming that a receiver had pointed a burglar at the two remaining Holbeins, and the burglar, failing

to locate them, had taken what came to hand. No connoisseur, he had grabbed Frans Hals's *An Old Woman* from one side of the fireplace but left its complement, *An Old Man*, on the other side. Holbein's *Portrait of Erasmus* had, however, vanished among the six paintings.

Several days later an approach was made to Lord Radnor. Unless the earl's insurance company paid 10 percent of the £7,500 the Hals was worth, he would never see it again. Lord Radnor refused point-blank to have any truck with villains and left it to the regional crime squad and Scotland Yard to do what they wanted.

Two things worried the Yard art squad. A small picture like the Hals — an eight-inch circular painting on wood — could easily be taken from the country in an overcoat pocket. Since only real experts knew the painting, it could easily filter into some foreign collection, protected by national property laws; second, not a single art-squad contact had heard a whisper about the men behind the Longford Castle raid. Months passed and Lord Radnor and the police were losing hope when finally a hint came along the prison grapevine to the Wiltshire police. An old jailbird called Fred Cottle had blabbed to a cellmate in Blundeston Jail, Suffolk, about a job he had pulled while out on temporary furlough. He had 'done' a big house and nicked half a dozen pictures that he had hidden until he was released for good. His cellmate seized the chance to win good-conduct marks and passed the word to the prison authorities. Detectives checked the story: Cottle had spent most of his life in prison and was now serving the final months of an eight-year sentence for housebreaking, theft, false pretenses, and forgery; at the time of the burlary he had spent several days free on furlough, and everything pointed to his guilt; he would be released on April 1, 1970. Could they make an April Fool of him and get back the pictures? The Bristol crime squad picked one of their most attractive policewomen, Delysia Smith, gave her another name — Dot Watson — and sent her to take a crash course in art. Back through the grapevine they got word to Cottle that some pals outside had found a buyer for his stuff.

On April 1 Fred Cottle, aged sixty, got off the bus at Lowestoft Station and saw an attractive brunette waiting by a car and carrying

an art magazine, as his prison chums had said she would. Miss Watson introduced herself and told him she had a buyer for his pictures. Cottle replied that they had a long way to drive and pointed them right across the country, to Dorset. As they drove the old jailbird chatted. He'd been told to do the job on Longford Castle. Somebody who'd cased the place. They wanted him to nick the best picture there, by a Spaniard, Velasquez. But it was dark and he couldn't shine a light. They'd told him the place would be empty, and it was crawling with people. He couldn't find the painting they wanted, so he'd whipped the first ones he'd come across. Cottle did not notice another car tailing them as they skirted north London and made for the West Country. Detective Chief Inspector William Banks and Detective-inspector Herbert Owens were keeping an eye on Dot Watson and Cottle.

At Bridport in Dorset they stopped. Cottle went to the disused barn where he had planted the pictures. With these in the trunk they drove the few miles to Poole, where Dot Watson suggested they would meet the prospective buyers to discuss terms; her buyers materialized as the two detectives. Cottle returned to prison, the only home he had known since 1928, for another five years. Delysia Smith and her two chiefs went to lunch with the eighth earl of Radnor to celebrate the return of the Hals in the ancestral castle.

Through the tenacity of men like Sir Roland Penrose and Lord Radnor, and the skill of detectives like Chief Inspectors Peeling and Lambert and Detective-sergeant Silk, the art squad had become a permanent part of Scotland Yard. In less than a year it had recovered pictures and other art objects worth more than a million pounds at market prices. Yet art theft was increasing much faster than the general crime rate; spiraling prices were attracting stolen paintings and other art works from Europe and other continents to Britain and the United States, where professional art gangs disposed of them through the black market.

# The Patience of Rodolfo Siviero

Rodolfo Siviero has created something of a legend for himself in the international art world. His stocky, quick-striding figure, his square face with darting brown eyes have popped up throughout the world wherever Italian masterpieces have surfaced — whether pillaged, stolen, smuggled, or otherwise dubiously acquired. Siviero, a voluble bachelor in his sixties, has had more imprecations heaped on his balding head than he has lost hairs. Germans have cursed the tenacity with which he fights to redeem loot seized by Hitler's special art commission, by Hermann Goering, and by other freebooters; Italian government colleagues have abused him for souring postwar relations with the German Federal Republic over the recovery of Nazi plunder; the Italian *carabinieri* (its hands not always clean in the art racket) have seen this determined little man as a rival and have tried in vain to topple him; some American museum directors revile his name, recalling his arm-twisting tactics to make them release priceless art procured by underhand methods. People who attack Siviero fail to appreciate the poet and artist in him; they forget he had risked his life resisting the Nazis to save art works; they cannot begin to understand what he felt on witnessing the willful destruction of his native Florence with much

of its unique Renaissance art, its bridges and buildings, by the retreating Wehrmacht; they do not realize that the redemption of Italian art treasures for Siviero is not a job but an act of faith, a promise to dead friends like the painter Bruno Becchi, who was shot by the Nazis while trying to save art works.

When Allied governments set up the recovery office in 1945, Siviero's catalogue listed some 3,600 art works missing from Italy; twenty-one years later seven hundred of those works remained on the list. Much of the unrecovered loot disappeared with Hitler's 35th Infantry Division when it retreated in August 1944 before the Allied Fifth Army and crossed the Brenner Pass into Germany. That unit carried plundered Raphaels, Memlings, Titians, Tintorettos, Peruginos, and a load of Greek and Roman statuary. Siviero is still waiting for just one hint of where that whole museum came to rest. Many of the repatriated works Siviero recovered himself — with his own money when his government would not reimburse expenses for his foreign trips. Sometimes he has had to 'horse-trade' pictures plundered by the Nazis against others they have claimed as their own through previous deals. In one case he had to wrangle for months over a batch of Renaissance masterpieces traded by a Florentine dealer against nine Impressionist pictures looted by Goering in France. That case he settled with American help, and the Germans returned the Renaissance pictures; many other cases still drag on, however. He has also achieved what many people considered impossible: wresting Italian art works from the Soviet high command in Berlin. For the Russians have stonewalled at every German attempt to retrieve their cultural treasures plundered by the Red Army. Siviero, who has the status of a minister without portfolio and the resonant title of Minister Plenipotentiary, Chief of the Foreign Ministry Delegation for the Recovery of Works of Art, has resisted all attempts to shut down his office following agreements between the Italian and German governments over wartime plunder. As he has said, many people are sitting on looted art, waiting for his organization to close so they can sell their illicit paintings and sculpture. Other groups of people would like to see Siviero out of the way, especially the crime syndicates that prey

on Italy's culture. Thieves who execrate Siviero's name should realize that his wartime underground cell actually ran from inside Gestapo headquarters in Florence. He is no mean sleuth.

Anyone with less sense of mission would have given up the recovery office long ago, for the job is too big. Italy has not one great artistic heritage, but several. Etruscan tombs disgorge ancient Greek art, while Attic colonies in Sicily have bequeathed some of the noblest Greek sculpture. Roman remains emerge everywhere, rubbing shoulders with the greatest art of the High Renaissance and the religious art of the sixteenth and seventeenth centuries. Paradoxically, Italian apathy may have done much to preserve these works; in a more progressive and dynamic society (New York, for example) might not a skyscraper have risen out of the Coliseum demolition dust? However, this indifference makes priceless relics easy targets for thieves — and that includes everyone from Mafia bosses through the small-time thug to the tourist who chips a furtive souvenir off Caesar's Forum or Pompeii. Siviero has to contend not only with thieves but also with double-dealing and voracious museum curators in other countries who want that Etruscan vase or that Raphael to boost box-office figures and who treat the ethics of acquisition as a minor impediment gentlemen may ignore. In fact, Siviero considers himself custodian of the world's greatest museum: Italy. Yet he has first watched the Nazis plunder its art patrimony, then, since the fifties, thieves and black-market dealers literally drain it of cultural treasures. In the twenty years following the war some 45,000 art works disappeared from Italy's 1,450 museums, thousands of churches, and private homes; by the end of the seventies some 64,000 art works from all sources had vanished, many channeled through art-dealers networks to foreign countries and therefore virtually lost. Each year an estimated $40 million in art is stolen for reward or ransom or on commission from underground markets abroad.

With an equally melancholy eye Siviero observes the rackets that Italians have developed around rewards and ransons for stolen art, often involving members of the carabinieri. A famous picture is stolen from a museum or church, so priceless that no bent dealer, black marketeer, or collector will touch it. A week later, the cara-

binieri flush a stolen car and hare after it, guns blazing. From the car window the priceless canvas sails into their police searchlight. Another triumph? Or some devious arrangement as well scripted and choreographed as professional wrestling? What can Siviero say about this reward industry that makes thieving a daily occurrence? No one can prove that carabinieri members are dipping their fingers into the extortion money. However, they do recover more pictures each year than are reported stolen — largely, they claim, because owners do not want the tax authorities to know they have lost valuable art works. Those pictures that get away land in Switzerland — in Geneva or Berne if destined for Britain or America, in Zurich if the stolen merchandise has a German buyer. Only then can Siviero act independently of the carabinieri to recover this stolen art through a constellation of informers, police, and Italian embassy officials built up over years. He prefers working with the foreign police to the dubious assistance he expects from the carabinieri.

Art and antique dealers have also developed petty rackets that have denuded hundreds of Italian churches of rare paintings and statuary. Often short of money for charitable work, churches and their priests sometimes succumb to offers from dealers who trade on the ignorance of the clergy to buy treasures for next to nothing, then export them. In September 1961 the case of the Neapolitan church of San Felipo Neri highlighted the problem. Two priests, Father Guido Martinelli and Father Allessandro Vasco, were accused of illegally disposing of $1.2 million worth of art work from the church and its art gallery and selling it to Naples dealers. Police also arrested eight antique dealers. Both priests had arrived in 1954, when the church had no money to fulfill its duty to the overcrowded poor of the Neapolitan slums.

But it had a fabulous art treasure built up over nearly four centuries from gifts by wealthy members belonging to the Order of San Felipo; aristocratic brothers had donated their whole fortunes, including works of art, gold and silver goblets, communion vessels, tapestries, and a library of 100,000 volumes full of rare editions and illuminated manuscripts. Father Vasco eked out the church income by selling its priceless possessions to art dealers

173

for a pittance. More than four hundred items had vanished from the church and its gallery; some turned up at restorers' workshops, others had been loaned to museums; but much had disappeared into antique shops and homes in Italy and abroad. Both priests pleaded that since their duties to the poor came first, they had sold the church treasure for the best motives; local people testified for them, calling them saints and not robbers. The court agreed and released the two men.

Behind many Italian thefts and the traffic in stolen art lies the hand of the international Mafia. If the actual theft presents no problems even to petty crooks, disposal of paintings and other art works demands organization and this, in many cases, means involving the Mafia. Rodolfo Siviero has tangled with this international crime syndicate several times. For instance, in February 1970, following a series of Sicilian Mafia raids on southern Italian churches, a group of mafiosi stole four paintings from Santo Domenico Church at Taverna near the toe of Italy. Investigations by the police and Siviero's office suggested the paintings had been smuggled abroad; but Interpol publicity and police inquiries in other countries yielded nothing.

However, six months after the theft, in August 1971, a pretty twenty-five-year-old Italian girl called Franca Bakaeva got a toothache and went to her dentist in London, where she was working as an interpreter. Under a light anesthetic, she babbled something about stolen paintings. When she had gone the dentist rang Scotland Yard and passed the information to Detective Chief Inspector Ronald Andrews and Detective-constable Donald Langton of the art squad. They did not act at once, but waited and watched Signorina Bakaeva and her boy friend, Giancarlo Molo, a barman aged twenty-seven. From this and their undercover inquiries, the detectives concluded the paintings might have come from several raids in Calabria, southern Italy. In October the two policemen acted on a tip-off, sealed off Euston Station, and opened luggage lockers until they came across a rolled-up carpet; inside lay four paintings. At the request of Scotland Yard, Siviero flew to London to identify the canvases; a glance told him they had come from Santo Domenico Church; two of them were by Mattia Preti, seven-

teenth-century Calabrian master — the *Child Jesus* and *St. Francis of Paola* — and would have fetched several hundred thousand pounds; another, *The Martyrdom of St. Lorenzo* by Lo Spagnoletto (José de Ribera), would have realized the same; the fourth canvas was by an unknown Neapolitan contemporary of Preti.

This operation confirmed what the London art squad and Siviero had suspected for a long time — that the Mafia had set up a connection in London for stolen paintings. First they smuggled them into Switzerland, probably using several of the thousands of immigrant Italian workers who crossed the frontier daily. Since Swiss authorities have no export controls on art, they could fly their booty into London or New York direct, or transport it to Britain by car and ferry. These mafiosi were picking lesser master-pieces either to sell to wealthy collectors who would ask no questions or to filter into the legitimate market when the limitations statute had expired.

Nine months later, when the case was heard in London's Old Bailey during June 1972, the Italian girl described how the Mafia had tortured her to secure her silence. Signorina Bakaeva said her lover, Giancarlo Molo, had let slip something about the stolen paintings one evening; he admitted a mafioso named Piero Pizani had asked him to look after a carpet in April 1970 and in it he had found the paintings. Piero would not take them back, and he and his Mafia friends had threatened Molo, his girl friend, and their families in Italy with reprisals if they did not cooperate.

Screwing up her courage, Franca Bakaeva made a special trip to Italy to see Piero and declared she would burn the paintings if he did not take them. Two men arrived and escorted her to a bungalow where five others interrogated her about the paintings and where they were hidden. Pushed into a dark room, she was tortured by the gangleader, who thrust burning cigarettes against her left leg to force her to confess what she had done with the paintings. She did not admit that Molo had decided to get rid of the stolen goods, then leave the country. When she returned to Britain she was so overwrought she let slip her garbled confession at the dentist's without even being aware of what she was doing.

Despite her plea Molo got five years' imprisonment for dis-

honestly handling stolen paintings, and Judge Gwyn Morris ordered his deportation on release, telling the Italian: 'You knew they were stolen from the sanctuary of the church and you knew the man who had stolen them was a member of an organization known as the Mafia. Without your help over a long period of time in protecting and concealing these pictures in London, that organization or its agents could not operate in the way it does, denuding the churches of southern Italy of their treasures and using victims like you to dispose of them elsewhere.' Signorina Bakaeva was acquitted of all charges.

Siviero had another tussle with the same branch of the Sicilian Mafia over a magnificent work of art that took six years and a gun battle to recover. For longer than anyone could remember, the *Ephebus of Selinunte* had stood in pride of place in the Castelvetrano town hall in Sicily. Dug up at Selinunte near the western tip of the island in 1886, the thirty-three-inch bronze statue of a young man was ascribed to Phidias, greatest of Greek sculptors, and ranked as one of the finest surviving Hellenic sculptures. No one could really put a market price on the Ephebus, although experts bandied about figures like $750,000 to $1.5 million. On October 31, 1962, while the mayor and his council staff were working in their offices, two strangers walked into the town hall, brazenly lifted the statue, and made off with it, unobserved in the sleepy Sicilian town. Detectives suspected two local mafiosi from Agrigento, seventy miles away, and their informants whispered that the men were acting on the orders of a Sicilian Mafia millionaire living in New York State. Within a few days underworld reports from the mainland indicated the men were trying to sell the statue themselves, having read in the press how much it would fetch at auction. But balked by police warnings to dealers, collectors, and galleries, the mafiosi were thought to have smuggled the statue into Switzerland to sell it where the law protected buyers. There too an Interpol alert had gone out with details of the statue and the two thieves. Frightened, the two mafiosi decided to enlist help and smuggle the *Ephebus* to the United States.

Over the months and years that followed, fragments of in-

176

formation trickled through to Interpol and the Italian police about the thieves and their booty. Their original customer, the New York gangster, had lost interest in such a hot piece of bronze, so the robbers had tried several museums where they met the same objections. One private collector offered them $45,000, then reneged on the deal. Back to Europe the two Mafia men trailed with their sculpture; five years later, still without a buyer, they continued to offer it here and there.

For five years, through his own contacts in Paris, London, New York, and Montreal, Rodolfo Siviero had tried to follow the fortunes of the *Ephebus*; he knew the thieves had hawked it round New York, had crossed the Canadian border and interred it in the crypt of a Montreal church. When it returned to Italy, he took action, seeking out a mafioso who had fallen out with some of his brothers in the Cosa Nostra and persuading him to go to Sicily and determine the exact location of the statue; but the Sicilian police unwittingly foiled this move by arresting the Mafia man, interrogating him, then leaking the fact that he was operating for the Italian government. He had to flee to escape vengeance.

Finally, one of Siviero's friends, Ugo Macera, the Agrigento police chief, heard a whisper that the *Ephebus* was available in Sicily through Mafia sources. Siviero went to a well-known Florentine art dealer, talking him into giving him papers identifying him as the dealer's agent with powers to buy the *Ephebus*. Then, armed with a Walther 7.65mm pistol, he flew to Sicily and booked into the Hotel Jolly at Agrigento, watched by both the Mafia and Macera's policemen. For days two mafiosi, Vicenzo Sciabica and Salvatore Nuccio, played cat and mouse with the then forty-seven-year-old minister, tailing him everywhere and threatening to shoot him if he tried to fool them. They wanted half a million dollars in cash. He haggled and kept haggling, beating them down to $120,000, then balking at that, and finally agreeing to pay $50,000. But he would not exchange the money for the statue in Sicily. Did they think him a fool in the middle of Mafia country? Both mafiosi eventually conceded they would make the exchange at Foligno, about a hundred miles northeast of Rome.

Siviero arranged a rendezvous in the basement of an antique

177

dealer's shop in Foligno. But he had already primed the dealer about his true identity and the type of deal he was making. Macera and his men and some of the Perugia carabinieri were posted all round the shop, waiting for the two Mafia men on March 12. But the mafiosi stalled, prevaricated, failed three times to show up. Macera advised Siviero to be careful; these men were taking no chances and were keeping watch on him and the shop before venturing to meet him. They feared a trap. On March 13, Macera called Siviero. 'You'll need all your calm, patience, and courage,' he whispered on the phone. 'There are six of them in two cars.'

It was one of the most dangerous moments of Siviero's career when Sciabica, Nuccio, and four of their henchmen appeared in that basement. '*Abbiamo portato l'*Efebo, *fuori i milioni,*' Sciabica said. ('We've brought the *Ephebus*, let's see the money.')

Siviero had to think quickly. If six armed men started to shoot it out with Macera's police in that cramped basement, several on both sides would die or be wounded. Siviero waved his hands, pointed to the six men, and stuttered. 'But how can I make a deal for a hot item like this in front of all these witnesses? And what happens to me if I'm stopped by a policeman in the street with this?' He persuaded Sciabica to send Nuccio and the others upstairs to wait in the street.

As Sciabica went to pull the *Ephebus* out of his valise, several of Macera's men surrounded him. Nuccio came back at that moment and was also arrested without a shot. Another of the Mafia men was arrested in a gun battle which went on for ten minutes to cover the retreat of the three who escaped. Sciabica, Nuccio, and Leonardo Bonafed were jailed for four years.

And the *Ephebus*? After its five-year tour of the old and new worlds it seemed little worse — a few scratches and a bit of verdigris on its bronze body.

Much of Siviero's time and energy goes into coping with the labyrinthine tricks of fences and dealers who keep the picture thieves in business; these men are expert at laundering stolen works so that auction rooms or collectors may fail to recognize

them as one or another famous original. Take the case of the *Madonna di Cossito*, which vanished in June 1964 from the parish church of Cossito near Rieti in central Italy. This exquisite thirteenth-century panel painting would never have eluded the eye of a good collector or auctioneer. So from the thieves it landed in the workshop of a Milan restorer who wrought some small but significant changes to fool those who might refer to an art catalogue. Over the frontier it went in the briefcase of an Italian 'businessman' to Switzerland and a fence who happened to be the director of a Liechtenstein auction house in Vaduz, capital of the principality. This Swiss receiver insinuated the painting into a catalogue of undistinguished art mixed with bric-a-brac (to deter any collector who might see it) for auction in Liechtenstein; in any case, his catalogue was circulated to a very few initiated dealers who came and formed a ring at the auction; for the *Madonna*, worth at least a million dollars, they bid a paltry sum among themselves. It now had an impeccable pedigree, having been sold at public auction; moreover, the dealer, who bought it with the connivance of the others, had a foolproof alibi if anybody asked questions. Each dealer in such rigged auctions either gets a share of the proceeds or has his turn at handling and profiting from some stolen object.

The *Madonna di Cossito* slept for several years before crossing the Atlantic. Three years after the theft, when everyone had forgotten it, a man suddenly offered an unspecified art work to a New York dealer for $300,000 — a high price for an undefined art work, but a bargain for anybody who realized the real value of the religious masterpiece. Suspecting the truth from the man's description, the dealer requested time to think and informed one of Siviero's network of friends in New York. After persuading the seller to send a photograph of the picture, this expert identified the painting as the *Madonna* stolen four years before in Cossito. At this point the middleman had to identify the seller, who turned out to be a former chief of a major German museum under the Nazis; since the war he had lived at Punta del Este, the coastal gambling resort in Uruguay. When the New York dealer haggled over the deal and declared he could not pay such a high price

for a work without having it authenticated by an expert, the seller agreed to let an independent connoisseur view the painting. A friend of his owned a villa in Switzerland where he could see the picture.

Siviero was the connoisseur. And with him on his visit to the villa at Weggis on the northern shore of Lake Lucerne he took a posse of plainclothes detectives. Of course, Signore Quinto Giorgini, the wealthy fifty-five-year-old Italian who owned the villa knew nothing of the provenance or value of the little painting. He was doing a favor for an acquaintance, not even a friend. However, he had to explain why his villa contained thirty other items of dubious source. With the *Madonna di Cossito*, these items were repatriated to various countries, including Britain, Austria, and Germany. That case proved how dealers can equip unique art works with a complete new ancestry and cross a dozen frontiers before offering them to the unsuspecting.

Another story, as strange as any in Siviero's files, concerns a consignment of paintings looted by the Nazis during the war and destined for the salt mines of Altaussee; nineteen years after their disappearance, their narrative took a curious twist seven thousand miles away in Los Angeles. In December 1962 a Californian art restorer, Dr. A. La Vinger, gave a TV lecture during which he urged people to rummage in their attics or take a closer look at what they had inherited from Grandma; they might unearth a treasure. A few days later Dr. La Vinger had a visitor. Johan Meindl, a postwar German immigrant and Pasadena waiter, brought two tiny and grimy panel paintings; he had picked them up in Europe just before he left for America after the war, he explained. Were they worth anything? La Vinger scrutinized the pictures, each measuring six inches by four. Carefully, he cleaned and restored them to reveal two masterpieces of Florentine art by Antonio Pollaiuolo — one of two brothers, both painters and sculptors — who pioneered new techniques of oil painting. These two works from Antonio's *Labors of Hercules* series, painted around 1460, would have brought half a million dollars, the Los Angeles restorer estimated.

180

However, when Siviero came to examine the fate of the pictures, Meindl's version of how he had acquired them had several holes in it. In fact, the Germans had looted them, with hundreds of other art works, from the Uffizi Gallery in Florence in 1943. Although earmarked for the salt mines and Linz, they never reached there. After the Nazis' capitulation, the Italians demanded a list of their treasures assigned to Hitler's collection. Page 18, which listed the two Pollaiuolos and several other works that Goering had grabbed for his own museum, was missing; Goering had intended the Florentine panels as presents for his baby daughter. But another mystery faced the Siviero investigators: the panels and other works never reached Germany with the consignment of Uffizi loot.

Prompted by Siviero the federal German authorities began to check the story of the missing Uffizi works in 1962. Meindl claimed that one of his old teachers (long since dead) had presented him with the two Pollaiuolos just after the war. He had no idea where the teacher had acquired them. That clue left the German detectives skeptical and led them nowhere. However, they had more luck in studying Wermacht records and locating Meindl's old army unit. In 1943 it had retreated from Italy before the American and British armies. And one of the tasks allotted Meindl and his company was the transport of art treasures from Montegna Castle, near Florence, over the Appenines into Germany. One by one the police eliminated the men of that transport company until they searched the flat of a master baker in Munich. They discovered five more Uffizi paintings hidden under a pile of clothing in a chest of drawers — a self-portrait by Lorenzo di Credi, a Nativity by one of Correggio's pupils, Domenico Feti's *Parable of the Vine*, Bronzini's *Deposition of Christ*, and an Annunciation by an unknown Bolognese artist.

According to the baker a crate containing these paintings had literally dropped off a truck on its way to Germany; he and Meindl had picked up the seven masterpieces and kept them. Prosecuting both men after nineteen years would have involved endless international wrangling, so after consulting the German authorities Siviero agreed to swallow the baker's story — the hoariest excuse

of any criminal caught with stolen property. Neither the baker nor Meindl knew anything about the three other paintings from the same crate — a van Dyck, another Bronzini, and a flower painting by an eighteenth-century Dutch artist, Jan van Huysum. Siviero believes the first two are hanging in some private house in Los Angeles and the third forms part of a private European collection.

Siviero is less accommodating about some other Italian masterpieces flaunted by public and private owners in Germany. Heading his black list is a huge eighteenth-century work by Sebastiani Ricci, grabbed by Hitler's special arts commission and now displayed in West Berlin's state museum. Germany claims Hitler bought it from Mussolini's son-in-law, Count Ciano, then Italian foreign minister, and there is evidence that money did change hands. Professor Henning Bock, director of the Berlin museum, says Germany bought it legally and the de Gasperi Commission, identifying it during their 1952 inquiry into looted art, recognized it as German. 'Lies, all lies,' Siviero retorted. 'Hitler was determined to get it by any means and the Germans have always refused to cooperate. But for the Allies we would never have recovered anything from them.' It angered him that the Germans could produce this work in 1972 and display it on the state museum ceiling.

In his black list he also cites a Madonna and Child by Francesco Giorgio, the fifteenth-century Sienese artist, stolen from a Florence gallery and now openly exhibited in the collection of a German steel baron in Lugano; a Crucifixion by the earlier Sienese master, Simone Martini, which vanished from a Pisa gallery and has since landed in an English stockbroker's home; some twelfth-century Tuscan frescoes, stolen from a church, which now grace the Swiss home of a Basel collector and dealer. Running to hundreds of rare and unique art works, the Siviero file remains, like the unsolved murder, ever open; while others have capitulated or urge the acceptance of the status quo, not Siviero. He toils on, knowing that every battle he wins to redeem one Italian masterpiece prevents or deters the thief, the dubious dealer, the unscrupulous collector, or the immoral curator from pillaging his country's

patrimony even more drastically. Despite efforts to sack him, Siviero has been able to keep his ministry going. His motive is plain: he is aware that if it closed, people who have concealed art works for a quarter of a century would feel they could safely place them on the market. Siviero has compelled governments and museum authorities to reassess their attitudes toward the import and acquisition of other countries' artistic glories; but for him, Italy and other lands, especially those of the Third World, would stand to lose more of their cultural legacies than they already have.

# 12

## *La Commedia Dell'Arte*

In the sixties and early seventies, Rome's dolce vita thrived on an explosive cocktail of hard liquor, hashish and heroin, LSD, and pep pills like Yellow Submarines and Purple Hearts — in short, anything to give the living-for-kicks crowd along and around the Via Veneto a new lift. In Roman nightclubs the most profligate fauna of Italian society romped and reveled among its most beautiful flora; rich playboys rubbed shoulders with pimps and prostitutes and even bishops and other members of the Vatican's black aristocracy congregated to do more than study sin at its fountainhead. These saturnalia and amalgam of high society and low morals or no moral touched off a series of sex-and-drug scandals that implicated several score of Rome's well-born families, certain politicians, and high-ranking police officials, plus assorted drug peddlers and petty crooks. A judicial inquiry revealed that the dolce vita had ended in premature death from drug overdose for several initiates, including the young wife of Paul Getty, Jr. One series of scandals, ignited by a row between two playboys over a case of stolen paintings, exposed several rackets that centered on the most famous of Roman night spots, Number One. More than thirty of its distinguished patrons found themselves answering

184

police questions about hard and soft drugs, currency frauds —
and picture thefts.

For it seemed that to fuel their wild nights Roman playboys
had invented another variation of the black art — stealing pic-
tures to collect from their victims or their insurance companies,
sometimes with the connivance, if not the collusion, of certain
police officials. Every other week Italians read of a spectacular
theft and equally spectacular recovery of paintings. But even
devout Italians ceased to believe in these miraculous redemptions
of stolen masterpieces, with the famed carabinieri flushing a stolen
car full of priceless art and pursuing the car with guns blazing
to retrieve the paintings — but never the thieves. To the less de-
vout, the whole business resembled a branch of the Commedia
dell' Arte with a scenario and stage and stunt directions drafted
by the Cine-Città studios.

It took a tranquil young Venetian, son of a celebrated Italian
painter, to lift a corner of the dolce vita and uncover the inter-
national racket involving upper-crust Romans and high-ranking
carabinieri members with picture thieves. Nicola Campigli, aged
twenty-nine, lived mostly at Saint Tropez in the villa built by his
father, Massimo Campigli, before the war. Campigli, a Florentine
artist who had settled in France, created a unique series of can-
vases, almost like pre-Christian art with primitive, childlike figures
drawn with geometric impersonality. When he died in 1971
Massimo Campigli left his son many of his best canvases — some
measuring three yards by two. Nicola, who writes and directs films,
never thought of protecting these works, which hung throughout
the Villa Bella Vista. When he went to stay in his Rome apart-
ment, he simply locked the liquor cupboard and turned the key
in the front door.

In September 1972 he made a trip to Rome. On the ninth, a few
days after his departure, his caretaker phoned to say that thieves
had broken into the villa and stolen six of the best pictures. Imme-
diately, Campigli drove the five hundred miles to Saint Tropez
without a stop, arriving that evening. It struck him at once that
whoever robbed the villa knew the layout perfectly, for they had

185

burst one pane of glass upstairs, opened the window, and climbed inside; they knew too where he kept his drink and had forced the cupboard lock and boozed their way through his vintage wines and liquor. As for the six paintings, they had eased them expertly from their stretchers and wrapped them in plastic sheets stolen from the house. Real professionals. They had also taken several sculptures and a collection of pre-Columbian vases. Nicola Campigli wondered who had tipped them off about his absence and exactly what to take; he suspected a former caretaker, a Roman he had sacked. Anyway, he decided he would do his damnedest to get his art treasures back. Little did he imagine then that his quest to recover his father's legacy would embroil him with dolce vita playboys, devious policemen, and odd magistrates, as well as thieves who did not shirk at murder and would cause him to fear for his life.

Saint Tropez police circulated details of the theft and the art, valued at more than $200,000; but hardly any mention appeared in the national press of France and Italy. However, a week later a letter arrived from Brussels. A small private detective agency in the Belgian capital offered to help retrieve his pictures for a reward of 3 percent of their insured value. Only then did the painter's son realize that his father's insurance covered only a quarter of the market value of the stolen pictures. Back in Rome a few days later, he received a second letter from the agency, repeating the proposal. Suspecting some trick Campigli replied that the paintings were not insured. On September 28 a third letter arrived, this time suggesting 6 percent of the estimated value of the stolen articles as their fee for finding them. He ignored it.

At this point Campigli had a curious phone call from a playboy called Gianni Buffardi, one of the luminaries of Roman nightlife and Italian cinema circles. He claimed an acquaintance with Campigli's father, then issued an invitation to his luxury flat in Via Paisiello near the Villa Borghese. What Campigli knew about Buffardi he had gleaned from following the Number One Club scandals in the Italian press. He passed for a film producer but had become better known for his roles in Via Veneto nightspots and his social contacts. Buffardi appeared to have friends every-

where — among top magistrates and small-time mafiosi, film stars and directors, newspaper editors and politicians. He flitted in and out of carabinieri headquarters and had the reputation of acting as one of their leading informers. In fact, Buffardi had broken the Number One sensation by accusing the club director of fencing stolen pictures. That led to a police swoop and the discovery of drugs, with accusations of drug taking and drug pushing against some top names in Rome's social register. Buffardi accused one of his playboy friends, Pier Luigi Torri, aged thirty-eight and a general's son, of peddling drugs; he in turn alleged that Buffardi was the real villain behind the drug business. Out of their legal tussle erupted the scandals that touched the best Roman families and finally brought about the closure of Number One. Torri discreetly dropped out of the picture. (In March 1980 he was sentenced to seven years' jail in London for bank frauds totaling $1.65 million.) Buffardi, who seemed immune from prosecution, decided to make a film about the Number One scandal and handpicked a dozen beautiful Italian starlets for parts that they eagerly rehearsed together in various night spots. Buffardi got no further than three rehearsals with his film project.

Campigli had a strange encounter with Buffardi, a bearded satyr who flaunted his teeth and dropped important names into his smooth patter, mostly about himself. 'I know something about the picture racket,' he told Campigli finally. 'I know because I have contacts among the playboys who tip off fences and thieves about who to raid and what to take.' Then Buffardi let something drop that put the painter's son on his guard. 'I know your paintings are in Brussels in the hands of a specialist,' Buffardi said. 'But he's not interested himself because they're not insured. So no reward. Now, since I'm a collector myself, I'm well placed to get them back for you. Just give me four or five days.'

Campigli left the flat, bewildered. So all those stories he had heard and read about the picture rackets were true! Now he had firsthand proof of how it operated through that talk with Buffardi, one of the men involved. Buffardi and the thieves, and perhaps even his carabinieri friends, fixed the theft between them, then split the reward; and if he, Campigli, and other losers fiddled

a little with the insurance company over compensation or restoration money everybody would finish happy. Thus the racket remained a nice, closed circle. However, Campigli was not going to play their little game.

Several times after that he met Buffardi; but now the film producer did not receive him at home, nor did he enter Campigli's apartment; all their talk about the stolen pictures took place in his car. But Campigli contrived to record their conversations; he carried a small radio transmitter, and some friends following Buffardi's car had receivers and were taping every word. Buffardi tried to frighten him by saying the Brussels fence was hoping to sell the paintings. Could he, Campigli, promise a little money to stop them from either destroying or selling his father's pictures? He mentioned 20 million lira ($30,000).

Campigli prevaricated. From other sources he was broadening his knowledge about the picture racket. Friends of his had lost pictures, but after they made a deal with a quick-talking middleman — resembling Buffardi — their chauffeur went to the French cemetery in Rome at the dead of night and behold — there lay the missing pictures! Campigli decided to go to the police with the full story of the theft and his dealings with Buffardi; but detectives shrugged, saying that if they pursued and caught the thieves Campigli would have a slim chance of redeeming his paintings. At his ministry office in the Palazzo Venezia, Rodolfo Siviero lent a more sympathetic ear. But what could he do, a minister without portfolio at loggerheads with the chief of the carabinieri?

Buffardi had good police contacts. At their next meeting he upbraided Campigli. Why had he asked friends about stolen pictures? Why had he gone to complain to the police and that man Siviero? Did Campigli really want to see his father's paintings again? As they parted he looked hard at Campigli and said, 'You know you're being watched.' After this the painter's son reckoned that every time he moved three separate people followed him — the first from the police, to see whom he met; the second a man from the carabinieri faction who were operating this racket with Buffardi; and the third someone working with the film producer.

Campigli felt certain the carabinieri spies were tapping his telephone. For instance, he rang to inform a detective called Giovanella about his tape recordings of Buffardi and had just replaced the receiver when his phone rang. A man mumbled he was sergeant so-and-so, babbling a name, then said, 'About that cassette, I'll come over and collect it.'

Suspicious, Campigli answered, 'What cassette? I'm a film director; I have three hundred cassettes.' Hanging up, he phoned Giovanella, who denied that anyone from his office had called about the tape recordings. When the detective eventually came and listened to the recordings, he declared he would have to arrest Buffardi on this evidence — but Campigli would have to say good-bye to his paintings.

Buffardi then made another move. To demonstrate his influence and immunity from arrest, he took Campigli to see Colonel Felice Mambor, head of the carabinieri, at his headquarters in Piazza San Ignazio. Near the entrance Buffardi suddenly shouted to two carabinieri whom he obviously knew well, 'When are you going to get the Campigli paintings back?' Pointing to Campigli, he chuckled and cried, 'This is the victim.'

Mambor, a small, roly-poly man with a luxuriant mustache, agreed to help recover the missing canvases. But Buffardi still acted as if he were pulling all the strings. To Campigli, it looked as though he were playing a role in one of his own mediocre film productions. On October 15, Buffardi called the painter's son, telling him to draw 18 million lira ($27,000) from his bank. He, Buffardi, was giving up his $5,000 commission as a goodwill gesture. 'The exchange takes place today, if you agree to the conditions,' he said. What choice did Campigli, having exhausted his own inquiries, have? Following instructions he drove to his bank, withdrew the money, and placed it in his car trunk. At 10:30 A.M. Buffardi appeared, this time riding a Harley-Davidson motorcycle. With Campigli in his car behind him, he made for the outskirts of Rome. When they arrived in open country he signaled to Campigli to stop and leave his car. From behind cover the artist's son watched Buffardi open the trunk and extract and examine the money. Later he whispered to Campigli, 'Everything's

fine. Your paintings will be found tonight. Listen to the radio tomorrow morning.'

Next morning, nothing. However, that afternoon a woman with a vaudeville French accent rang with a one-line message. 'Your paintings have been discovered at Saint Tropez.' Campigli immediately put through a call to the gendarmerie in the French resort and was told, 'Yes, something's happening.' Another call to Colonel Mambor, who admitted, 'Yes, your canvases have just been recovered.' When his caretaker at Bella Vista reported that French gendarmes had just returned the pictures, Campigli drove through the night to Saint Tropez. His six paintings lay in the villa, but they looked as though they had spent the missing six weeks in a quagmire — the canvas in each had swollen and the paint had cracked all over.

'You've got some droll fellows in the Italian carabinieri,' one of the French detectives remarked. Seemingly, one had turned up in a leather jacket and blue jeans, and the French detectives' description fitted Buffardi. At that time the film producer was figuring in the Italian press, publicizing his projected film on the Number One nightclub. Campigli drove to the port and bought an Italian paper with Buffardi's photograph. 'I'm pretty certain that's him,' the detective said, studying the picture. 'Same face, same pepper-and-salt beard. Only he called himself Solina.' It appeared they had discovered the canvases close by a camping site in the French alps, near the Italian frontier. Campigli felt sure Buffardi had stage-managed the whole business of the recovery — if not the theft itself. How had he known about those Brussels letters unless someone he knew had arranged to post them from the Belgian capital? He had used the Belgian trick to convince Campigli that he could retrieve the paintings.

While he had gotten his paintings back, Campigli nevertheless felt he had been duped and so could not leave the matter there; he decided to lodge an official accusation against Buffardi with the procurator-general of the Italian republic, Signore Carmelo Spagnuolo. No sooner had he done this than his phone began to ring in Saint Tropez, and insistent Italian voices warned him that unless he shut up they would shut him up. But he persisted

with his official protest. Thicker with each move, the Campigli-Buffardi dossier slid from one office to another in the department of justice until finally it lost itself in the convenient obscurity of Rome's bureaucratic catacombs. Spagnuolo was posted elsewhere; his successor was suspended. Colonel Mambor retired prematurely. Buffardi was remanded in custody by an examining magistrate on other charges but managed to secure his release on the grounds of ill health. Months faded into years, and still the Campigli-Buffardi dossier lay dormant. Finally another series of scandals and an upheaval in the Roman magistrature threw the file onto a new judge's desk, and he decided that Buffardi should be indicted for receiving the Campigli pictures. Arrested and charged, Buffardi found lawyers who secured one postponement after another until they too ran out of legal arguments. In 1978 the film producer was found guilty and given a sentence of two years and three months. A series of appeals followed, and finally the sentence was squashed. Buffardi could plead, with the backing of no less a personage than Colonel Mambor, that he was acting as a collaborator of the carabinieri and was Mambor's art consultant and confidant in such theft cases.

However, the Campigli case tarnished what gloss remained on Buffardi's image. By the time it ended most of the dolce vita itself had decomposed and the crowd Buffardi frequented had vanished, many of them dying in curious ways. Buffardi himself met a strange death. In the summer of 1979 he went swimming in the Tiber and a week later came down with a mysterious illness that caused high fever, jaundice, and skin hemorrhages. Within four days he was dead. Doctors affirmed he had caught Weil's disease from bathing in the river. Buffardi had every sign of this illness, fatal in one in seven cases and caused by a microbe in the urine of infected rats; doctors thought it had entered his body through a cut or skin abrasion, or even penetrated the nasal or oral membrane. His doctors had no doubt, but people in Buffardi's circle persisted in saying that a man with so many enemies and false friends did not die from drinking rat urine mixed with Tiber water but from some stronger, man-made potion.

That bizarre Campigli story has mysterious echoes in so many cases handled by the carabinieri in the crescendo of Italian art thefts; it almost seemed that the Latin theatrical flair played no small part in the duel between the carabinieri and the thieves. Until it became an epidemic or too much of a scandalous game, the authorities and public did not take these thefts too seriously, all the more because Italy is strewn so lavishly and carelessly with art treasures in public and private buildings and in churches. In any one of the two hundred Roman churches listed in most comprehensive guides, thieves can find a famous painting — say, a Raphael, a Lorenzetti, a Masaccio, a Lippi, a Titian. For example, on the night of July 26, 1970, art stealers picked a medieval church that houses a veritable museum of religious paintings, sculpture, and ornaments. Santa Maria del Popolo in the heart of Rome was undergoing repairs at the time, so the thieves borrowed a ladder and entered by breaking one of the rare stained-glass windows and shinning down a rope. From this art cornucopia they stole one object only — a thirteenth-century primitive painting of the Madonna. According to local legend, the *Madonna del Popolo* had wrought countless miracles; soon after being painted, it had halted an outbreak of plague in 1280 and touching it had since cured innumerable illnesses. What motivated the *Madonna* thieves? With Raphaels, a Caravaggio, a del Piombo, and other masterpieces within reach, why take this unique and unsalable painting?

Their coup had an interesting sequel. Colonel Mambor's carabinieri, who handled the quest for the *Madonna*, soon had leads from their underworld informants. Furthermore, it seemed that remorse was gripping the criminal classes; the pangs of religious contrition even reached hardened mafiosi, who offered to cooperate with Colonel Mambor to restore the sacred image to its rightful place. Again a middleman stepped in — it might even have been Buffardi — with the news that the painting had crossed several frontiers and now lay in the hands of a Dutch receiver who wanted his share of the reward money. At this point the story took another twist. An undercover carabinieri agent had infiltrated the thieves and frightened them so badly with talk of divine retribution that

they agreed to wrest the *Madonna* from the receiver's hands and return it through a go-between; according to the carabinieri's version of its fate, this accommodating man grew so scared of God's wrath that the saintly object burned his hands and he discarded it in a sleazy boarding house in northern Rome — a mile from Santa Maria del Popolo — and fled.

Only very pious Romans refused to doubt that story; the more incredulous and impious majority asked how much state money had changed hands to redeem the *Madonna*.

For some thieves nothing was sacred. On August 30, 1971, a three-man art gang hid in the parish church of Pieve di Cadore, a small hill town a hundred miles north of Venice, famous for only one thing — Titian had been born there. Out they walked with the one painting the great Venetian master had done for his native village, *The Holy Conversation*. Titian had painted himself into the canvas, depicting the Madonna and Child with Saint Andrew and Saint Titian; he had used his daughter, his brother, and his nephew as models for the painting destined for Titian's family chapel. This painting and thirteen others stolen from the same church by the three men had an estimated value of $1.5 million; it brought the haul by different gangs for that one week to fifty-eight paintings, mostly stolen from churches. With the raiders went icons, statues, chalices and other communion silver, wine stocks — anything they could lay hands on.

Eighteen days later, on September 17, the carabinieri had a tip-off: the painting would be offered to a dealer in the northern university town of Padua, which seemed to figure in so many Italian art cases. A restaurant owner phoned the carabinieri to say one of his customers was acting strangely and had flashed a wad of 10,000-lira notes ($15 each). Putting all this information together, the carabinieri identified two stolen cars in the early hours of the morning and gave chase; as they jinked and dodged after the cars through the narrow, medieval streets, the Titian sailed from the window of the rear car and landed in a shop doorway, and the cars sped off into the darkness. Was a ransom paid? Or did a middleman arrange a reward for the recovery and contrive the face-saving chase with the police? Unlike morality

193

plays, these adventures had a happy ending for everyone — even the villains.

On the day the police recovered the Titian, two more spectacular church robberies took place, one in Padua itself. There, from Saint Thomas's church, thieves stole sixteenth-century paintings by Antonio Vivarini and Francesco Maffei; less than a hundred miles away, at a church in Castelnuovo di Teolo, another gang cut a Tintoretto measuring six feet by three out of its frame and vanished with it. This same gang was believed to have robbed another Venice church, Saints Paul and John, earlier that month and taken five masterworks by Giovanni Bellini and Vivarini. Again, the recovery of these paintings had every hallmark of a staged operation. Like some assault landing, police launches racketed across the Venetian lagoon in the moonlight, beached on one of the islands, and police surrounded a disused building where, lo, they found the missing Bellinis and Vivarinis. No sign of the thieves who had pocketed their £3,400 ($8,200) reward.

Italian churches were becoming a vast cultural supermarket into which art pirates could dip at will. In the first eight and a half months of 1971, more than 3,000 art works had been stolen, and police had recovered no more than a quarter of these, either by detective methods or by using their many go-betweens. Most of the other paintings had been sent abroad for private sales in countries where the law protected the bona fide buyer, as in Italy itself; or they might filter slowly into legal markets where the law favored the original owners. Some would never surface again, having been acquired by very private collectors or destroyed by amateur thieves who had not succeded in selling them.

In the Venice region with its 3,000 churches, where all had something to loot and none had antitheft devices, an epidemic had broken out. Hardly a week passed without some church losing pictures or statues; criminals could obviously pick their time and place without fear of discovery while they worked. On December 10 three raiders broke into the cathedral at Castelfranco Veneto, twenty-eight miles from Venice, and stole what many art lovers consider the world's most beautiful painting, Giorgione's *Madonna Enthroned*. Nothing impeded them in an unguarded cathedral:

the key was in the main lock, there was no burglar alarm, and the window had already been breached by previous thieves. Signore Francisco Vallanover, regional head of the fine arts ministry, had uttered three warnings about the lack of security. But who would buy or even dare keep Giorgione's *Madonna,* one of the glories and attractions of the crenellated citadel where he was born and a masterpiece known to everybody with any artistic background? If it could have been sold openly, it would have realized about $10 million.

However, the thieves obviously had no intention of hanging on to the six-foot-by-five-foot painting or trying to sell it. Within a week their middleman had popped up in response to a $12,000 reward offer by the municipal authorities. From this man the carabinieri learned only that the Giorgione lay hidden about twenty miles north of Padua. For another week the middleman and the carabinieri played hide-and-seek; a nameless voice warned the Giorgione would be smuggled over the border into Switzerland unless the money were paid. Colonel Mambor mobilized his men all round Padua and set up road blocks on every road north. In the early hours of December 21, as though responding to their cue, or teasing Mambor and his police, an Alfa Romeo sports car crashed through one of the road blocks and headed north for either Switzerland or Austria. Pursuing it with siren whining, police in a carabinieri patrol car fired several submachine gun bursts. But before the police could catch up with the car the one man aboard stopped, leaped out, and disappeared across the fields into the darkness. A coiled rope in the car trunk gave the detectives the idea that the thief intended to attach a heavy load to his car. They began searching houses in the area; less than a mile from the chase scene the picture was discovered. Still on its stretcher, it lay wrapped in jute inside a plastic envelope. Police arrested a twenty-nine-year-old unemployed laborer who lived a few yards from the hiding place; but they could not prove he stole the painting or acted as a receiver. Nothing more was heard of the middleman, who presumably collected the $12,000, though this was never officially admitted. Was it police scheming or merely luck that won back the Giorgione? Most Italians did not even pose the

question; they had grown so blasé about these weekly miraculous redemptions that they greeted the recovery with the same apathy as they had its loss.

But even Italian cynicism and indifference came under strain three years and countless thefts later when, on February 6, 1975, a gang broke into the Palazzo Ducale in Urbino, home town of Raphael and a Renaissance center of art and science. Itself a Renaissance masterpiece, the Ducal Palace museum contained some of the finest works by Raphael, Titian, Signorelli, Vivarini, and even four small pictures by Raphael's father, Giovanni Santi. This time the thieves knew exactly what they wanted: three of the finest works in one of the country's leading museums. Using builder's scaffolding erected for repair work, they climbed the wall, broke a window, then calmly prized the three pictures from their gilt frames. When the two night watchmen discovered the empty frames and raised the alarm at 2:30 A.M., the stunned curator verified that Raphael's *Portrait of an Unknown Woman* was missing. And so was Piero della Francesca's *The Flagellation of Christ* and *The Madonna of Senigallia*. On the open market those three paintings would have realized no less than $12 million. Raphael and della Francesca had both worked in Urbino at the court of the powerful Montefeltro family when the town became known as the Athens of the North. Both della Francesca pictures represented landmarks in the artist's life and production, while the Raphael was his only work in his native town. An official lamented that they were dealing with the greatest art robbery in modern Italy, and connoisseurs compared it with the *Mona Lisa* theft. Local police and the carabinieri art squad mobilized and made a lot of noise, but they did not know where to begin their hunt. Within a week they arrested one man, only to release him for lack of evidence, then arrested another, who also proved his innocence. The paintings had vanished.

As the carabinieri were concentrating their forces on Urbino, another museum raid occurred in Milan. From the city's Museum of Contemporary Art, twenty-eight paintings by modern masters were stolen on February 16. Now the art pirates seemed to be challenging state authority itself. Like the Urbino thieves, these

were experts; they entered through a window after silencing the
five alarm systems and, operating a few yards from the night
guards, calmly removed the twenty-eight modern masterpieces and
drove off with them in a small van. Unlike the Urbino paintings,
this haul could be sold, and experts reckoned its market worth
at more than $5 million; it included two Corots and one canvas
each by van Gogh, Cézanne, Gauguin, Renoir, Bonnard, Ensor.

For a week or two Italy forgot its complacency. Its new Min-
ister of Cultural Heritage, Signore Spadolini, had to answer ques-
tions in the Senate and flew to Urbino to direct operations there.
Politicians talked of drafting troops to mount night guard on the
state museums. Experts uttered warnings to the thieves that the
delicate Raphael and della Francesca canvases, nearly five cen-
turies old, would crack and crumble unless handled with infinite
care. Carabinieri patrols buzzed around Milan and kept watch
on the frontiers of Switzerland, Austria, and France. In the midst
of all this activity, Rodolfo Siviero received a visit from a man
who had already served three years in prison for stealing a paint-
ing by one of the fifteenth-century family of painters, the Vivarinis,
from a Milan church. 'Give me a reward of 800 million lira
[$120,000] and I can help you get the Urbino pictures back.'
So the state paid the old jailbird, who was probably working on
commission for the men who had plotted and executed the raid.
And the carabinieri duly discovered the three paintings which had
never been taken from Urbino! A few weeks later the Milan paint-
ings turned up after a similar deal with state funds.

What part do certain carabinieri members really play in these
sinister farces, masking what has grown into a criminal industry?
Somewhere along the line it seems cooperation between the police
and the underworld through informers often becomes connivance
and sometimes collusion. *Il Carabinieri*, the monthly magazine of
the paramilitary national force, showed the redeemed Urbino
Raphael on its glossy cover and praised the carabinieri exploit in
recovering it. Of the magazine's eighty-four pages, no fewer than
fourteen dealt with art thefts and frauds in which the carabinieri
played the heroic role — though some people would change the
script and give them a more dubious part. Until the police beat

the reward racket, Italy will continue to suffer from its plague of art thefts — 5,843 art works stolen from churches, museums, and private homes in 1972, jumping to 8,520 the following year and 10,952 in 1974, the year before the Urbino and Milan thefts. Even now thefts are running at more than 12,000 a year and show little sign of abating. Those Italians who cherish their artistic heritage, both secular and religious, wonder just how long such cultural bloodletting can go on and whether the present system protects the villains rather than the art treasures they appear to steal with impunity, if not immunity. 'Visit Italy quickly,' say the wags. 'While there's something left to see.'

# 13

## A Dancing God, a Hot Pot & a Smuggled Raphael

As he was preparing to photograph the group of Hindu gods in Sivapuram temple near Madras, it struck the British oriental scholar Douglas Barrett that they shone a bit too brightly for bronze relics that had lain buried for centuries. Not much of the god *Ganesa*, the *Somaskanda*, and the *Siva Nataraja* showed through the garish ritual garments that adorned them; but as Barrett studied them more closely he felt certain they were fakes. Keeper of Oriental Antiquities in the British Museum and a world authority on early Chola Dynasty bronzes, Barrett wanted the photographs for the book he was writing. One of the statues, the *Siva Nataraja*, he considered among the earliest and finest of these Chola idols. Dug up in June 1951 on the Swagurunathaswamy temple ground, it belonged to the religious authorities who had placed it in the Sivapuram temple for local worship and religious ceremonies; but since it had verdigris, they had given it to a sthapathi, or bronze caster, with other statues for restoration in 1954. Two years later the statues came back. However, somewhere along the line someone had palmed the real statues and substituted these forgeries. Of this Barrett had no doubt, the more so since he had seen a Ganesa looking like the original on its way from Madras to New York four years before.

199

No connoisseur who had seen the marvelous *Siva Nataraja* could forget it; certainly no one could confuse it with this flashy imitation sitting in the temple shrine. Siva the Destroyer, third member of the Hindu trinity, was portrayed as Siva Nataraja (Lord of Dancers). Cast by a tenth-century sculptor, his forty-four-inch figure danced inside a halo of cosmic flames, his four hands holding symbols of his divine power; in one hand he bore a drum to produce the first primordial sound and by extension creation itself; tiger and cobra skins sheathed his body, testifying to his power over the animal kingdom; his flowing hair represented the goddess Ganga, the sacred river. In his classical dancing posture Siva symbolized the eternal cycle of death and rebirth, cosmic ebb and flow, which he personified in his dual role of creator and destroyer through infinite universal cycles. Although hundreds of these bronze idols existed, no two resembled each other perfectly. All the experts agreed with Douglas Barrett that the *Siva Nataraja* of Sivapuram was a masterpiece.

Barrett left the temple wondering where the sacred work had gone. However, he said nothing at that point. A month later, in February 1965, he was visiting one of India's most distinguished dealers and collectors, Mr. Boman Behram, and there, to his astonishment, he spotted the original *Siva Nataraja* and the original *Somaskanda*. Barrett did not raise the matter with Behram but mentioned it to two Indian experts; they assured him the Bombay collector meant to donate the pieces to the nation when he died to prevent them from leaving India. Shortly afterward Behram died, and everyone waited for the legacy of the two idols. In vain. Before his death the dealer had sold the *Somaskanda* and the *Siva*; and the bronze dancing god had started on its complicated itinerary, so strange and tangled that even the Indian police found it almost impossible to trace its path.

For a start the authorities arrested and interrogated the sthapathi, who acknowledged having the statue for restoration but maintained that the temple officials had agreed to accept a copy to replace the damaged original; he confessed having sold it, shortly after restoring the diseased parts, to Thilakar and Dass, a Madras firm that dealt in such art works. Questioned in turn an official of the

firm admitted the *Siva* had gone to an English businessman, Lancelot Dane, who lived in Madras. Dane seemed innocent of the real significance of the dancing god and kept it openly in his living room for several years; he had even used a picture of it as the back cover of a brochure called 'A Kaleidoscope to Madras' in 1959; he had bought the bronze in good faith and considered it his property, an argument the Indian authorities had never appeared to contest until its disappearance. Next halt in *Siva*'s odyssey was Behram's Bombay home. Influential and wealthy, with many friends in the Delhi government, Behram seemed immune from attack and had circulated the rumor among his high-placed friends that he meant to bequeath the *Siva* to the state. In any case (Behram argued) what could the Indian government do? Temple authorities had an immemorial right to dispose of religious relics and it seemed the priests had accepted the sthapathi's statement that the idol had gone beyond repair and taken a copy in exchange. It appeared that had Douglas Barrett not scrutinized the bogus Siva and other antiquities they would have remained there like hundreds of other fakes replacing original figures sold abroad.

Meanwhile other people had heard of the dancing god, among them the New York dealer Ben Heller, a hard-headed businessman with many contacts in India and the Far East. On a visit to Behram in Bombay during the early sixties, Heller saw the statue but did not buy it straightaway. In 1965 Behram sold the *Siva Nataraja* to another Bombay dealer, who kept it a short time before a New Delhi curio merchant named Harman Singh acquired it. After this several other art and antique dealers handled the statue, each of them able to supply evidence they had bought it. Thus the *Siva Nataraja* was covering its tracks and gaining a sales pedigree, making things difficult for the Indian authorities, who could not prosecute a small army of dealers for trafficking in stolen property — if they could even prove it stolen.

In 1969 the *Siva Nataraja*, crated and equipped with all the necessary papers, was flown to New York by Harman Singh's representative. An Indian export permit classified the idol as 'a tenth or eleventh century dancing Siva.' Once the statue was in

New York, the Indian businessman contacted Ben Heller and offered it to him. Heller bought the statue, and for three years it remained in the living room of his home before it was identified by an Indian research student. The student alerted the Indian Archeological Survey and the International Council of Museums, who protested that such unique items of India's art heritage should never have been allowed to leave the country.

Already the Indian government had issued worldwide notices about four other missing statues, including the *Ganesa* and *Somaskanda* from Sivapuram temple; but they focused their attention on the *Siva Nataraja*, affirming it to be the greatest work of Indian art outside their country and demanding an inquiry into its presence in America. They themselves were following its trail from Sivapuram to Madras to Bombay to New Delhi and New York. But native Indian talent for double-talk, pure fantasy, or downright mendacity left them with scores of versions of *Siva*'s journey; they had three separate stories for even the original switch of the statue: the sthapathi had conjured his counterfeit idol into the temple and sold the original; he had tricked the priests into believing the original had gone beyond restoration and bought it from them with the free copy for the shrine; the temple authorities, unable to afford the restoration fee, had instructed the sthapathi to use its original bronze to cast his copy.

One particular part of the journey puzzled them; how had the *Siva* gotten through the Indian customs? Had Indian customs officials examined the religious idol, the country would have exercised its right to acquire the work before it left national territory. Harman Singh had died, and with him the secret of how customs clearance was arranged. At the Indian government's insistence, U.S. customs officials questioned Ben Heller and went away satisfied with the art dealer's explanations. Heller maintained that Singh's representative had invited him to a city warehouse to view the idol; he had assured himself, and the U.S. customs, that the importer had complied with the regulations.

Blandly, Heller assented to the Indian proposal that he compromise and sell them back their statue. He would cooperate with any buyer. They could see the statue in his living room and pur-

chase it — if they could raise the necessary cash. 'The asking price is one million dollars,' he emphasized. When the Indian government haggled, then threatened civil action, Heller stood firm. He had other customers, among them a friend of his, someone who did not quibble about a few hundred thousand dollars or worry unduly about litigation or upsetting India or anybody else. This was Norton Simon, a restless, self-made millionaire who started in 1931 by bottling tomato products, assembled a huge national consumer corporation, and then retired to devote himself to his several foundations furthering education, art, and science. Collector-investor-perfectionist Simon applied his business techniques to his art ventures. But along with his time-and-motion ideas he brought a deep and original appreciation and the zeal of a late convert to art. He wrote: 'Art can help us not only look at ourselves, but also makes it possible to see others with greater sensitivity and insight. It is particularly useful when cultural barriers are involved. The more we are exposed to the art of other countries, the better we are able to understand and communicate with people from whose culture the art comes.' In the sixties the art world buzzed when he bought the Duveen Gallery, then paid a stunning £798,000 ($1.9 million) for Rembrandt's *Portrait of Titus*. Since then he had made spectacular purchases of painting and sculpture; the year before considering buying the *Siva Nataraja* he had paid between $15 and $16 million for Asian art. His second wife, the actress Jennifer Jones, had an interest in Yoga and persuaded him to visit India soon after their marriage. He came back hooked on oriental art. He constructed no permanent building for his collections, preferring his conception of a 'Museum without Walls' and lending his assemblage of art to various museums and galleries for exhibitions or long periods.

Yet even Norton Simon trod warily, taking a six-month option on the Indian sculpture before buying. In that time he did his own sleuthing about the alleged theft of the *Siva Nataraja*; although he gathered few concrete facts, he guessed the temple guardians had made some deal with the sthapathi, parting with the old statue for a new copy. Questioned about smuggling he came back in his forthright style. 'Hell, yes it was smuggled,' he said. 'I spent

between $15 and $16 million over the last year on Asian art and most of it was smuggled . . . I believe the authorities in Indian temples have the right to sell works. It's not like Italy, where the work belongs to the state.' Norton Simon's inquiries among dealers and museum curators confirmed that very little emerged from India and other Asian countries with state approval; everyone knew and connived at the smuggling of antiquities. For him what mattered most was that Heller had legal title to the idol and it had entered the United States legally.

One other thing spurred Norton Simon to acquire the sculpture; he was planning to lend his Asian collection, seventy-five pieces in all, to the New York Metropolitan Museum for a spectacular show. What would set off his exhibition more than the *Siva Nataraja*? But just when the Metropolitan officials and the Simon Foundation were finishing their preparations, the wrangle over the title and alleged theft of the statue caught Simon in a barrage of criticism, some of which ricocheted over to the Metropolitan. His purchase of the religious relic raised the whole question of whether countries or private individuals had the right to acquire smuggled art, or even deplete other countries' cultural heritage. 'Norton Simon Buys Smuggled Idol,' said the *New York Times* headline over the article by David L. Shirey on May 12, 1973, in which Simon admitted the smuggling.

The Indian government protested to the Metropolitan Museum and made an official request to the State Department, asking it to intervene and stop the exhibition of the idol. As a result the Simon Asian collection never went on view. At the end of 1974 the Indian government filed suit for ownership in England (where the statue had been sent for restoration), in New York, where Ben Heller lived, and in Los Angeles, headquarters of the Simon Foundation. It alleged conspiracy to steal the idol and sell it in America, thus violating the legal and religious rights of the Indian people. In addition, since Indian law considered the *Siva Nataraja* legally a person, the Americans were unlawfully detaining him and by so doing were denying Indians their freedom of worship. Altogether the Indian government demanded damages of $1.5 million if the statue were returned and $4 million if it remained in the

United States. Norton Simon's lawyers contested India's right to the statue; since Behram had displayed it in his collection since 1965 and the Indian authorities knew this, they had foregone any title because the statute of limitations in England, California, and India had run out.

In May 1975 the Indian government agreed to a one-year pause in their litigation to allow a settlement to be worked out. Lawyers finally agreed to a solution. Norton Simon gave up his title to the *Siva Nataraja* in exchange for the right to keep it over a ten-year period, during which time it could be displayed in any country that had diplomatic relations with India. India authorized Simon to keep the rest of his Indian collection. As part of the settlement Ben Heller handed over to the Norton Simon interests art works and a sum of money. By this time Simon had taken over and refurbished a whole museum in Pasadena. Originally intended to exhibit modern art, it now contains several hundred million dollars' worth of old masters. There, from August 1976, holding pride of place in the South India gallery sits the *Siva Nataraja*, which caused such a flurry in the art world and the diplomatic corridors in Washington and New Delhi. Some four million people will have seen the dancing god by August 1986, when he returns to the temple under which he had lain for so many centuries before his strange odyssey started.

At the height of the arguments over the *Siva Nataraja*, the Metropolitan Museum was running into the worst storm in its one-hundred-and-two-year-old history over another acquisition — a crisis that brought its flamboyant and controversial director, Thomas P. F. Hoving, into head-on conflict with the Italian authorities and the redoubtable Rodolfo Siviero. Hoving believed fervently that all art belonged in museums — his own first, then others. At that time the Metropolitan had some 3 million art works on show and in store. No stranger to headlines, Hoving had already figured in several booming controversies. Should he have paid $5.5 million for Velasquez's *Juan de Pareja*? More debatable, should he have flouted the expressed will of Miss Adelaide Milton de Groot and sold — the term for this in the dodgy parlance of

museums is 'deaccessioning' — fifty paintings that grand dame had been persuaded to leave his museum, to help pay for the Velasquez? Mr. Hoving, many people contended, thought more of his entry statistics and the droves who came to marvel at the price rather than the paintings. Then, during the ethical wrangle over a Turkish treasure acquired by the Boston Museum of Fine Arts, Hoving surprised certain people by appearing to reverse his stand, declaring that he and the Metropolitan would respect export laws of countries suffering art pillage and, if in doubt, would check the origin of art works.

At the beginning of November 1972, with a hyperbolic turn of phrase, Hoving announced that 'histories of art will have to be rewritten' because his museum had obtained a hitherto unknown calyx krater (mixing bowl) created by two great Athenian artists, Euxitheos the potter and Euphronios the painter, in the sixth century B.C. Waxing lyrical about his Greek bowl, Hoving wrote in his museum bulletin it was 'majestic without pomp, poignant without a shred of false emotion, perfect without relying on mere precision.' Prudently, he revealed that the museum had raised the million dollars to buy the work through selling ancient coins that had not left its vaults for years. Yet about the source of the Euphronios krater the Metropolitan and even Mr. Hoving appeared reticent. 'How did you get it, who did you buy it from, and how much did it cost?' A TV interviewer asked.

'Three of the questions the museum in its crafty way never answers,' replied Hoving, with elegant unconcern. 'We got it from a dealer who was the agent for a person who has had this in the family collection since about the First World War, and we don't talk about the name of these people because they have other things we might want to buy in future. You know, we might lose some of these things.'

However, three months later the Metropolitan had to name names when the *New York Times* revealed the Greek vase had come from an expatriate American dealer who was persona non grata for his business style with at least one government. According to the Italian authorities, *tombaroli* (pot hunters) had dug up the krater in November 1971 from an Etruscan tomb north of

Rome. Moreover, the Italians claimed, the vase had been smuggled out of the country. To this clamor Siviero added his voice, saying that if it were proved the Greek vase had been stolen from Italy within five years of its discovery, it remained Italian property.

After some arm-twisting by Siviero's ministry, the Metropolitan curator of Greek and Roman Art, German-born Dr. Dietrich von Bothmer, revealed that a Lebanese of Armenian descent, Dikran A. Sarrafian, had sold the vase through an American middleman, Robert E. Hecht, Jr. Letters from Sarrafian to von Bothmer attested that the Armenian did not know the provenance of the vase, only that in 1920 his father had exchanged Greek and Roman gold coins for it with a London dealer. Sarrafian, who lived in Beirut, stated he had first seen it in pieces and had recently decided to have it restored and sell it because he was moving from Lebanon to Australia. He had since changed his mind about emigrating. Sarrafian passed for a war hero who had parachuted into Yugoslavia to serve with Marshal Tito's guerrilla forces as a British intelligence officer (one of the huge SIS army that secrecy prevents Britain from acknowledging or disowning). No one remembered Sarrafian's wartime exploits, and no record exists, either British or Yugoslav. Other snippets from his curriculum vitae mentioned he attended a British school (unnamed) and then became a Quaker gentleman before being inducted into the honored profession of coin collectors.

Hecht also cut a curious figure as the other protagonist in the tale of the Euphronios krater. Born in June 1919 in Baltimore, scion of a family with chain stores in Baltimore and Washington, he graduated from Haverford College, then became interested in ancient art, developing a reputation as a connoisseur with a nose for the big find. Based in Rome since 1955, Hecht had traveled extensively throughout the Mediterranean and the Near East; his antique hunting had landed him in trouble with both Turkish and Italian authorities. Turkey, already sensitive about the pillaging of its lost cities and gold hoards, discovered Hecht with a collection of ancient coins, confiscated them, and declared him persona non grata. In Italy during the early sixties he was accused of receiving looted antiquities, and though this charge was later dropped

*View of the Euphronius Krater on display at the Metropolitan Museum of Art, New York, showing the dead warrior Sarpedon being removed by the winged figures Hypnos and Thanatos, as Hermes watches. (William E. Sauro/NYT PICTURES)*

the Italian authorities kept a close watch on him and even requested him to leave the country.

Hecht had a long friendship with von Bothmer, and in February 1972 contacted him with the news about the Euphronios krater. When both von Bothmer and Hoving had examined photographs of the Greek bowl they flew with Hecht to Switzerland, where it lay in the Zurich home of a restorer, Fritz Buerki. At first sight von Bothmer recognized the krater as a masterpiece; it depicted the Trojan War scene of Sarpedon, son of Zeus, being borne bleeding to death from the battlefield by the gods Thanatos

*Second view showing young warriors arming. (William E. Sauro/NYT PICTURES)*

(Death) and his brother Hypnos (Sleep). Leaving von Bothmer to rhapsodize over the art work, Hoving bargained with Hecht, who demanded more than a million dollars for the Euphronios vase. His haggling ended, Hoving put the crucial question: 'Is this a hot pot?' Hecht assured both museum officials the krater had neither been looted nor smuggled. As Hoving recalled it later, 'Mr. Hecht said the vase was definitely not a hot pot. We had no reason to doubt him. He's the kind of guy whose opinion I'd ask on an ancient work.'

209

Hecht failed to convince quite a few people. Colonel Felice Mambor bluntly called him a liar and produced thirty-seven-year-old Armando Cenere, farmhand by day and pot hunter by night, to say he had dug up the Euphronios krater at a place called Santangelo, northwest of Rome. He well remembered the figure bleeding from the heart and knee. Siviero and other Italian authorities requested an FBI investigation into the acquisition of the Attic bowl. Hecht judiciously stayed away from Italy, quipping that he had no plans to return until assured the government would not offer him free bed and board — in prison. A check for a million dollars had already swollen his account in a Swiss bank; although Hecht declared he was selling the vase for Sarrafian, the Lebanese coin dealer denied ever having received anything like that sum.

Whom and what to believe in all these tales? Soon after announcing the Metropolitan prize, Dr. von Bothmer talked about it to the annual meeting of the Archeological Institute of America in Philadelphia. There the pundits lent little or no credence to the hoary fable about the krater suddenly surfacing out of an old European collection; they laughed off Sarrafian's unsubtle excuse that the krater sale would pay his passage to Australia. They plumped for the *tombaroli* theory. Most archeologists — and pot hunters — knew the Greeks exported much of their pottery to Italy, and prize pieces by Attic painters like Euphronios turned up mainly in Etruscan tombs. Not only did von Bothmer's colleagues remain skeptical about the origin of the krater, they scoffed that the Metropolitan had paid at least five times too much for it. Hoving and his museum sat tight on the krater, weathering Italian assaults and ridicule from their rivals. Perhaps he and his staff felt that fifty times more people would come to have a look at a million-dollar pot — even if it were not hot — than would go round the corner to look at a calyx krater — even one made by the Greek potter Euxitheos and decorated by the painter Euphronios — five times cheaper.

Two hundred and fifty miles northeast of New York, another famous museum had run into trouble on two counts, both con-

cerning the acquisition of art treasures. Like the Metropolitan, the Museum of Fine Arts in Boston was holding its centenary and wanted to astonish the public at large, and the Met into the bargain. On February 4, 1970, as part of an initial show called Art Treasures for Tomorrow, two items caught the attention of the cognoscenti. One was a painting attributed to Raphael, titled *Portrait of a Young Girl*, which had cost the museum $600,000 in 1969. Experts stared, wondering where the museum director, Perry T. Rathbone, had unearthed that unknown Raphael. But more attention focused on the other major item, a gold hoard of Bronze Age jewelry acquired for an unspecified six-figure sum in 1968. Again the museum remained coy about the provenance, merely disclosing it came from 'one of eleven or twelve countries located in the eastern Mediterranean.' Immediately the museum was assailed by journalists who challenged it to deny the hoard emanated from Turkey; the *Boston Globe* affirmed it had probably been found at Sardis, King Croesus's former capital in Western Turkey.

Soon the U.S. Government was facing a demand by Turkey for an inquiry into the source of this royal treasure. At the mere mention of stolen treasure Turkish wrath understandably boiled over. A poor country, it had seen much of its rich heritage pillaged after the German, Heinrich Schliemann, discovered Troy in the late nineteenth century and spirited away a priceless collection called Priam's Treasure to embellish a Berlin museum. An archeologist's paradise at a crossroads between Asia and Europe, Turkey has something like fifty thousand digs, from family burial grounds to buried cities like Troy; so many civilizations have halted and left their traces, from Neolithic colonies through the Bronze Age tribes and peoples like the Hittites, Assyrians, Lydians, Persians, Armenians, Greeks, Romans, Byzantines, Arabs. Until the Second World War, archeologists helped themselves and museums to the choicest discoveries from this immense territory of the buried past. Many of them hoped for some of Schliemann's luck and the 'strike' of a city like Sardis, Croesus's capital. Brazen postwar looting of Turkish sites saw more than a thousand important treasures smuggled out of the country in the fifteen years from 1955 to 1970. Whole regions became one huge dig, with archeol-

ogists, treasure hunters, bounty hunters, and thieves disputing the pickings.

Several finds of ornaments and jewels in buried cities and vaults created gold fever, which reached its climax with the Dorak affair. This most mysterious of all treasure stories began when a girl calling herself Anna Papastrati entered a train compartment occupied by archeologist James Mellaart, who was going to Smyrna (Izmir), the western Turkish port in 1958. Mellaart, Dutch-born assistant director of the British Institute of Archeology in Ankara, noticed a solid-gold bracelet on the girl's wrist; on a closer look, it struck him as the kind of jewelry discovered near Troy. Miss Papastrati astonished Mellaart by declaring she had a whole collection of such things at home. Would he like to see them? At her house in Smyrna Mellaart spent several days poring over a treasure of figurines, daggers, scepters, and gold cups that Miss Papastrati claimed had been dug up, illicitly, at Dorak, a buried town near Troy. Her treasure obviously came from a royal burial, Mellaart concluded. On returning to Ankara he reported his find to his superiors and the Turkish authorities, though without mentioning Anna Papastrati. During the next year he published the sketches he had made in the *Illustrated London News*. These and the accompanying text created a sensation, and some time later a Turkish newspaper investigated the Dorak affair and accused Mellaart of smuggling the treasure out of Turkey. Forced then to make inquiries, the police searched for Anna and the house described by Mellaart, but neither could be traced. Mellaart was banned from archeological work in Turkey amid speculation about whether the Dorak treasure existed or not. One suggestion was that Mellaart invented the Dorak affair to publicize himself; yet he must have foreseen it would ruin his very high reputation in archeological circles. Another version proposes the Dorak trove does exist, but a prospective buyer wanted the stamp of an eminent scholar; the treasure hunters had picked Mellaart and used the girl as bait. Although the Dorak treasure has never come to light and doubts about its existence remain, its very name angers the Turkish government and explains its thin-skinned attitude to the drain of its other treasures.

Turkey had cause to complain about other cases of plunder. In 1959 the Schmuckmuseum in Pforzheim, Germany, obtained the Sardis treasure, dug up by moonlight robbers from a burial site near the old Lydian capital; four years later, the Dumbarton Oaks Museum in Washington acquired the Kumluca treasure, a collection of Byzantine silver made between A.D. 565 and 575 and dug up near Antalya on the south coast of Turkey. It too had its legend. A peasant woman's dream led her family to dig between tree roots, and lo — a huge cache of priceless silver, more than a hundred pieces! A dealer happened that way, bought part of the Kumluca hoard, and sold it for a million dollars to the American museum, prudently moving to Switzerland before word of the deal reached Ankara.

It was this same Anatolian dealer who sold the Boston museum its gold hoard in 1968. He had already offered it to the Metropolitan, but Hoving had dismissed it airily as a 'dealer's bag' of disparate pieces in a job lot to increase the price. He omitted to mention he had acquired an even bigger Turkish trove some years before but had discreetly placed it in the Metropolitan vaults and more discreetly left it there during the 1970 anniversary exhibitions. At the final show five pieces did break surface, compelling the disclosure that the museum had paid the Madison Avenue dealer, J. J. Klejman, half a million dollars for 219 pieces between 1966 and 1968. Klejman claimed he bought the collection in Europe from junk merchants ignorant of its real value. Classical archeologists who studied the five pieces identified them as Lydian — and looted.

Hoving erred about the Boston treasure. When Boston's curator of classical art, Dr. Cornelius Vermeule, saw the collection he realized it had probably come from a royal burial and was a significant find. It included bracelets, rings, a necklace, diadem, pectoral chains, and an Egyptian Fifth Dynasty gold cylinder seal — in all 137 pieces between 4,500 and 4,200 years old. Landon T. Clay, a museum trustee who lived in Switzerland, donated the purchase money. Both the Boston and the Metropolitan museums hung on to their Turkish acquisitions, employing similar arguments to defend their title against official demands. Were they not doing

archeology and the world a favor by keeping such collections intact rather than watch venal and illiterate brigands scatter them? As for the countries of origin, they should spend more on preserving their antiquities and preventing thieves from despoiling them.

But no such argument could settle the other scandal that hit the Boston museum on its same anniversary occasion. For this time museum officials were tangling with Rodolfo Siviero, who accused them of having no less than smuggled Raphael's *Portrait of a Young Girl* out of Italy. Siviero's concern began in the middle of December 1969, when Rathbone announced the discovery of a hitherto unknown Raphael. It had come from an old European collection belonging to an elderly private collector who was nearing eighty and wished his favorite painting to go to a great institution where the public could appreciate the beauty of Raphael. His price: $600,000.

Siviero had heard such stories before. In his Rome office he started to take the pedigree of the Boston Raphael apart. Measuring 10½ by 8½ inches, it showed a young girl in early sixteenth-century court dress, identified as Eleanora di Gonzaga on the occasion of her betrothal in 1504 to Francesco Maria della Rovere, later Duke of Urbino and the painter's patron. The portrait passed into the hands of the powerful Fieschi family, where it remained for more than four centuries before being sold to a Genoese dealer in 1947. Siviero could trace no record of this transaction. But one thing struck him — the frame had changed. Some clever sleuthing enabled him to track down the frame carver, who led him to an octagenarian dealer, Feruccio Ildebrando Bossi, living in Recco, twelve miles east of Genoa. Yes, Signore Bossi admitted, he had once owned a frame not unlike the one Signore Siviero described. And yes, he might have used it to frame a small portrait not unlike the Raphael. But he had sold this modest little painting some years ago to a Swiss collector.

Siviero persisted. He discovered Bossi had a criminal record dating back to 1924, with a five-year conviction for art smuggling; furthermore, he had been banned from dealing. Under pressure Bossi finally confessed he had bought the Raphael from the Fieschi

family, paying an estimated $1,000. It had taken him two long years to find a buyer when he decided to sell, primarily because prospective customers did not believe the Italian government would grant one of its rare export licenses for such a work. Hotel registers completed Siviero's case, proving that on July 12, 1968, three Boston museum officials arrived in Genoa to see Signore Bossi; they were Perry T. Rathbone, Hanns Swarzenski, the chief curator, and John Goelet, a trustee. Six weeks later Swarzenski returned alone to Genoa; on the following day he flew back to Boston via London and, according to Siviero, he carried the picture with him and failed to declare it either on leaving Italy or arriving in Boston.

Making the most of this cloak-and-dagger operation, Siviero immediately informed the United States embassy in Rome of the alleged smuggling offenses; through Genoa's prosecutor he had both the Boston museum director and chief curator named on charges of illegally exporting an art work, smuggling, and breach of financial regulations. Both men would have to make the journey to Italy to stand trial on such charges. At the same time the Italian government requested the U.S. authorities to confiscate the painting and make their own investigations. In January 1970 U.S. customs seized the Raphael, took statements from museum officials, and questioned Swarzenski, who pleaded he had not cleared the picture with the U.S. authorities knowing it would incur no duty and being under the impression his museum had already declared it. He had committed a technical breach of U.S. law and a more serious offense in failing to declare the portrait at Genoa. The news caused a sensation throughout the art and museum worlds. Who would have believed that the elegant and urbane Rathbone would lend himself to art smuggling? Or that his chief aide, the white-maned and dignified Swarzenski, would tuck a $600,000 Raphael into his suitcase and forget to declare it?

In the middle of the legal inquiries, Bossi died in May 1970, aged eighty-four. Even without his testimony it was clear the Boston officials had flouted the law. In the summer of 1970 Siviero arrived in Boston to negotiate the return of the Raphael, to which the museum had agreed providing the charges were dropped. In

*Rodolfo Siviero in triumph with the restored Raphael,* Portrait of a Young Girl. *(L'Espresso)*

September 1971 the portrait went back in the Italian diplomatic pouch — the first time an undeclared painting that had not been stolen was returned to its country of origin.

A month afterward Swarzenski retired as curator and two months later Rathbone announced he had decided to retire early to pursue private activities. These cases of the Boston Raphael and the various Turkish treasures led museums in the United States, Britain, and other European countries to reconsider their ethical rules for acquiring antiquities and paintings from other countries. Many United States museums made public declarations that they would buy nothing that did not possess a full pedigree and that could not show an official export certificate from its country of origin and an import license from U.S. customs. Art theft was still an international epidemic, but it would get immeasurably worse unless museums, however extreme their ambition, refused to purchase art of dubious origin.

# 14

## *Altaussee: A Lamb in the Salt Mine*

Maybe the cathedral light was tricking him, but Jos Trotteyn
could have sworn the panel of the painting he was cleaning dated
from five and a half centuries ago rather than forty years. It had
that fine crazing of well-preserved medieval work, that yellow
bloom on very old oil surfaces. But surely he was deluding him-
self, for the painter who had made this copy to replace the stolen
original had given one of the Virtuous Judges the features of the
young Belgian king, Leopold III. And on the second-last judge
from the left he could discern Leopold's face quite clearly under
his magnifying glass. Only . . . only it seemed there was another
face underneath. Maybe the copyist had merely repainted that
one face on the original panel. Trotteyn did not know what to
suppose. For each of twenty years the Flemish artist had cleaned
this painting, one of the most famous of all Northern Renaissance
art works — the *Adoration of the Lamb* by the brothers van Eyck
and the glory of Saint Bavo Cathedral in Ghent. Curious he had
never noticed before this restoring session in March 1974, Trotteyn
reflected. Like every other Flemish painter, he knew the strange
history of this masterpiece, how a panel had disappeared in 1934
and how a mystery still surrounded that theft. Had someone,
somehow, returned the original panel and disguised it by over-

painting one face? Closer scrutiny strengthened this conviction in Trotteyn, a surrealist painter as well as restorer. He spoke to his friend and fellow painter, Hugo de Putter, who came to the cathedral to scan the twelve panels of the *Adoration of the Lamb* and compare them with the bottom, left-hand panel, that part of the Virtuous Judges that had been stolen and presumably replaced with a copy of the original. He shared Trotteyn's view. Paint would not age and assume that patina in a mere forty years. And who could duplicate those marvelous figures and that limpid quality of the van Eycks that had survived five and a half centuries?

Their findings caused a sensation in the art world. Experts arrived to study the van Eyck masterpiece; they agreed the panel had aged remarkably, but x-ray analysis revealed subtle differences with the original woodwork; the van Eycks always used a special plaster and glue preparation, and a comparison of the wood grain and paint particles proved the Virtuous Judges panel was the copy made by the Brussels painter Joseph van der Veken soon after the theft. And there was no face underneath the painting of Leopold III. Though subdued by this evidence, Trotteyn still had his doubts. More so since he received a mysterious phone call after stating that he believed the panel to be authentic. His anonymous caller, who seemed anything but a crank, said he knew something about the missing painting: it had been cut into several pieces, but it had never left the city of Ghent. When Trotteyn pressed the man for his name he refused to give it because he feared revenge.

Trotteyn was mistaken, but he had proved one thing at least — the curious power of the *Adoration of the Lamb* to reinforce its troubled and enigmatic story. For the van Eyck masterpiece ranks as the most stolen, most coveted, most itinerant of all great art works. Even its creation remains a puzzle and its creators a mystery. Was it Jan alone or Jan and Hubert van Eyck together who painted it? Art historians, scholars, and painters have never really made up their minds. It looks like the work of a single hand, Jan's, and no one has ever discovered anything about or by Hubert, except an inscription on the frame of the *Adoration* during clean-

ing in 1823. It reads: '*Hubertus——Eyck, Mator quo nemo repertus icepit, pondusque, Johannes Art secundus——ecit. Judoci Vijd prece Fretus. VerV SeXta Mai VosceoLLocat aCtat Ver I.*' Guessing the missing letters and deciphering the chronogram of the last line, translators have come up with this text: 'Hubert van Eyck, painter with no equal, began this painting. Jan, second in art, finished it at the instigation of Josse Vydt and invites you by this verse on the Sixth May 1432 to contemplate it.'

More ink has been spilled on the painting and that conundrum than on anything else in art history. It appeared that someone other than Jan had carved the inscription in silver foil over the original gold foil of the frame. And Jan could hardly have used the sixteenth-century language in which it is couched. Did the Ghent notables want to invent another painter for the greater glory of their town? If Hubert outshone Jan — no mean artist — why are more of his works not preserved? Why do we know so little of the painter himself? Why did great patrons like Philip of Charolais and the dukes of Burgundy not keep commissioning him? Were rebellious Ghent burghers really staking claim to the *Adoration* through the mysterious Hubert because Jan had painted for so many foreign princes who might seize his masterpiece when they took over Ghent? Those questions have kept art pundits debating for centuries.

Legend has it that Hubert began and Jan finished the painting. Whatever the reality, the *Adoration of the Lamb* is a great masterpiece by the painter (or painters?) who founded the Flemish school. If Jan van Eyck did not invent oil painting, as some claim, he produced something far ahead of his own time and his great rivals; his brilliant use of oil and varnish mixtures as a paint medium smacked of alchemy to contemporaries; painters like Albrecht Dürer (1471–1528) came to study the *Adoration*, marveling at the radiance, clarity, and transparency of its colors, wondering at the art that could render dozens of disparate figures with genius and weld them with perfect symmetry into a natural background. Around the centerpiece of the mystic lamb stands an adoring multitude, symbolizing the Christian belief of sin redeemed by Christ's sacrifice. Above this main panel sits Christ,

flanked by Mary and Joseph. On the side panels are Adam and Eve, angelic choirs, the Garden of Gethsemane, and the two panels depicting a group of mounted men, elaborately costumed and bearing pennants. These were the Virtuous Judges. On the reverse side of these exterior panels another group of saints and angels appeared with the figures of Josse Vydt and his wife. In all the polyptych comprised twelve heavy oak panels covering fourteen and a half feet at its widest and eleven and a half feet at its highest.

The polyptych formed the altarpiece at the Saint Bavo Cathedral for a hundred and thirty-four years before its turbulent story began. In 1566 the Reformation erupted in Ghent, and a crowd broke into the cathedral to seize the *Adoration*; they hunted everywhere for it, unaware it lay concealed in the church tower. When Ghent turned Protestant its burghers thought of offering it to Queen Elizabeth of England, who had subsidized their movement; but Josse Triest, one of Vydt's descendants, opposed the idea and it stayed in Flanders. When the town reverted to Catholicism in 1584, it again stood over the altar. For two hundred years, while Flanders and other parts of the Netherlands were changing hands, the van Eyck masterpiece remained intact and unmoved — until the enlightened but priggish despot, Joseph II of Austria, was visiting his new dominion and his outraged eyes fell on Adam and Eve in their primordial nudity. Recovered from his shock the king ordered copies of both figures, decently covered in bearskins, and dispatched the offending van Eyck panels to the church cellars. In 1794, during the French Revolution, Ghent fell to French troops; when they returned to Paris the four center panels went with them, later to add luster to the Louvre in Napoleon's capital of the arts. In 1814, when Napoleon escaped from Elba and seized power, Louis XVIII sought refuge in Ghent. When he was restored to the throne he returned the *Adoration* as an act of gratitude.

However, the altarpiece was soon traveling again. In 1816, a year after the French returned the center panels, Vicar-general Le Surre of Saint Bavo disinterred the folding doors and sold them to a Brussels antique dealer. This merchant in turn smuggled

them across the frontier to Prussia, selling them to Frederick William III. Eighty years later the panels were split to exhibit the paintings on both sides at the same time. Finally, this section landed in the Kaiser Friedrich Museum in Berlin. Meanwhile, in 1861, the Belgian government bought the two remaining panels, the nude figures of Adam and Eve, and the bearskin copies; these went on permanent show at the Brussels Musée des Beaux Arts. So now Ghent had the center panels, Brussels the offensive Adam and Eve, and Berlin the wings.

When the First World War broke out in 1914 and Germany invaded Belgium, the cathedral authorities feared for the altarpiece; they had reason to believe the Germans would grab the museum and church sections to complete the whole painting. Monsignor van den Gheyn, custodian of the *Adoration* and archeologist, conferred with his bishop and town officials, who seemed reluctant to do anything that would bring German wrath on Ghent. So the canon had to act alone. A few days before the German troops arrived he and four of his flock hid the panels temporarily in the bishop's house. Those who noticed the void thought vandals or looters had stolen the van Eyck. With the help of a Belgian cabinet minister the canon evolved a plan to save the altarpiece. First he found a hiding place. Wrapped in blankets and crated, the *Adoration* was trundled through the city on a junk cart, to finish in the lofts of two private houses.

For a frail, diffident Roman Catholic priest, Canon van den Gheyn discovered he had a flair for undercover operations; on his cabinet minister's official notepaper he forged a document declaring the van Eyck had been taken to Britain with other Belgian treasures. On and off for nearly four years, under interrogation by skeptical Prussian officers, detectives, and intelligence men, the brave canon dissembled, prevaricated, dodged questions, and double-talked, yes, and even lied in his teeth to save the glory of his cathedral. Who had physically removed the panels to Britain? How had they gone? When? And this cart loading cathedral material and transporting it somewhere in Ghent? Canon van den Gheyn trembled but bit his tongue. In 1917 a German platoon swooped on the bishop's house, turning it inside out in quest of

the panels that lay no more than a few hundred yards away. On two occasions the Saint Bavo clergy thought they had lost the game. German reinforcements were requisitioning half the district where the panels were hidden. In February 1918, gathering the original gang, the canon transferred the *Adoration* to another private house. Seven months later the Germans threatened to destroy the city, but the Armistice saved Ghent and its treasure.

Two weeks after the war ended the main part of the *Adoration* again stood in the shrine of Saint Bavo, and five years later the wings were returned from the Berlin museum as compensation for the art works destroyed in Belgium by the German army during the war. A shaky excuse for retrieving property the Germans had bought, as the Belgians acknowledged by saying little and the Germans by protesting and threatening to withhold 11.5 million gold marks — their evaluation of the work — from their reparations bill. All of Belgium fêted the recovery of the missing parts of the van Eyck; whole towns and villages turned out to cheer the train bearing it back to Ghent; throughout the land, churches rang their bells.

But on the morning of April 11, 1934, the *Adoration* again caused a sensation. As the sexton of Saint Bavo was tidying around the altar he suddenly noticed the bottom left-hand panel — the part known as the Virtuous Judges — had vanished. A thief, using some carpenter's skill, had prized the fifty-two-by-twenty-two-inch panel off its antique iron hinges and in its place pinned a placard, reading: 'Taken from Germany by the Versailles Treaty.' Belgian anger exploded and protest crowds surged into the cathedral, incidentally erasing many traces of the theft. However, no one in authority suspected the Germans of such crude reprisals, least of all the police.

Three weeks after the theft the Bishop of Ghent, Monsignor Coppieters, received a ransom note demanding a million Belgian francs (about $46,000) for the return of the stolen panel. Typed and signed with the initials D.U.A., the note gave precise instructions about the ransom payment and threatened destruction of the Virtuous Judges if the money were not forthcoming. To confirm he had the painting the thief enclosed a baggage ticket for Brussels

Nord Station. There the police found the reverse of the hinged panel, depicting St. John the Baptist. Brussels detectives advised the bishop to promise payment through the man D.U.A. had designated to act as go-between. This man, a parish priest named Father Meulapas, knew nothing of his real mission at this point; he apparently believed he was acting as an intermediary to recover scandalous and defamatory letters stolen from a prominent Belgian family. Father Meulapas would collect and hand the ransom money to an unknown individual, receiving in return half a torn newspaper page and the Virtuous Judges. That same day the matching half of the page would go by post to the bishop, who would thus identify himself to Father Meulapas and retrieve the painting.

Belgian police were discovering a new twist to the mechanics of ransom bargaining — a thief using a priest and the secrecy of the confessional to collect his money while leaving himself immune from arrest. However, the man signing himself D.U.A. faltered on his next move. When the police feigned cooperation, handed over 25,000 francs, and promised 225,000 more for the Virtuous Judges, the thief demanded half a million francs ($23,000) immediately and 400,000 ($18,500) more on return of the painting. To detectives this suggested an amateur thief heavily in debt. They advised the bishop not to reply. Six months and several more threats later the thief wrote his last letter. He declared, if he had no response and no money, 'the immortal masterpiece will disappear for ever . . . nobody in the world, not even one of us, will be able to see it . . . it will remain where it is now without anyone being able to lay hands on it.'

Six weeks later, in the small town of Wetteren, eight miles southeast of Ghent, a local baker and prominent citizen, Arsène Goerdetier, suffered a heart attack. Realizing he was dying, he summoned his lawyer, Georges de Vos, and managed to whisper, 'I alone know where the Mystic Lamb is. You will find the complete file in my small study, in the right-hand drawer of my desk . . .'

There, indeed, the lawyer unearthed carbon copies of all the D.U.A. notes and ransom demands; but a search of the desk and the house revealed no other papers, no other clue to the missing

223

masterpiece. All this information Maître de Vos transmitted to the Wetteren magistrates who in turn informed the Ghent public prosecutor and three senior lawyers. For a whole month these lawyers conducted their own private inquiry, keeping the police ignorant of their findings in order, as they claimed, to safeguard the Goerdetier family name. They discovered the typewriter used for the letters and a strange key that no one recognized and that fitted no lock in the house, but nothing more. Nor did the police do better. They virtually took the baker's house apart, dug up the garden, and quizzed every known relative. However, Goerdetier did have numerous debts and this evidence, with his death-bed confession and other facts, seemed to point irrefutably to him as the man who stole the Virtuous Judges.

Since the secret of the stolen panel appeared to have died with Goerdetier, the state commissioned Joseph van der Veken, official restorer to the royal fine-arts museums, to make a copy; in 1935 this copy replaced the missing panel, and the Belgian police considered the case officially closed. However, one Belgian detective, Commissaire Mortier, fascinated if not obsessed by so many unanswered questions, pursued the inquiry in his own time. After years of chasing flimsy clues, Commissaire Mortier arrived at the hypothesis that someone in authority wanted to camouflage the crime and hush up a scandal. No other logic explained so many curious coincidences and lapses, so much slipshod police work. Why had documents relating to the Mystic Lamb vanished from Ghent archives? Why had the whole file of a later Nazi inquiry into the theft also disappeared? Why did the police stand aside in 1934 and let lawyers do their job and conduct a secret investigation? Why didn't detectives interrogate Maître de Vos and his circle of friends? Why did the Ghent church authorities obstruct a Belgian journalist who was probing for the truth behind the Goerdetier inquiry in 1934? Something else intrigued Commissaire Mortier: a small, portly man like Goerdetier could never have removed that heavy panel on his own. Therefore he had to have had an accomplice. Who? His family had always contended he stole the altarpiece to help some eminent person in heavy debt. In his last letter, undelivered, Goerdetier had written: 'The Vir-

tuous Judges lies in a place where neither I nor anyone else can remove it without attracting public attention.' But in his search for the personage behind Goerdetier and the missing panel, Commissaire Mortier always came out by the same door he went in. Like so many investigators before him, he got no further with the mystery of the Mystic Lamb.

Trouble appeared to stick to the *Adoration of the Lamb.* In May 1940 the Germans again invaded Belgium and the Belgian government and cathedral authorities in Ghent remembered the ire with which Germans had surrendered the part of the painting they had rightfully bought after the Versailles Treaty ending World War I. They must send the masterpiece abroad. But where? The Vatican? Italy had just entered the war on the German side. France offered a safer hiding place — Pau Castle, where Henry IV was born. So, in ten crates, the *Adoration* was moved south into the Pyrenees, along with many of the Louvre treasures from Paris. Yet it remained there for only two years before the Nazis traced its whereabouts and seized and transported it to Paris, where it vanished, with so many other artistic glories, eastward into the Third Reich. Moreover, Hitler did not rest content with eleven of the twelve original panels. That stolen part of the Virtuous Judges had after all belonged to Germany, bought by King Frederick William III a hundred and twenty-five years before. So the Nazi government ordered Oberleutnant Köhn of their Art Protection Department to track down the errant panel. After swallowing years of archive dust in the Ministry of Justice and police libraries, Köhn went round interviewing everyone with punctilious zeal — detectives, the lawyers, de Vos, the Goerdetier family. He got nowhere. Van Eyck's masterpiece remained flawed.

In the summer of 1944 the Allies landed in France and began their drive toward Germany. Each army had several officers and men specially assigned to detect plundered art works and protect those in their path; many of these officers had been art scholars, artists, museum curators in civilian life. Or architects, like Captain Robert K. Posey, serving with the U.S. Third Army. By the longest of coincidences, Posey picked up the trail of the *Adoration of the Lamb.* In March 1945, soon after General George S. Patton's

army took Trier — the Rhineland town full of Roman antiquities and where Marx was born — Captain Posey got a severe toothache; a member of his staff, Private Lincoln Kirstein, unearthed a local dentist who happened to speak English; in his chair, the American captain explained his job, and the dentist disclosed that his son-in-law had been performing the same task for the German armies.

Within hours both Posey and Kirstein were talking to the son-in-law, an SS officer named Hermann Bunjes who lived just outside the town. For years Bunjes had served as art adviser on the staff of Alfred Rosenberg, who had looted French art treasures and exported them to Germany. In his *Rhymes of a PFC*, Kirstein described how this quiet German scholar, recruited into the SS, told them everything he knew. 'As we talked, in French, information tumbled out, incredible information, lavish answers to questions we had been sweating over for nine months, all told in ten minutes.' Bunjes revealed the remarkable story of how such treasures had all ended up in a fantastic Nazi treasure trove created out of a disused salt mine in the Austrian mountains near Salzburg. Bunjes identified the place on a map: Altaussee. But he warned the Americans that the Nazis would never allow either the mine or its fabulous hoard to fall into enemy hands; indeed, the SS troops guarding the mine had orders and plans to blow it up if they failed to defend it. Among the great pile of hidden masterpieces was the *Adoration of the Lamb*, the van Eyck chef-d'oeuvre, Bunjes said. Bunjes never lived to find out what happened; some time later he shot his wife, their small child, then himself.

But he had given the first real hint any of the Allies had of Hitler's master scheme to plunder European art treasures and create his own Kulturhaupstadt (cultural capital) in Linz, the Austrian town where he spent his boyhood. Would the SS really destroy so much of Europe's artistic patrimony in a final, crazed gesture? Posey and other art experts with the Allied armies could not drive forward quickly enough to try to save the mine and its treasures. Kirstein related: 'Captain Posey went forward to prime the tactical commanders. If they had not been pinpointed for our

spot, American troops would have had no reason to occupy it until weeks later. There was nothing of strictly military importance in the vicinity. The terrain was extremely difficult. The mountains were lousy with SS and the retreating German Sixth Army streaming up over the Italian Alps.' When finally the art experts arrived at the Altaussee mining village, Allied sappers had already confirmed that the whole place had been wired with dynamite charges and detonators. Engineers were slowly defusing the explosives.

Inside, the mine surpassed even Bunjes's graphic description. Posey and Kirstein lit themselves into the tunnel, the glow from their carbide lamps picking out sticks of plastic explosives in the walls. A German guide opened an iron door with a key. There before the two Americans lay eight panels of the *Adoration of the Lamb*, mixed up on the floor with other paintings that had arrived at Altaussee about a year earlier, after their first halt at Neuschwanstein Castle in Bavaria. Later Posey located the other panels and now had the eleven originals and the copy of the missing part of the Virtuous Judges. Had the Nazis won the war the van Eyck masterpiece would have figured prominently in the cultural Valhalla Hitler had conceived.

No one could imagine the scene in the fabulous maze of scintillating galleries where the Nazis had cached their art plunder. For three thousand years people had mined salt at Altaussee; since the middle ages the same families had worked the mines, still speaking their medieval tongue and growing more and more like gnomes through inbreeding and environmental adaptation. Altaussee proved ideal as a place to store fragile art objects because of its unvarying humidity and equable temperatures winter and summer. Since the thirties the Austrian government had conserved valuable art works there; in 1942, when the Nazis were hunting for an underground depot for the war plunder that would eventually become part of the world's greatest museum at Linz, they took over Altaussee. Architects, engineers, and builders moved in and spent a year converting the mines; they sheathed everything in wood treated with waterproof material, wired the place for electric light, and constructed racks along the galleries. A small army of maintenance men checked the labyrinth of galleries

227

and tunnels and shafts each day to ensure against collapse or temperature changes. Behind them came art experts, restorers, administrators, and the first shipments of pillaged art. At its height the Altausee mines held nearly 7,000 oil paintings looted from Europe, about 250 watercolors and drawings, 1,000 etchings, hundreds of sculptures, and thousands of rare books. And that amounted to no more than a fraction of Hitler's dream for Linz.

By spring 1944 Allied bombing prevented anything from moving in or out of Altaussee. When the Nazis realized they were losing the war the SS planted high explosives throughout the mine, intending to blow up the place and flood it with glacier water from the mountains. They had already burned and broken up piles of stolen art to stop it from falling into Russian and British hands. But the U.S. Third Army thwarted attempts to destroy the mine and soon it was disgorging its fantastic hoard, including the *Adoration*.

Captain Posey flew the masterpiece back to Brussels in a special military aircraft and handed it over to the Belgian prince regent on behalf of General Eisenhower. In November 1945 the twelve panels were again dominating the altar at Saint Bavo. Somehow, in its five and a half centuries of existence, the *Adoration of the Lamb* has always contrived to return to its first home. Few art works can claim such a checkered story. Those who know the work and those who pray before it feel sure that one day the stolen Virtuous Judges panel will return to its true place in the van Eyck chef-d'oeuvre.

# Anybody for 118 Stolen Picassos?

Picasso is one of the master artists of our age, a child prodigy and then a protean and prolific genius who transformed every style from High Renaissance through impressionism and cubism to primitive finger painting, a chameleon who absorbed dozens of art movements and made a druidic difference in all. Which explains his appeal to connoisseurs. As an alchemist of modern art Picasso had a cynical insight into its commercial ways, knowing his signature under two lines or daubs of color converted them into cash. Which explains his appeal to thieves, professional or amateur, for Picasso breaks every record as the most stolen artist of all time. Hardly a day passes without someone, somewhere making off with one or more Picassos; Interpol files are choked with reports of missing works by the Spanish master from the four corners of the earth. Picasso's immense legacy in itself stirs criminals to action; in eighty working years he produced thousands of paintings, drawings, etchings, and pottery, all reproduced in millions. No artist has set his stamp on any century more than he on ours. But his astounding productivity has its snags. Fake Picassos turn up in the best collections and museums, and the fact that no official Picasso catalogue exists renders his paintings and their origin difficult to verify. But what most attracts thieves is

the fact that Picasso has become as negotiable as a credit card —
and the prices he fetches! A small oil painting thrown off in a
few minutes during a bad year will bring £50,000 ($125,000)
or more; his more important paintings will realize a million
dollars each, and one of them, *Seated Acrobat with Folded Arms*
(1923) broke records for twentieth-century works in May 1980
in New York, going for $3 million to a Japanese museum.

Such is Picasso's perennial popularity with art stealers that
when his widow, Jacqueline, agreed to the great exhibition of two
hundred and one paintings in the Papal Palace at Avignon it was
insured for more than $2.5 million (even though none of the can-
vases was signed by Picasso) and patrolled day and night by three
municipal guards. Picasso, who knew Provence well, always wanted
to show his work in the City of Popes and considered the four-
teenth-century Papal Palace, with its tall turrets and crenellated
walls, the ideal stage for his paintings. His eye did not fool him.
In the magnificent setting of the Chapelle Clémentine the first big,
posthumous Picasso exhibition surpassed every previous Picasso
show. The widow had given the organizers the production of Pi-
casso's last year in his Mougins villa and studio overlooking
Cannes. Even at ninety Picasso had not lost his power to shock,
painting on corrugated cardboard and even using household paint
to record his unique vision in distorted faces, fragmented land-
scapes, bullfighting scenes, and still lifes. Hung in their Gothic
setting the paintings attracted huge crowds during the last weeks
of 1975 and the first weeks of 1976.

On Saturday night, January 31, 1976, one of the municipal
guardians, forty-year-old Jean Malleterre, closed the main doors
of the gallery and courtyard at 5:45, when the last visitors left
the exhibition. Nothing stirred inside the vast fortress, 150 yards
square, containing a labyrinth of chapels, chambers, and the
audience rooms surrounding two large courts and a garden.
Malleterre heard nothing but the sounds of the Saturday-night
crowds eating, drinking, and merrymaking in the main square of
Avignon less than a hundred yards away. At 8:45 he unlocked
the gallery door to descend the main staircase to greet his relief,
forty-six-year-old Jacques Colas. As he stepped outside three men

leapt from a corner of the landing; one hit him on the head with a revolver butt which would have crushed his skull save for his peaked cap. As they tied his hands Malleterre, though groggy, noticed they were of medium height, wore knitted balaclavas over their faces and heads, and had tennis shoes on their feet. They all carried guns.

*'Appelle tes copains'* ('Call your mates'), one of them said in a Provençal accent. Malleterre called and, when someone answered, the gang escorted him to the ground floor, where they pounced on Jacques Colas, clubbed him ruthlessly over the head, and left him lying by the doorway to the courtyard. At the main entrance the three raiders lay in ambush for Raymond Véran, fifty-five-year-old night guardian, to come on duty. As soon as he showed up they ran to overpower him and batter him on the head with their pistol butts. They carried both injured men upstairs to the gallery, where they bound and gagged them. Then without haste they ransacked the huge gallery, working methodically round the 150 yards of walls covered with two or three tiers of paintings. To unhook the highest canvases they used smaller paintings; they stacked 118 of the best pictures and two sketchbooks by the door. When they had finished they began to relay the paintings downstairs and through the courtyard; from their movements and the fact they had quit the gallery by 10:30, the guards concluded they had several accomplices and had left a van in a side street of the old town. As they left with their last load the gang warned the three men, 'Don't move, we're coming back for more.' A quarter of an hour later, when no one had reappeared, Malleterre freed himself, repaired the phone wire the thieves had cut, and contacted the gendarmerie. An ambulance took both the injured men to Sainte-Marthe Hospital where doctors discovered that Colas had head wounds and crushed temples, while Véran had a fractured skull.

Within an hour detectives from Marseilles realized they were dealing with the biggest-ever art theft. Only fifteen of the more important Picasso canvases remained with a number of smaller ones and a few dozen drawings. No one could estimate the value of the 118 stolen paintings, but the police and experts spoke of

something between $25 and $35 million — though only if the canvases came up for legitimate sale. But they asked the eternal question: Who would buy such a load either in bulk or singly? None of the canvases bore Picasso's signature, for the artist signed only those pictures he sold. It smacked of the classic Mark Twain joke about the white elephant: easy enough to steal, but mighty hard to get rid of.

Yet the trail left by the raiders indicated they had acted with some ingenuity and the precision and ferocity of a military commando; they seemed to have cased the palace several times during visiting hours; on Saturday three of them had entered the exhibition as tourists and had hidden inside a builder's truck in a courtyard until the guard changed just before nine. Their own Renault van had been spotted between 10:30 and 11:00 that night, stationed brazenly in front of the Papal Palace. Eleven days after the coup detectives found the abandoned Renault at Nimes and traced it to a Marseilles garage which had rented it to someone with a fake driving license and identity card a few days before the crime. According to the odometer the gang had traveled 157 kilometers, the distance from Marseilles to Avignon to Nimes. Forensic tests confirmed that the van had carried the Picasso paintings. But this seemed the only lead. Even the Marseilles gangs, often voluble about crimes other than their own, had gone strangely silent about the most spectacular modern art theft. Paris assigned two ace members of its art squad, Commissaire André Sarda and Inspector Philippe Sahraoui, to the case. When they had alerted the national police forces, customs officials, and Interpol, they could do no more than put out feelers in the art world, then wait until the thieves or their fence broke cover with either a reward or ransom demand; both Paris detectives thought the gang too intelligent to try the absurd scheme of selling their 118 Picassos.

It took seven long months, until the end of August, before they got a break. Through Interpol headquarters Belgian police transmitted information that a band of international thieves — French, German, and Belgian — were claiming to have the Picasso haul from Avignon and were offering the canvases in Brussels. That tip-off rang true, for the Belgian capital figured prominently in

stolen-art traffic. With French consent the Brussels police briefed one of their go-betweens to play the part of an eventual buyer and put the word around the underworld that he was in the market for stolen paintings. It demanded intelligence and cool nerve on the part of the nameless middleman, for the Avignon gang had already proved itself violent enough to commit murder. But it required something else — a convincing story. For just as the thieves had problems selling 118 stolen Picassos following the worldwide publicity the raid had received in the press, on TV, and on police boards everywhere, buying such a hot load also took a lot of explaining. What could anybody do with 118 Picassos who was not a mad or megalomaniac multimillionaire?

Working closely with the insurers, who provided the funds, Brussels detectives decided to invent an American crime boss who had an underground market for stolen paintings, especially Picassos, which were easy to unload. Their go-between posed as a Dutch businessman with connections in Belgium, France, and Germany; he drove the latest Mercedes and flashed an impressive roll of money in every currency — guilders, Deutschmarks, Belgian and French francs, sterling, and dollars; he ran an import-export agency in Amsterdam through which he smuggled the hot pictures he bought.

Soon the thieves made contact with the go-between. But it took weeks to quell their suspicions about him. They finally agreed to arrange a rendezvous in Düsseldorf. In that Rhineland city the go-between met a surly, laconic German shopkeeper named Heinz Tillmans, aged thirty-four, and a tough, fast-talking Frenchman called Gérard Donadini, three years younger than Tillmans. Donadini, who lived in Germany for good reasons, did the bargaining; his friends, who had given him the paintings, wanted a lot of money — at least a million dollars. No cash and they'd burn the lot, all 118 canvases. The go-between stalled. Even a wealthy Dutch businessman could not easily raise that sort of money in used notes without incurring police attention; they would have to give him a week or two. In any case, before tapping his American contact for the cash, he would have to examine the paintings to see whether they were genuine and in good condition. He did

233

not want Mafia trouble. Donadini and Tillmans finally agreed to meet the 'Dutchman' at the Holiday Inn Hotel in Avignon on September 3. That appointment gave Commissaire Sarda and Inspector Sahraoui their first hint that the paintings had never left the area within the Marseilles-Avignon-Nimes triangle.

At the Avignon meeting another three men turned up, led by an old jailbird who had started his criminal career in his native city of Marseilles. Gabriel (Gaby) Carcassone and his two friends from the Marseilles Milieu talked as though they owned the pictures and had pulled the job. In the hotel room next door Sarda and Sahraoui were listening to the arguments over the deal and recording it on tape. Gaby Carcassone affirmed that he could hand over all the 118 paintings immediately — but first he wanted to see the money. And the Marseilles criminal now wanted at least twice the original amount — $2 million. This gave the 'Dutch businessman' his chance to hedge once more, pleading that he was having difficulty getting half that sum together and needed more time. They fixed another meeting, this time at the Novotel on the south side of Aix-en-Provence and the 'Dutchman' brought with him one of Sarda's inspectors, posing as his bodyguard.

Both Paris detectives now felt convinced that the whole of the Picasso haul lay hidden somewhere in Marseilles, and the Aix meeting confirmed that theory. After hours of wrangling between the gang and the two bogus go-betweens it was decided to swap the pictures and money the following day, September 9. However, something happened to arouse the thieves' suspicions, perhaps a slip by one of the middlemen; they suddenly demanded a piecemeal exchange, holding on to half the paintings as insurance against double-dealing. It needed another meeting at the Hilton Hotel at Orly Airport outside Paris to set up a once-for-all exchange. To convince the gang, the 'Dutchman' produced a suitcase that looked full of money in every denomination — dollar bills, pounds, francs, deutschmarks, guilders, lira. This was the most dangerous moment of the bluffing operation: the bills were forgeries, and under a thin veneer of forged notes lay bundles of blank paper. Commissaire Sarda could not risk putting more than a million dollars in forged money into circulation if, for

instance, the gang had snatched the suitcase and disappeared. Dozens of plainclothes detectives mingled with guests in the Hilton and ringed the place in case the thieves grabbed the money — or discovered the trick and turned on the go-betweens. Fortunately not even Donadini and Tillmans, the two brightest members of the gang, scrutinized the notes; it seemed the very sight of all that money drove suspicion out of their minds. They agreed to a single swap to take place on October 6 on La Canebière, the famous shopping and commercial boulevard running through the center of Marseilles down to the Old Port. Just before the banks shut the two buyers would draw the rest of the money and place it in a car, which they would park on the Canebière between nine and nine-thirty that night. At nine-thirty precisely, the gang would arrive with the paintings in a Renault Estafette van which they would leave instead of the car.

Commissaire Sarda complied with every detail of the plan. On October 6 the 'Dutch' buyer, accompanied by his bodyguard, a police inspector, and Gérard Donadini — to ensure they were following the gang's instructions and had the money — went to a bank near the main Protestant church in the center of Marseilles; in the strong room the three men collected two valises full of money. Had Donadini done any more than glance at the contents he would have found mostly cut newspaper wrapped in forged notes. That evening the three men drove a hired car to the Canebière, left it there, and posted themselves in a nearby cafe to watch and wait.

At nine-thirty precisely, a gray van drove up the boulevard, followed by a getaway Ford with two men inside. No sooner did the van stop than a score of detectives sprang their ambush, surrounding the van and car. Soon they had disarmed the van driver, Gérard Réynaud, a local man who had already served a long prison sentence. When they wrenched open the back door a charge of buckshot went off in their faces; a man threw a shotgun at them and darted up one of the many narrow, twisting alleys alongside the Canebière. A detective hared after him, caught up with him in a bar, and wrestled with him, but was himself set upon by some of the customers, who took him for an aggressor. Later

Fernand Odore, thirty-two-year-old Marseillais with a long criminal record, was found hiding under a car. The detectives arrested the others one by one. Donadini offered no resistance. Tillmans and Gaby Carcassone had booked into a luxury hotel to wait for their share of the $2 million booty and were quietly arrested; in the Ford another Marseillais, Antoine Armao, gave himself up with the driver, a Belgian — Théodore Timmers, alias Theo the Wheel. Within forty-eight hours of his arrest Timmers had died from a heart attack. Another man implicated in the theft and receiving the stolen paintings had fled. He was Georges Arnetoli, a twenty-eight-year-old Marseilles restaurateur, suspected of planning the commando raid on the Palais des Papes.

From inside the van the Paris and Marseilles detectives retrieved the 118 Picassos, somewhat creased for their eight months under wraps in some Marseilles back room.

Of course, every member of the gang denied taking part in the Avignon raid — or even knowing about it. Donadini professed complete ignorance of what he was trying to sell and where it had originated; Tillmans would only admit to making contact with a buyer for unknown merchandise; Carcassone had not been anywhere near Avignon for years and did not know who Picasso was; the others had merely driven cars. Arnetoli was never found, and Marseilles police had a strong hint that he was dead, probably killed by the Milieu to settle some account not unconnected with the Picasso case. No one even looked for his body.

French justice prides itself in searching for the whole truth, a minute and notoriously slow process, especially when confronted with as much criminal circumlocution as the Picasso gang fabricated. But four years to bring the case to court seemed excessive and set journalists and jurists to wondering why. Even more surprising, the state decided to try the seven accused men in Avignon magistrates' court for the misdemeanor of simple receiving when everyone anticipated they would go before the assizes at Nimes or Aix charged with the felony of receiving the 118 Picassos, knowing them to have been stolen. In a vehement protest Maître Paul Lombard, one of the advocates acting for the Picasso family interests, said, 'This theft had a universal impact. Anyone would

have had to be blind not to see it in the press or on TV, and deaf not to hear it on the radio.' Yet the court stuck to its ruling and the final chapter in the story of the most spectacular modern-art theft finished as a complete anticlimax. Why the endless delays, why the summary and inconspicuous lower-court hearing? Perhaps only the police and certain of the criminals could answer that question fully. However, the rumor ran that a deal had been made between the police and the gang, promising leniency if the pictures were returned; an equally insistent story circulated that the insurance company had paid a reward for the recovery of the paintings and the division of this money caused a quarrel among the gang and led to Arnetoli's death. A long assizes trial might have produced awkward revelations of police and insurance undercover work and trade-offs they may have made with the gang or certain of its members.

The trial took place in March 1980, but by then some of the gang had seized their chance to disappear when released in 1978 after two years' preventive detention, among them ringleaders Tillmans and Donadini. Both men got four years' jail in absentia, with Tillmans fined $9,000 and Donadini $12,000. An international arrest warrant was issued for them. Arnetoli was given three years in absentia, but no one considered it worthwhile to put out a warrant for him. Réynaud, Armao, and Odore all got two years (which they had already served), while Carcassone was too ill to appear for trial.

And the owners of the paintings — Jacqueline Picasso and Picasso's daughter, Madame Ruiz-Picasso? They were awarded the symbolic one-franc damages, to be paid by the accused.

# 16

## Special Prices for Artists

What France came to call the Affaire Pétridès contained every component of the modern art racket — an armed holdup of a rich private collector, a practiced go-between, a confidence man who faked documents to sanctify the booty, an international art dealer who turned a blind eye to the origin of the paintings he bought, experts and customs men duped into clearing the stolen art for foreign sales, and unsuspecting collectors who paid millions of dollars for it.

It all began at ten minutes past four on April 24, 1972, in 9, avenue de Maréchal-Manoury, a luxury flat belonging to the millionaire Albert Lespinasse, in the tranquil and chic Bois de Boulogne district of Paris. Two men in blue workman's overalls, faces concealed behind empty cartons they carried, and a third in a chauffeur's uniform stepped out of the service elevator and rang the tradesman's bell. They were delivering goods, they told the maid, Julie Bidegaray. Once inside they pulled masks over their faces, rounded up the six servants at revolver point, then handcuffed and gagged them with adhesive tape over their mouths and even their eyes. They burst into the living room where Madame Yvonne Lespinasse and three women guests were settling down to a bridge party, bound and gagged them, took Madame Lespi-

238

nasse's rings and earrings and just over 11,000 francs ($2,200) in money; they trussed and gagged Albert Lespinasse, aged seventy-two, and the woman physiotherapist who was giving him a massage. Then, coolly, they set about unhooking paintings from the walls, choosing thirty-one canvases from the whole collection; one of them even knew where to locate the two deed boxes containing the dealers' certificates for the art works. In just over half an hour they had filled their cartons and disappeared.

Downstairs, Marcel Gram, forty-year-old caretaker, noticed two men emerging from the front elevator. 'Where are you coming from?' he asked one.

'From Lespinasse's flat,' the man replied. At that moment he stumbled, the carton lid flew open, and Gram spotted the paintings. Running after the two men to their Renault van, he saw, to his astonishment, a revolver clatter to the ground from the second man's pocket. As Gram went to kick it into the gutter, the first man pressed a gun against his belly. 'Take off or I'll do you in,' he muttered. Gram turned and sprinted for the door, shouting for help to a man in a chauffeur's uniform. 'Out of my way, I'm with the others,' the bogus chauffeur barked as he ran to a Citroën. Within minutes both the van and car had vanished. From the gang's commando precision and skill, as well as their seizing the certificates, Sûreté detectives judged they had inside information from someone who had worked for Lespinasse.

After the raid, silence. Not a hint from the Paris Milieu. No reward or ransom demand. That mystified the police and art dealers, who declared it impossible for anyone to sell those paintings legally since they were catalogued and too well known. Two police bulletins went out — one from the French Interior Ministry, the other from Interpol — to ninety-eight countries. Both listed the paintings, the Interpol version carrying pictures and captions in English and French. Lespinasse, millionaire head of the Banania food firm, supplied exact descriptions and photographs of all his collection. But despite everything it seemed his paintings, valued officially at 3.42 million francs ($685,000) had gone into cold storage, to surface years later abroad or in very private sales.

Yet the police did receive a pointer to this robbery, and a hint

**S T O L E N**

**Subject :**    Theft of paintings
**Date of theft :**    April 1972
**Country :**    F R A N C E

During the evening of 24th April 1972, several armed offenders entered the flat of Mr. Lespinasse, 9 avenue du Maréchal Maunoury, PARIS 16è, gaining access by the service staircase. After overpowering the people in the flat, the offenders removed from their frames and stole 31 paintings by modern masters of the 19th and 20th centuries.

Description of the stolen paintings :

1. BONNARD : "Pot of Hyacinths", 32 cm x 22 cm, oil on canvas, signature, bottom left. *(see photo 1)*

2. BOUDIN : "Trouville Beach, 1893", 55 cm x 90 cm. Oil on canvas, signature bottom left. *(see photo 2)*

3. BOUDIN : "Etaples, 1890", 51 cm x 74 cm, oil on canvas, signature, bottom left. The word ETAPLES is written in the lower right corner. *(see photo 3)*

4. BOUDIN : "Fécamp, 1884", 24 cm x 33 cm, oil on wood, signature and date, bottom right. *(see photo 4)*

5. COROT : "Pool in Rambouillet Forest", 33 cm x 24 cm, oil on cardboard covered with canvas, signature, bottom right. *(see photo 5)*

6. DUFY Raoul : "Deauville Harbour", 65 cm x 81 cm, oil on canvas, signature, bottom right centre. *(see photo 6)*

7. JONGKIND : "Arrival in the harbour (Holland), 1862", 24 cm x 33 cm, oil on wood, signature bottom left. *(see photo 7)*.

8. KISLING Moses : "Marseilles Harbour", 55 cm x 46 cm, oil on canvas, signature bottom right. Dated "MARSEILLE 1933" at lower left. *(see photo 8)*

9. LEGER "Vase of flowers and statuette, 1952", 65 cm x 54 cm. Signature and date, bottom left. *(see photo 9)*

10. MARCHAND : "Sunset over the sea, 1956", 55 cm x 46 cm, signed "André MARCHAND" bottom centre. *(see photo 10)*

11. MARQUET : "Navigation in the Old Port, 1927", 65 cm x 81 cm, signature bottom right. *(see photo 11)*

12. MARQUET : "Madame MARQUET on the terrace of the Carthage Hotel", 60 cm x 81 cm, oil on canvas, signature, bottom right. *see photo 12)*

13. METZINGER : "LOCHES, 1917", 73 cm x 60 cm. Oil on canvas, signature bottom right. *(see photo 13)*

14. MONET Claude : "Fishing boats", 65 cm x 92 cm, oil on canvas, no signature. *(see photo 14)*

15. QUIZET : "Le moulin de la Galette in the snow", 46 cm x 38 cm, oil on hardboard, signature bottom right. *(see photo 15)*

I.C.P.O. PARIS                        File n° 1598/OV/412/72
June 1972                            Control n° : B.1317

*This page and the next three pages, Interpol bulletin on the L'Espinasse raid.*

- 2 -

16. QUIZET : "Rue des Pyrénées, Belleville", 46 cm x 38 cm, oil on hardboard,
    signature bottom right. *(see photo 16)*

17. QUIZET : "The Garden of the Institution at Pré-St.-Gervais", 46 cm x 55 cm, oil on
    hardboard, signature bottom right. *(see photo 17)*

18. QUIZET : "Chateau des brouillards, Montmartre", 46 cm x 55 cm, oil on hardboard,
    signature bottom right. *(see photo 18)*

19. QUIZET : "The La Villette Canal, in front of the slaughter houses, 1943", 46 cm x
    55 cm, oil on hardboard, signature bottom right. *(see photo 19)*

20. RENOIR : "South of France landscape, 1914", 25 cm x 38 cm, oil on canvas, signature
    bottom right. *(see photo 20)*

21. RENOIR : "Love in bronze", 14 cm x 15 cm, oil on canvas, no signature. *(see photo
    21)*

22. RENOIR : "Flowers", 20 cm x 16 cm, oil on canvas, signature top right. *(see photo
    22)*

23. RENOIR : "Naked woman bathing, 1910-1912", also called "The Source", 55 cm x 38 cm.
    Oil on canvas, signature bottom left.*(see photo 23)*

24. ROUAULT : "The way of the Cross" (original title), or "Presentation of Christ,
    Woman and Soldier", 64.5 cm x 48.5 cm, oil on paper covered with canvas, signature
    bottom right. *(see photo 24)*

25. SISLEY : "Moret in the morning", 38 cm x 55 cm, oil on canvas, signature bottom
    left. *(see photo 25)*

26. UTRILLO : "The King's Market-Place in Tours, 1934", 54 cm x 73 cm, oil on canvas,
    signature and date bottom left. *(see photo 26)*

27. UTRILLO : "Le Sacré-Coeur, 1934", 24 cm x 19 cm, oil on wood, signature bottom
    right. *(see photo 27)*.

28. VAN DONGEN : "Young woman in a village", 55 cm x 46 cm, signature bottom right.
    *(see photo 28)*

29. VLAMINCK : "Banks of the river Oise", 54 cm x 65 cm, oil on canvas, signature
    bottom right. *(see photo 29)*

30. VLAMINCK : "The Seine at Chatou, 1910", 60 cm x 73 cm, signature bottom right.
    *(see photo 30)*

31. VLAMINCK : "The Seine - Fisherman under Argenteuil Bridge, 1906", 46 cm x 55 cm,
    oil on canvas, signed by VLAMINCK on the back of the canvas. *(see photo 31)*

Please inform : SALES ROOMS, GALLERIES,
ANTIQUE DEALERS, PAWNBROKERS, MUSEUMS,
CUSTOMS AUTHORITIES etc ...

*REASON FOR THIS CIRCULATION :*

Done at the request of the FRENCH authorities for recovery or information. If found
or anything be known of this matter, please inform : Direction Centrale de la Police
Judiciaire, Police Nationale, 11, rue des Saussaies, 75 / PARIS (8°) (INTERPOL PARIS
BCN) - ref. PN/DC.PJ.AC.4/BC N° 541 72 5930 of 27.4.1972 and also the I.C.P.O.-INTERPOL
General Secretariat, 26, rue Armengaud, 92 / SAINT CLOUD (INTERPOL PARIS).

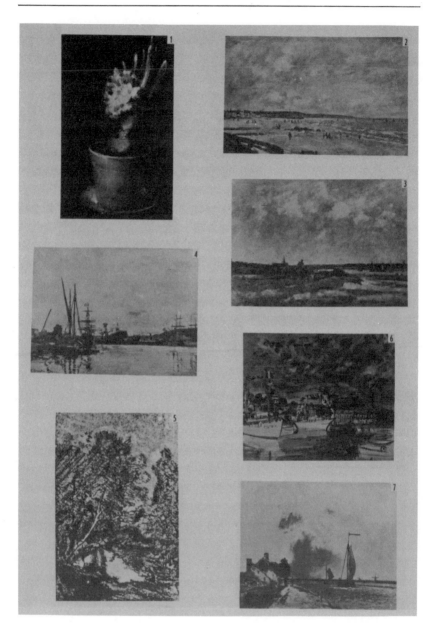

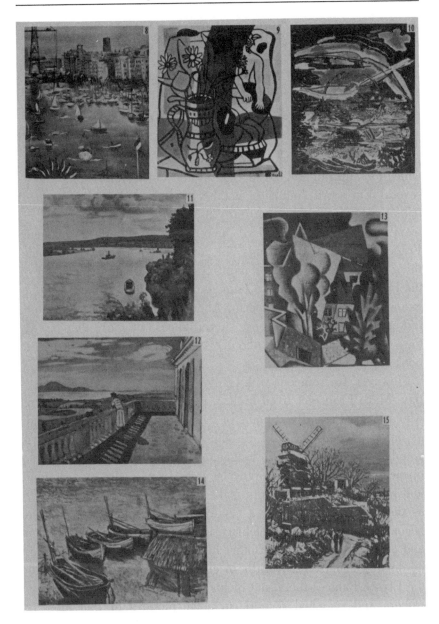

243

about some others that had preceded it. The U.S. Narcotics Bureau has kept a staff in Paris, since the early days of the 'French Connection' to watch drug racketeers. Several years before, their eye had lighted on a personable young man named Marc Christian Francelet, a freelance reporter and photographer for the mass-sale illustrated magazine *Paris-Match*. To Jack Kière, one of the U.S. Narcotics Bureau investigators, it seemed Francelet consorted with some strange people and had some curious foreign assignments, which took him in and out of Central and Latin America as well as several European countries, notably Switzerland. Thinking these trips gave him ample opportunity to smuggle drugs, Kière and his team tailed him for several months; they found no evidence Francelet was pushing drugs but confirmed his interest in something equally suspicious — paintings. Word went to the head of the French fine-arts squad, Commissaire Jacques Mathieu, who began with his colleague, Inspector Abdelkader (Philippe) Sahraoui, to keep Francelet under loose surveillance. For more than a year they watched Francelet without ever finding enough evidence to book him.

However, for someone with no more than a magazine journalist's pay, Marc Francelet lived high, a playboy member of the jet set who appeared equally at home in Paris salons and the beau monde as in sleazy bistros and discotheques. His *Paris-Match* card, coupled with charm, a glib tongue, quick wit, and dark good looks opened all doors. In fact, Francelet came from a very modest home and left school at fourteen to make his own way. Two years later, as the youngest man with a reporter-photographer card, he had become something of a celebrity in French press circles. Talent and a taste for risk had brought him several scoops. For his best he donned a mason's overalls to climb some scaffolding opposite the Elysée Palace; there, out of his kit, he assembled a Long Tom camera and snatched several exclusive pictures of that most remote head of state, President Charles de Gaulle, taking his constitutional in the gardens outside his study. In his working-class home district Francelet had carved something of a legend for himself — the boy who had made it. Some of his schoolmates had discovered easier and quicker ways of lining their pockets than

working. Francelet tried them and in April 1967 was condemned, for check frauds and theft, to a two-year suspended sentence. But again Francelet listened to them and heard what fortunes he could make with stolen pictures. Thus began his strange odyssey among the art pirates; his roving commission for *Paris-Match* gave him an ideal cover for his operations in the European and American continents. He met thieves, squatting on paintings worth millions of dollars, who had no idea of their artistic value; he gazed, horror-struck, at Modiglianis and Utrillos left like punched cards by thieves who had used them for rifle and revolver practice; he bought and sold to dealers and fences, which gave him money to indulge his jet-set tastes and meet people who mattered. He joined one of France's most exclusive golf clubs, Mortefontaine, near Chantilly, where he rubbed shoulders with people like former Prime Minister Couve de Murville, statesmen, industrialists, stockbrokers, and people from the art world.

In 1969, through the well-known Paris journalist Max Corre, he met the most famous art figure in the club and one of its best golfers, Paul Constantin Pétridès. As old as the century, Pétridès had made a considerable fortune out of art and an international reputation for his profound knowledge of the modern masters. Hardly anybody dared buy or sell an Utrillo that had not received the blessing of P.P., who had controlled the painter's output since 1935; he exercised much the same authority over the paintings of Utrillo's mother, Suzanne Valadon, and over those of Marie Laurencin, Kees van Dongen, Maurice de Vlaminck, and Léonard Foujita. A scratch player even at seventy, Pétridès gave Francelet several wrinkles on the game, and soon they were addressing each other by Christian names and using the intimate 'tu.' Francelet could talk about painting; his sister had been engaged to Jean Kisling, son of Moïse, the Polish-born artist whom Pétridès knew well. Just over a year after they met Francelet felt confident enough to whisper to Pétridès, 'I've something interesting for you, only don't ask me too many questions.' Surprisingly uninquisitive, the art dealer bought a small Utrillo, *La Caserne de Compiègne* (Compiègne Barracks) from his golf partner in December 1971, five months before the armed robbery at the Lespinasse flat. In

*Paul Pétridès and his portraits. (Paris Match/Jarnoux)*

Francelet's view the door had opened; if an art dealer like Paul Pétridès, with a vast international clientele, would buy stolen pictures, he could procure them. Francelet seized his chance and soon played another card. On vacation in 1970 at a Mediterranean resort he had made the acquaintance of Christian de Galéa, an architect and godson of the multimillionaire art dealer and collector Ambroise Vollard. De Galéa had inherited the fabulous Vollard collection when the dealer died in 1939. Francelet mentioned his new friend, and Pétridès immediately asked if he could persuade de Galéa to market some of his collection. Francelet quickly appeared with a catalogue from which de Galéa proposed to sell two pictures, a Berthe Morisot and a Cézanne. Pétridès bought the Morisot and offered to buy anything else Francelet could obtain. Between the beginning of January and the end of May 1973, without prying too closely, the art dealer bought fifteen of the canvases stolen from Lespinasse in nine different transactions; one of their most important deals took place in Geneva, and the dealer settled with money drawn on a Swiss bank.

All this time, unknown to Francelet, two detectives, Commissaire

246

Jacques Mathieu and Inspector Philippe Sahraoui, were keeping tabs on him, watching for the clue that would break open their case. One day, a few months after the Lespinasse raid, Mathieu followed the journalist to the Mortefontaine golf course. There he saw him lunch and then play with Pétridès and fell to wondering about the disparity in their ages, why a crack golfer like P.P. would play with a long-handicap man and what an ultra-rich art dealer could have in common with a reporter on the make. Suddenly it struck Mathieu he had stumbled on a possible solution to the Lespinasse theft — and perhaps others where paintings had vanished. However, he failed to convince his chiefs, and one in particular, Commissaire Pierre Ottavioli, head of the Paris flying squad; he scoffed at the very notion that his good friend, Paul Pétridès, could have anything to do with stolen-art traffic. Yet at that time Ottavioli had evidence linking Pétridès' friend, Francelet, with other people suspected of involvement in the Lespinasse raid. Chief Inspector Robert Broussard, of the anti-gang squad, had a hint that a certain Claude Fénayron, calling himself a painter and sculptor, had something to do with the raid. Moreover, he knew that Fénayron had close relations with Broussard's own brothers-in-law, Jean-Pierre and Patrick Hillairaud; these brothers, former rugby players, had criminal records. And it seemed all three knew Francelet well! Ottavioli's own squad knew that Patrick Hillairaud had even shared a prison cell with Lespinasse's former chauffeur and therefore had access to information about the flat layout. But inexplicably, Ottavioli made no move to interrogate any member of this quartet.

It was Pétridès himself who denounced Francelet. At the end of May 1973 he rang Ottavioli, whom he had known for twenty-three years, accusing Francelet of forgery and fraud. Pétridès claimed to have discovered how Francelet had duped him when he sent two photographs of paintings by Eugène Boudin, precursor of impressionism, to the expert who was preparing an official Boudin catalogue. This man, Robert Schmidt, immediately exclaimed, 'But these pictures come from the stolen Lespinasse collection!' Pétridès confessed to the commissaire that he had bought seventeen other canvases from Francelet, including Renoirs,

Rouaults, Vlamincks, a Modigliani, a Dufy. In a long statement he lodged a formal complaint against the journalist.

On June 13 Francelet was arrested and an examining magistrate, Monsieur Émile Cabié, opened his dossier on the Affaire Pétridès. Soon he identified the Monsieur Charles who provided the pictures as Claude Fénayron, but he had gone into hiding and would not emerge till three years later. And no one prompted the judge to question Francelet about the Hillairaud brothers. As he probed deeper into the relations between Francelet and Pétridès, the magistrate began to wonder if the art dealer were victim or villain. How, for instance, did an Utrillo, sold by Pétridès to Madame Weinstein in 1950 and stolen in 1968, turn up again in the Pétridès gallery without a mention in his official register? Madame Weinstein had actually asked the art dealer to value the missing painting for insurance purposes before he bought it from Francelet! Then the magistrate puzzled about *La Caserne de Compiègne*, stolen from the Paris home of a woman doctor, Marie-France Lagrange, early in 1971 and reported as stolen to the art dealer. Why hadn't Pétridès recognized that same painting when Francelet offered it to him some months later? Especially when it bore such obvious signs of having been sliced from its frame by a razor blade that he had sent it for reframing before exporting and selling it to a near relative of the Japanese prime minister, Yusuka Miki of Yokohama? And why hadn't Pétridès, the world expert, identified those famous Lespinasse canvases he had bought? Like everybody else he must have seen the French and Interpol circulars and photographs. Even amateur art lovers would have spotted the Bonnard, three Boudins, four Renoirs, two Utrillos, three Vlamincks, the Monet, the van Dongen. Monsieur Pétridès protested too much and left too many inconsistencies in his story, the magistrate decided. In March 1974 he charged the art dealer with receiving the paintings, knowing them to be stolen.

Pétridès arrested! In the art galleries clustered round the avenue Matignon and Faubourg Saint-Honoré they could hardly believe it. An international celebrity among picture merchants being caught buying stolen pictures! Worse still, being arrested for it! Yet both

his friends and enemies whispered that a professional survivor like Pétridès had weathered worse crises, although some dealers, like Alex Maguy in Place Vendôme, remembered Pétridès's past and wondered.

Pétridès had indeed lived a checkered existence from the moment he began life as the thirteenth son of a poor dyer in the small port of Paphos on the southwestern extremity of Cyprus. As a boy goatherd he daydreamed of what lay beyond his small island. Even then he had ideas. Rearing and fattening pigs, he sold them to pay his passage to Egypt, where a Greek tailor taught him his trade. By toil and thrift young Pétridès saved enough money to journey to his promised land, Europe. For awhile he worked in Toulouse, and at twenty he arrived in Paris with a cutter's papers that earned him a job with Mazella, a stylish gentleman's tailor. In the fitting rooms his eye fastened on something that set him dreaming again — reproductions of Impressionists like Monet and Renoir; Fauvists like Matisse, Vlaminck, and Derain; Cubists like Picasso and Braque. He had heard of the fabulous riches Ambroise Vollard was making out of Cézanne, Gauguin, Renoir, and Degas. That too fueled his imagination. He married a woman who ran a bric-a-brac shop and sold certain painters. She also knew a drunken, dissolute genius called Maurice Utrillo, who seemingly painted as a form of psychiatric therapy, though by exchanging his pictures for bottles of pinard (rough red wine) and imbibing this in vast draughts, he did himself more psychological damage than he could ever make good by painting. Of his wife, Pétridès said, 'She was my first bit of luck.' With her help he set up his tailor's shop in rue Rougemont, not far from Montmartre, where Utrillo and other artists lived and painted. Soon he was making suits for those painters his wife helped to sell. He even took a large advertisement in the Salon des Indépendants exhibition catalogue for 1925: PAUL C. PÉTRIDÈS, Tailor and Dressmaker — SPECIAL PRICES FOR ARTISTS. Some of these artists could not pay cash — so Pétridès took pictures instead. Some he kept; others he sold. 'A suit for Utrillo cost 1,000 francs and the painting I got for it fetched 1,500 francs from an art dealer,' he ex-

*Advertisement in the catalog of*
*the Salon des Indépendants, 1925.*

plained later. He was beginning to realize he had achieved the commercial miracle of transforming woolen cloth into suits and then into canvases painted by a master hand.

Next he took over Utrillo, signing a contract in the thirties with the artist and his new wife, Lucie Valore, to handle his work exclusively. Now no one could sell an Utrillo without the magic P.P. cachet. With this contract as his guarantee, Pétridès opened his first gallery in 1935.

But by this time Utrillo was a burnt-out case, his great prewar and postwar painting days behind him. Fatherless son of the painter Suzanne Valadon (also controlled by Pétridès), he had grown up with a glass of red wine in his hand. To soothe the boy's nerves, his grandmother said. To keep him occupied, his mother gave him some of her painting equipment and bribed him with bottles of red wine to use it. Soon the young alcoholic was drifting from one drinking binge to another with Modigliani, Soutine, and others, often finishing bruised and beaten in police stations around Montmartre. He spent long months of internment at Sainte-Anne's Hospital, for time after time the combination of drink and his

nervous temperament created explosions of madness. Yet, for some reason no one can fathom, this weak-minded and wandering young man began to paint masterpieces. On his canvases Montmartre took shape, as solid and immemorial as he was fickle and unstable; its shabby, run-down streets and sleezy bistros he endowed with the magic a child might have seen in them; in zinc whites, glowing reds, greens, and blues he transfigured poor dwellings or bleak squares into enchanted architecture. What taught him his art and formed his genius remains a mystery. Becoming as familiar as the Sacré-Coeur church, Utrillo painted in Montmartre squares amid a pile of emptied wine bottles; still he drifted from the bistro to the police station to the asylum and back, round and round like a circus pony ignorant that he was painting chefs-d'oeuvres hoarded in dozens by the prescient among art dealers and collectors.

When Pétridès took over Utrillo, aged fifty-two, his stock had begun to soar but his genius had blown out. Now he painted merely to produce, not to create or express, not to assuage his mental or emotional turmoil. Frail and fearful, he complied with people's wishes — and his canvases now mirrored his emptiness. His mind too had foundered. In the late forties, during a court case brought by Pétridès against artists who had faked Utrillos, it was said Utrillo could not even recognize his own work and would have signed his name to a fake — or even a photograph.

But art often needs no more than a name to sell it. Picasso, the cynic, appreciated this when he signed his restaurant napkin for a supplicating artist, saying, 'Don't let it go too cheap.' So did Pétridès. He had learned several of Vollard's maneuvers, filtering his Utrillos slowly on to the market, watching them being bid up at auctions, and especially building up an official catalogue of the painter's work. This virtually made him arbiter of true and false Utrillos, important when handling someone as easily counterfeited as Utrillo. Whoever controlled the official catalogue could make or break a painting; works in the catalogue acquired value, whether genuine or not; those excluded, even masterpieces, remained dubious for many authorities and lost value. Art dealers like Pétridès knew this and turned it to profit. Someone would

251

approach one with a painting for his official catalogue, and the dealer would look at it and shake his head. 'I think it's a fake,' he might say. 'Tell you what I'll do, I'll give you so much for it just to take it off the market. There are too many of this painter's fakes around.' If the owner refused, his painting never reached the official catalogue; if he sold it for the lower price, he could not complain if he noticed it later in the official catalogue and found it had been sold for a hundred times more than the dealer paid him. Any dealer could make a mistake — as Pétridès himself tried to prove at his trial. He had built up official catalogues on Marie Laurencin, Vlaminck, Foujita, Valadon, and others.

By 1939 Pétridès had amassed a fortune and his vaults in rue de la Boétie contained several more fortunes in unsold Utrillos and other modern masters. When France fell in June 1940, many people expected P.P. to flee. They pointed out that he still held his British passport from his Cyprus days, and Britain had not signed an armistice with Hitler. So Pétridès had to report daily to the local police station, for the first months of the German occupation at least; but as so many Jewish art dealers and others had shut shop and moved, or were lying low, Pétridès flourished. High-ranking German officers — including Hermann Goering — made up for the loss of his normal clientele. In September 1943 Pétain decree number 2467, published in the *Journal Officiel*, conferred French nationality on him. 'People have to adapt to circumstances,' he explained. How could he evict German officers from his gallery or refuse an invitation to the marriage of a German colonel with the daughter of a Belgian client? When a magazine published a picture of him at this wedding Pétridès had it print another photo showing him with the French president, Vincent Auriol, after the war. But hints of collaboration, allegations of trafficking in confiscated Jewish art — nothing it seemed could touch him. Even in the art world he had become something of a legend and everyone agreed (including Pétridès) that P.P. was an extraordinary man. In his late seventies he had one good eye which would rove purposefully over women a quarter his age, and they found him attractive; his gallery, with its gilt P.P. monograms and plush interior, echoed with the highest and wealth-

iest in France as well as international art collectors and connoisseurs.

His arrest provoked a sensation in keeping with his vast reputation. But Pétridès defended himself against every accusation, contending Francelet had duped him into buying the stolen Lespinasse pictures by furnishing the de Galéa letter and certificates; he conveniently overlooked the deals with Francelet before he met de Galéa; and Pétridès had forgotten one small painting, bought before the Lespinasse raid, and sold in Japan. He argued that Utrillo had painted dozens of barracks like the *Caserne de Compiègne*. But how could he explain away those razor cuts in the canvas? Two French police commissaires went to Japan to 'extradite' the painting, and its original owner, Dr. Marie France Lagrange, identified it. Gradually the examining magistrate built up evidence that nineteen pictures had passed through Pétridès' hands — part of the proceeds from four burglaries in private houses — on their way to collectors in France, Switzerland, and especially Japan.

Detectives rounded up the suspects one by one and recovered the Lespinasse collection and four other pictures. For some time Commissaire Marc Leclerc, head of the morals squad, had been keeping an eye on Pierre (Toni) Zevaco, a forty-year-old Corsican pimp who was gambling heavily, running flashy cars, and generally living it up. Two of his friends, Joseph Voison, aged thirty-four, and Victor Sowinski, aged thirty-five, also seemed flush with money. By tailing them detectives seized eleven Lespinasse pictures; others were unearthed at the Lyons homes of a retired art expert, Ange Peretti, a seventy-two-year-old Corsican, and a rich Algerian-born antique dealer, Lakhdar Nouri. Everyone claimed the paintings came from Monsieur Charles or Monsieur Georges, already identified as Fénayron. It took three more years to find and charge him. Finally, the brothers Hillairaud were charged with theft and receiving. All of them appeared at the Palais de Justice in the heart of Paris for a trial that ran for three weeks in February and March 1979.

Everyone in the international art world followed the Pétridès trial, a rare case of a prominent art dealer accused of receiving

253

stolen paintings, of financial and customs frauds. This time it seemed the famed Pétridès luck was running out. For presiding at the trial was one of France's brilliant young judges, Michel Guth, who had mastered every detail of the gargantuan, five-year dossier prepared by the examining magistrate; prosecuting for the advocate-general was the equally formidable Maître Bernard Guyot, while Pétridès had mustered three 'lions' of the French bar to defend him — Maîtres Bernard Baudelot, Jean-Denys Bredin, and Paul Lombard, the latter having defended some of the country's most notorious criminals. Since Francelet had pleaded guilty, only Pétridès mattered, and from the outset it became clear that neither Judge Guth nor Maître Guyot meant to spare him on account of his age (seventy-nine) or his global reputation. Pétridès did not help his case by trying to bluff.

'I couldn't have known those paintings were stolen,' he said. 'Marc Francelet showed me these paintings as having belonged to Vollard's heir, Mr. Christian de Galéa. On my request, Francelet even produced certificates and a letter from Monsieur de Galéa authorizing him to make the sales in his name.'

Judge Guth countered that the dealer had made six previous transactions with Francelet before buying the genuine de Galéa picture. As for the certificates, they were crude forgeries in which Galéa was misspelled with two els. 'This should not have escaped such a great specialist as you,' said the judge. 'Even if you sold the first six pictures in good faith, you broke the rules of your profession in reselling the others, which were not accompanied by certificates.'

'I demanded them from Francelet in vain,' Pétridès replied. 'But I had no reason to be suspicious.'

'Yet you had received, like all your professional colleagues, circulars giving the list of stolen pictures,' exclaimed the judge.

'I never read them,' Pétridès stammered.

He had started the trial a dapper figure in a dark suit, with jet-black hair and alert eyes behind tinted glasses, looking at least fifteen years younger than his age; but as Judge Guth probed ruthlessly into his actions over the pictures, he began to sag, physically and mentally.

What had he paid for the Lespinasse pictures? Pétridès claimed he had given Francelet 3.9 million francs ($800,000) but Francelet countered by insisting he had received no more than 1.3 million francs ($260,000). At this point Guth demanded to know why Pétridès had changed the titles and dimensions of the painting in his registers and given false names for the sellers if he did not know their fraudulent origin.

'I don't know,' Pétridès pleaded. 'It is only an error. It isn't serious.'

But Guth came back: 'If you succeeded in exporting those stolen canvases from France, it is because you changed the titles and gave false dimensions. Thus *Résurrection* by Rouault became *Portement de Croix.*'

'But there is no rule concerning the titles and dimensions,' Pétridès argued. 'Besides, that isn't important.'

'Yes, it is!' exclaimed Guth. 'It is important because the customs and museum files are alphabetic. *Résurrection* comes under *R* and not under *P.*'

In any case, Pétridès had no trouble exporting the pictures, since the customs authorities had him registered as one of the foremost art consultants who appraised their foreign consignments. Two experts testified to the ease with which anyone might circumvent the rules and customs formalities governing the export of pictures, even national treasures.

Judge Guth had thought up another poser. 'After the theft of Utrillo's *Sacré-Coeur*, its proprietor, Madame Weinstein, showed you a picture and asked you to confirm its authenticity for the insurance company. You knew this painting when you bought it to resell. Furthermore, you described it as a gouache when it was a watercolor.'

Pétridès had no answer to the first part of the question, but replied blandly, 'Gouache or watercolor — they're much the same thing. It's still water paint . . .'

From the buzz that ran round the chamber, he realized what a gaffe he had committed. Every student knows that watercolor gives a washy, transparent effect, while gouache or poster paints have had gum or honey mixed into them to render them opaque

and more like oil paint. Pétridès tried to camouflage the error by adding quickly, 'It was probably my secretary who made a mistake.'

Commissaire Ottavioli, his trim figure and angular face familiar to the man in the street and every criminal in France, had just as harrowing a time on the witness stand. Admitting his twenty-three years of friendship with Pétridès, he agreed his detectives should have followed up many leads and failed to do so. Why no attempt to trace the chauffeur who had shared a cell with Patrick Hillairaud? Why did no one act on Commissaire Broussard's tip-off about Fénayron, Francelet, and the Hillairaud brothers? Why didn't he spot the many gross irregularities in the Pétridès registers and the curious tax returns which he dismissed as very French? Ottavioli, a Marseilles man of Corsican origin, could only confess his mistakes and plead he had never doubted Pétridès and had no real evidence to call his good faith into question. A millionaire art dealer buying stolen pictures! Guth expressed his regret that it took four years to arrest the Hillairaud brothers, who then benefited from the absence and uncertainty of eyewitnesses, especially when half a dozen people had seen and remembered the gangsters during and after the theft.

Now came the turn of Maître Guyot, prosecuting counsel, who must have seemed to Pétridès like one of those terrifying nineteenth-century lawyers painted by Honoré Daumier in the same Palais de Justice. Pointing a finger at the slim, immaculate figure in the dock, Guyot rebuked him for uttering evidence that was no more than a litany of lies. 'You are the unscrupulous conjurer who exploits the moral condition of a man unable to defend himself, who had given himself over to drink and finished as a human wreck, Maurice Utrillo. You are an art dealer who produced Utrillos with the aid of gros rouge [bar-room red wine] as others produce battery chickens with hormones. Maurice Utrillo, who knew so well how to evoke the melancholy of Paris, its humble people, and its poorer quarters, was ensnared by you in trap after trap . . . What conferred a guarantee on many Impressionist canvases was to have passed through the hands of the celebrated collector, Ambroise Vollard; for others, henceforth, their guar-

256

antee will be *not* to have passed through the hands of Paul
Pétridès.' And Guyot added, 'Art isn't a thing you tinker with,
you fake, you use to swindle, or you fence. You have debased
it for money.'

As well as making this impassioned moral and artistic indict-
ment of Pétridès, the prosecutor dissected his schemes to sell the
stolen pictures. However, in view of the art dealer's age, he did
not demand the maximum penalty, but a light sentence of three
years' jail. He requested the same sentence for Francelet, calling
him a jet-setter, a freeloader who made no secret of his connec-
tions among the Paris underworld.

Even considering the weight of evidence against him and his
poor showing on the witness stand, the majority of people thought
Pétridès would benefit from his immense reputation and influence.
He had also retained his three famous barristers, who made the
most of his age, his infirmity, the loss of his wife, and the doubts
about his judgment. Maître Jean-Denys Bredin spoke with such
eloquent fervor that even Francelet was convinced of Pétridès'
innocence. After him came one of France's really brilliant crim-
inal lawyers, the Marseillais Paul Lombard, distinguished as
much for his elegant leonine mane as his legal wit and bite. From
a dossier a foot thick he made an inspired defense of Pétridès; he
redressed the cruel portrait of the art dealer by showing how he
had done his bit during the war, helping fleeing Jews with money
and earning the gratitude of Resistance hero and martyr Jean
Moulin by setting him up in a Nice picture gallery with free pic-
tures as a cover. Lombard sketched the portrait of Francelet, the
good-looking, smooth-talking charmer who weaseled into Pétridès'
confidence, dazzling this little self-made tailor with his jet-set atti-
tudes, spinning him stories of high-society connections, and finally
ensnaring him in the stolen-picture racket. 'It isn't surprising that
Pétridès was led astray by this brilliant but unhappy person . . .
Pétridès had everything — but one thing was lacking. He dreamed,
this Cypriot tailor, of belonging to the jet society. And Francelet
opened that door to him. However, it is absurd to think a wealthy
man, never once reproached by justice, would launch at seventy-
three into a form of highway robbery; it is absurd to think he

would let himself get mixed up with stolen paintings knowing he was dealing openly with them and would be discovered. And Pétridès hid nothing. Indeed, it was his demand to have his two Boudin canvases inscribed in the official catalogue that led to his arrest and trial.

'In the art world, nobody believes Pétridès guilty. But in any case, this man is punished by his very imprudence. Between what he has to reimburse and the tax authorities, he will be ruined; he will be forced to pay immense sums of money. This old man has destroyed those years left to him. He is a lamentable dupe.' Maître Lombard said it was the word of Francelet, the man with a police record who had admitted his guilt, against the word of a man with a clean sheet who had wrought great services for France to the world of art.

Despite the plea Judge Guth had no doubt that art dealing and art stealing had gone hand in hand. Sentencing Pétridès to three years' jail and 30,000 francs ($6,000) fine, he said: 'The deeds are particularly grave because they were committed by a distinguished expert who used his name and reputation. Specialist art thieves only act because they are assured of getting rid of their booty with the complicity of go-betweens and receivers of stolen property.' Francelet got three years' jail and a fine of 5,000 francs ($1,000); Fénayron, two years and 10,000 francs ($2,000); Zevaco, two years and 15,000 francs ($3,000); Voisin, eighteen months; Peretti, two years and 5,000 francs ($1,000); Sowinski, ten months. Both Hillairaud brothers went free for lack of evidence. Pétridès also had to pay a 2-million-franc ($400,000) fine for customs and exchange frauds.

A year later, in mid-February 1980, the appeals court dismissed the arguments advanced by Pétridès and the other accused persons and handed down stiffer sentences. It gave Pétridès another year in prison — four years — and increased his fine to 500,000 francs ($100,000). Francelet's fine was doubled to 10,000 francs ($2,000) and Fénayron got a further year in prison, though his fine was halved.

Pétridès could not invoke his good faith after buying master paintings from someone with no background in art dealing and

after losing himself in so many attempts to misrepresent the truth, said the judgment. 'Such acts are a fatal blow to art dealing,' the court concluded.

A cause célèbre in the art world, the Petridès case sent a strong tremor through quite a few well-known galleries and set picture dealers checking their stock and consulting official catalogues of master works and those growing piles of police circulars to ensure they had not transgressed. By dealing so summarily with an eminent personality like Paul Pétridès, by indicting him with other villains of the art racket, the French judges made it plain that any gallery owner who received and trafficked in stolen paintings would plead ignorance at his peril and could expect no leniency from the law.

# Epilogue: The World's Biggest Museum

With wry wit detectives working to stem the art racket have coined their own description of the vast underground pool of paintings, antiquities, and other art treasures stolen in the past two decades. The World's Biggest Museum, they dub it. In fact, an estimated 5 per cent of all art in circulation has been stolen and laundered at some time in its history. During 1978 alone more than 42,000 art works worth about $33 million vanished from museums, churches, and private homes; only one in twelve of these items has returned through police action or reward payments. Art thefts in Europe and America, using money as a crude measuring stick, are now running at about $100 million a year, a figure that continues to rise.

Since the Second World War cultural thefts have left all other crimes behind as a growth industry. And although in the future this pattern may change, the volume and cost of stolen objects will increase as the spiraling demand for art drives prices higher. In a sense, we ourselves have created the conditions for these robberies by converting art into a precious commidity like gold or diamonds, a sort of gilt-edged boom stock with its own market influenced and controlled by moneyed men, museums, and the auction rooms. What artist, art lover, or collector believes nowadays that art is its

260

own reward? Paintings and sculpture and antiques act as a hedge against currency erosion, as status symbols, or as investments. In our consumer society money has driven a wedge between people and the art that represents their culture. Seventy years ago the world viewed the *Mona Lisa* theft as an incalculable disaster; these days we would treat it merely as another out-of-pocket expense for a large insurance company.

Auction houses have done much to promote the art boom. In 1979 Sotheby's and Christie's netted more than $700 million; in five days during November 1979 Sotheby Parke Bernet in New York sold $21 million worth of Impressionist and modern art, almost its entire turnover for 1967. Even over the years from 1975 to 1978 its turnover more than doubled, from $165 million to $360 million. Similar increases have occurred in other important Western auction houses. France's main salesroom, the Hotel Drouot, had a turnover of $100 million in 1974 — twenty-one times the 1950 figure. In 1978 it reached $128 million. Often these auction sales, where a single picture is bid up to several million dollars, take place 'live' before TV cameras and make press headlines — as well as interesting reading for art stealers. As we have seen, auction houses unwittingly run the risk of selling stolen art themselves, even though most of the large American, British, and Continental firms have their own security officers — often former art-squad detectives — to check dubious merchandise. However, no less than Salvador Dali complained recently to an art critic and connoisseur that one well-known auction house took care not to send him its catalogues when selling his work — in case they were auctioning forged Dalis!

From the recent history of art thefts one thing emerges — the need for vigilance among collectors and curators and anyone who has a responsibility for art works. Thieves and crooked dealers prey on the gullibility of art lovers and rich amateurs, so it behooves them and members of the public to keep on their guard when buying art, especially when they are offered bargains. As the stories of the Mona Lisa, the *Duke of Wellington*, and many Italian cases have shown, picture thefts touch an ambivalent chord in the public mind. Like Kempton Bunton, the man in the street often

discounts or disbelieves the six- and seven-figure price tags on this Goya, Picasso, or Rembrandt. To him, paintings have become a pawn in some big-money game played between the rich, with dealers and auction houses holding the ring. Art as speculation, investment, or an inflation hedge means little to him; with many contemporary artists, he wonders that masterpieces created by the penniless Hals, bankrupt Rembrandt, and maligned Cézanne should now be sought not for their aesthetic qualities but should change hands like gambling chips. It strikes some people as almost immoral, so they often look with a tolerant indifference on the art stealer, whether he be a crook, connoisseur, or a struggling artist who pilfers from a museum or gallery as a protest or to enjoy his loot in privacy.

Professional thieves do not share these considerations; over the years they have grown more ruthless, as armed holdups in Montreal and some U.S. galleries, the Lespinasse raid in Paris, and the theft of the 118 Picassos have proved. In fact, security guards, strong-room doors, and detection equipment seem to challenge the art robber. Throughout the Western world detectives are noting a change in art-theft patterns; professional gangs are stealing to order for oil millionaires or crime bosses, or even for the rich collector who lives well beyond the country where the thieves operate and can arrange to launder the art work or wait for the statute of limitations to expire. Now the raiders will break into a mansion or a gallery and steal certain pictures but leave much more valuable art behind. Within hours those paintings have been smuggled abroad and will probably not break cover for at least a decade. By then they have either dropped to the bottom of the wanted list or are legally clean enough to sell.

Art thieves have a vast and ever-growing operational territory, unlimited cultural treasures to plunder, and an expanding underground network to help them dispose of their booty. As more private individuals and public institutions place their wealth in art, thefts increase. In the past twenty years new museums have proliferated and older ones have spent more lavishly on acquisitions. Canada, for instance, doubled its museum population from 700 to 1,400 between 1968 and 1978 and now ranks third behind

the United States' 3,020 museums and Italy's 1,450. Soviet Russia has 930, France 850, West Germany 400, and Switzerland 300. Most European museums, converted from palaces and public and private buildings, adapt badly to modern security requirements; many hardly know what treasures they have either on their walls or in their vaults. For professional burglars or armed robbers, they offer no problems.

All too often thieves are aided by the casual and even careless ways people have with art works. One hijack gang found itself with 15 million francs' ($3 million) worth of paintings when it merely wanted to steal a truckload of furniture. On June 28, 1978, three petty crooks watched the solitary driver of a moving van enter a Marseilles café for his evening meal, then drove away his van. To their shock they found ten master paintings by artists like Daubigny, Sisley, Gauguin, Courbet, Signac, and Guigou, all of them being returned to the half-dozen museums throughout France that had loaned them for an exhibition in Peking, China, and Seoul, South Korea. It took Paris and Marseilles detectives a whole year to track and catch the thieves with the stolen goods; they received prison sentences in March 1980. But had that truck carried $3 million in bills or gold, how many security guards would have accompanied it?

Not all art theft originates with professional criminals. Wartime plunder has not stopped. Items still filter into the legal market from combat areas like Cambodia; and in 1974, following the invasion of Cyprus, hundreds of antiquities dating from Egyptian, Greek, and other pre-Christian civilizations began to appear in London and New York, many of them looted by Turkish soldiers or plundered by government and international civil servants.

As a clearinghouse for black-market art and antiques, London outdoes every other capital. However, it has one of the most efficient art squads in the world. Since its formation in 1968, with never more than eleven detectives, it has recovered more than $100 million worth of stolen art. And this despite hundreds of cases of art-napping, where detectives have had to save the stolen treasure and catch the crooks. To a long tradition of brilliant criminal investigation the Yard has welded perhaps the best network of na-

tional and international informants in the world; art-squad officers have become adept at hobnobbing with both the art world and the underworld. But they owe much to their records office. Among the first to use a computer, the Yard has built up an international log of 10,000 paintings and sculptures and other stolen art treasures. A sort of Identikit description of art works is fed into the computer, using a basic code; within seconds Yard men can check on dubious items offered for sale to an auction house or recovered by police forces in Britain or abroad. From the metropolitan police headquarters a monthly bulletin listing stolen objects goes out to the art world and police stations throughout the country. Many of these items also appear in the magazine *Art and Antiques Weekly*, which runs a special section called 'Too Hot to Handle' to alert dealers and others in the trade. Scotland Yard has a good record of international cooperation, its art squad receiving more than 1,500 inquiries each year from foreign forces. During 1978 and 1979 it made more than two hundred arrests, acting on information from other countries and Interpol; a third of these inquiries originated from the FBI and U.S. law agencies.

France has also taken strong action to beat art bandits. From 1970, the year the country started keeping serious statistics, art thefts have doubled. Something is stolen every three minutes. In 1970 police files logged 1,260 stolen paintings; in 1978 this figure had reached 3,207; thieves visited 3,746 individuals, 165 antique dealers, 77 galleries, 183 churches, 178 manor houses, and 82 museums. Since 1945, according to French interior ministry statistics, 12,000 art works have been stolen, a long way behind Italy's missing 45,000 works. But the French art squad has scored some brilliant successes, first under Commissaire Jacques Mathieu, then under Commissaire Principal Gilbert Raguideau. Now the art squad numbers between twenty-five and thirty men, split into four groups and aided by elaborate backup equipment such as camouflaged cars, two-way radio links, Long Tom cameras. Round-the-clock access to a central computer unit gives Raguideau and his squad information on criminal records, thieves' haunts, hideouts, women friends, dress, type of car, fences — in fact, a complete portrait of every known art stealer. An international group ensures

that thefts committed abroad are pursued in France and works closely with Interpol. Raguideau's unit has handled, among other things, the Avignon Picasso raid and aspects of the Pétridès case.

All European police forces realize they need to act rapidly after an art raid. For thieves can easily conceal several million dollars' worth of pictures in a valise or on their person and walk through any number of airports undetected. And every frontier they cross makes it that much harder to catch them with their haul or nail the receiver and dealer who helps them unload it. Interpol plays a vital part in alerting police forces throughout the world. Twice a week it issues bulletins on stolen objects, and it has its monthly 'Wanted' notices; but it also has a world radio link that can contact fifty important countries within minutes of receiving details of an important theft. This type of action shuts every legitimate door in the thief's face, leaving him only the fence and crooked dealer, with the consequent risk of betrayal.

North America followed the European pattern whereby criminals first went for ransom, then reward, and now steal to supply the black market or private collectors. In the United States, since stolen pictures invariably cross state lines, the FBI can act immediately, throwing its immense experience and resources behind state and local lawmen. Their special agents have set ingenious traps, masquerading as anything from Texas millionaires to Arab sheikhs to catch thieves and middlemen and recover stolen art. With few antiquities and a dearth of classical painting and sculpture to fill its hundreds of museums and galleries, the United States has to import vast quantities of art; thus much of the pillaged treasure from European public and private collections filters into the U.S.A., often across the Mexican or Canadian border. Once there, with its real provenance suitably 'bleached,' it finds a collector or dealer patient enough to sit on it until he can claim legal title. Art community leaders have set up a special organization to serve the interests of everyone, from art lovers and small collectors to large museums. The International Foundation for Art Research, non-profit-making and based in New York, compiles and edits a monthly publication called *Stolen Art Alert*, sold on subscription;

this logs art works recently stolen anywhere in the world, giving their details, a description, and often a picture. In its archives the foundation has records of several thousand thefts, which individuals, dealers, and detectives may consult to help them search for lost art works.

How can international authorities, the police, the art trade, and the public cooperate to stop this assault on the cultural heritage of their countries? Governments can do much. Through the United Nations they could bring their laws into line on the import and export of art works, giving each a passport and issuing it a visa for the country to which it is going. This would make it much more difficult to smuggle Raphaels, Etruscan pots, and Indian idols. To help identify stolen objects, museums should have a complete inventory of everything they possess, with full descriptions and color photographs. How many historic objects remain unclassified and therefore a prey to thieves, pot hunters, and light-fingered tourists? Italy has done no real census; France has made a half-hearted attempt and lists 80,000 historic art works and sites, though the real figure is nearer a million. Severe internal laws and punishments should deter the art stealer or the *tombaroli* and the dealers and receivers who exploit their crimes. In the late sixties and early seventies Britain broke the reward racket with the Theft Act, which made 'dishonest handling' an offense, France made an example of Pétridès, and in the United States the go-between often walks into an FBI ambush and receives a stiff sentence.

Countries could also require fine-art dealers to register every purchase they make over a certain figure, noting the vendor's identity, profession, and address. This would assist police to trace stolen objects back to receivers and thieves. And once the bond between robber and receiver is broken, large-scale art theft will cease. Governments could also agree on a much longer and uniform international limitations statute. At present this can vary between three and ten years in different countries. To keep a valuable painting for three years, or even ten years, means nothing to the art lover or collector, especially as its worth will probably double or treble before the longer statute runs out. Where theft occurs in

a state museum, the government must refuse reward or ransom demands and order its staff to cooperate with the police.

Too many authorities do not take art stealing seriously enough. New York, a major art capital, has dozens of museums, scores of galleries, hundreds of dealers; it also has a fat art-theft file packed with everything from casual robbery to syndicated rackets. To cope with its art problems the city has assigned just one detective, Robert Volpe. Notwithstanding his talent as a painter, his personal flamboyance, and minor celebrity status, he is not enough in a cultural metropolis of New York's obvious importance in the international art world. Each country and each art center should have a trained art squad backed by modern equipment and kept together long enough to exploit its experience and pass it on to recruits; it should deploy enough funds to buy not only information but to compete with the underworld for stolen art in order to trap the thieves. Only when countries mean business about art stealing will the cultural hemorrhage stop.

Insurance companies can help prevent theft by insisting on a complete record in print and a picture of any object they underwrite over a certain value. Where they insure museum contents they should demand antitheft devices, from guards to the latest alarms. Today these include infrared and ultraviolet beams, photoelectric cells, and electronic equipment so sensitive that any movement in a room triggers the alarm. Pictures themselves can be booby-trapped so that even a mere touch will set off anything from a bang or wail to a drenching stain or a smokescreen; another alarm system, wired to pictures, runs off a car battery to stop thieves who cut the main electric cables.

But no amount of security or vigilance can stop art thieves so long as prices and inflation rates soar and masterpieces fetch ever more fabulous sums. Even the most efficient art squad must always lag that one step behind determined bandits, just as the most rigorous laws will always leave loopholes for the slippery receiver and his accomplice, the bent dealer. Only when people began to think of art mainly in monetary terms did the crime wave start; and only when art is treasured essentially for its own sake will it

267

seriously lessen. It is no coincidence that art stealers do not operate in Eastern Bloc countries because there is neither a legitimate art market nor a black market in which to dispose of stolen art. Society, which has pinned price tags on masterpieces, has to pay the penalty by witnessing increasing numbers of them join the world's biggest museum, the one forever closed to the public.

# *Acknowledgments*

My first debt is to my editor, William B. Goodman, who proposed the subject and encouraged me to tackle it. But the book owes much to the scores of people who unconditionally and unstintingly gave their time and information. Some I have named in the text; others must remain anonymous, like the French commissaire who looked like Maigret and fed me Scotch and the secrets of the Riviera underworld, the old jailbird and the jurist who in their characteristic fashions unravelled the complexities of the Pétridès case, the London loss adjuster who dispelled the mysteries of the reward game, or the Italian playboy who enlightened me about the dolce vita rackets. Nor can I mention some men on the right side of the law, because they are serving police officers, and some on the wrong side, with a dubious past, or future. I am no less grateful to them all. I should single out the pseudonymous Henri Collet, who generously allowed me to consult his unpublished manuscript. I also thank the following persons for their help: Professor Hermann Auer, head of the federal German section of the International Council of Museums; Dr. Amalendu Bose, head of ICOM India; Homer A. Boynton, Jr., Executive Assistant Director, FBI, Roger Young, FBI head of Public Affairs Office, and several FBI special agents; Miss Bonnie Burnham, Executive Di-

269

rector, International Foundation for Art Research; Harry Cox, Chief Librarian, Mirror Group Newspapers; Miss Denise Monney, head of the French police archives; Assistant Deputy Commissioner Peter Neivens, Scotland Yard; Madame Marguerite Nifenecker-Ruf; Paul N. Perrot, Smithsonian Institution; Commissaire Principal Gilbert B. Raguideau, chief of the French central office for the repression of art thefts; Robert Sauger of Interpol; Minister Rodolfo Siviero, head of the Italian art recovery delegation; Jos Trotteyn, Flemish artist.

I wish to thank the following publishers and individuals for permission to use material in copyright:

Editions Stock, Paris, for an excerpt from *Picasso et Ses Amis*, by Fernande Olivier.

Editions Gallimard for permission to use extracts from three short poems by Guillaume Apollinaire.

New Directions for short quotations from *Rhymes of a PFC* by Lincoln Kirstein.

Fawcett Publications, Inc., for an extract from 'Long Shot on a Hot Bundle' by Pierre Lafitte as told to James Phelan in *True, the Man's Magazine*.

Ogden Nash for permission to use his poem, 'The Collector.'

# Bibliography

*Survival: The Salvage and Protection of Art in War.* New York: Abelard Press, 1950.

Apollinaire, Guillaume. *Chroniques d'Art.* Paris: Gallimard, 1960.

Barnes, Albert C. *The Art in Painting.* Philadelphia: Merion Art Foundation, 1925.

Bazin, Germain. *The Louvre.* London: Thames and Hudson, 1971.

Bazin, Germain. *The Museum Age.* New York: Universe Books, 1967.

Bernham, S. N. *Duveen.* London: Hamish Hamilton, 1952.

Bernier, Georges. *Art et Argent.* Paris: Robert Laffont, 1977.

Burnham, Bonnie. *The Art Crisis.* London: Collins, 1975.

Burnham, Bonnie. *The Protection of Cultural Property.* Paris: International Council of Museums, 1974.

Esterow, Milton. *The Art Stealers.* London: Weidenfeld and Nicolson, 1967.

Grant, Judith. *A Pillage of Art.* London: Robert Hale, 1966.

Hamblin, Dora Jane. *Pots and Robbers.* New York: Simon and Schuster, 1970.

Hemingway, Ernest. *A Moveable Feast.* London: Jonathan Cape, 1964.

Kahnweiler, Daniel-Henry. *Entretiens avec Francis Cremieux.* Paris: Gallimard, 1961.

Kirstein, Lincoln. *Rhymes of a PFC.* New York: New Directions, 1964.

Lake, Carlton, and Maillard, Robert (eds.). *A Dictionary of Modern Painting.* London: Methuen, 1964.

271

Leitch, David. *The Discriminating Thief*. London: Hodder and Stoughton, 1969.

Malraux, André. *La Voie Royale*. Paris: Gallimard, 1968.

Meyer, Karl E. *The Plundered Past*. London: Hamish Hamilton, 1973.

Middlemas, Keith. *The Double Market*. London: Saxon House, 1975.

Moat, Edward. *Memoirs of an Art Thief*. London: Arlington Books, 1975.

Montaron, Marcel. *Histoire du Milieu*. Paris: Editions Plon, 1953.

Moulin, Raymond. *Le Marché de la Peinture en France*. Paris: Editions de Minuit, 1967.

Olivier, Fernande. *Picasso et Ses Amis*. Paris: Editions Stock, 1933.

Pearson, Kenneth, and Connor, Patricia: *The Dorak Affair*. London: Michael Joseph, 1967.

Reitlinger, Gerald. *The Economics of Taste*. London: Barrie and Rockliff, 1961.

Rush, Richard H. *Art as an Investment*. New York: Bonanza Books, 1961.

Saarinen, Aline B. *The Proud Possessors*. New York: Random House, 1958.

Schack, William, *Art and Argyrol: Life and Career of Dr. Albert C. Barnes*. New York: Thomas Yoseloff, 1960.

Seligman, Germain. *Merchants of Art*. New York: Appleton-Century, 1960.

Steegmuller, Francis. *Apollinaire: Poet among the Painters*. London: Rupert Hart Davis, 1963; New York: Farrar, Straus and Giroux, 1963.

Stein, Gertrude. *Picasso*. London: Batsford, 1946.

Taylor, John Russell, and Brooke, Brian. *The Art Dealers*. New York: Scribner's, 1969.

Tomkins, Calvin. *Merchants and Masterpieces*. New York: Dutton, 1970.

Treue, Wilhelm. *Art Plunder*. London: Methuen, 1960.

Vollard, Ambroise. *Souvenirs d'un Marchand de Tableaux*. Paris: Albin Michel, 1948.

# Index

273

ROGUES IN THE GALLERY

*has been set by Lamb's Printing Company, Clinton, Massachusetts, in Bodoni Book, a face named after Giambattista Bodoni (1740–1813), the son of a Piedmontese printer. After gaining renown and experience as superintendent of the Press of Propaganda in Rome, Bodoni became head of the ducal printing house of Parma in 1768. A great innovator in type design, his faces are known for their openness and delicacy.*

*The book has been printed on Mohawk Vellum and bound by the Alpine Press, Stoughton, Massachusetts.*